Hedgecoe
ON
PHOTOGRAPHY

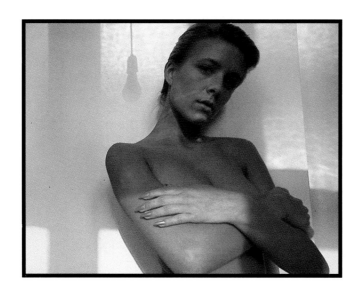

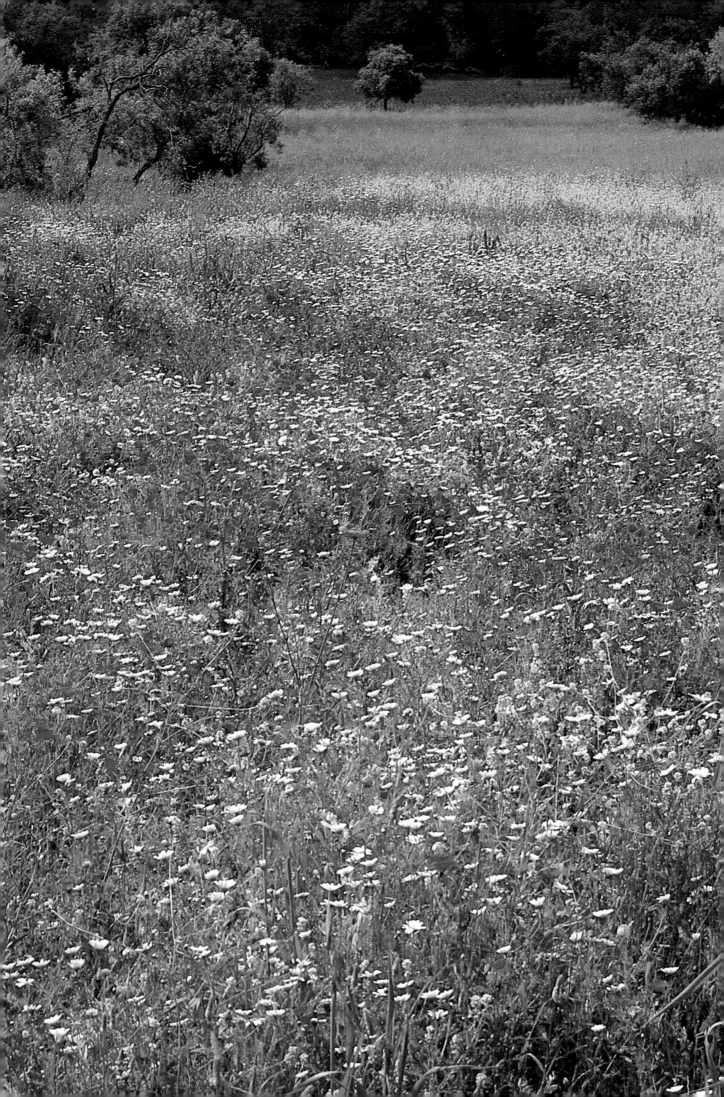

Hedgecoe

ON
PHOTOGRAPHY

John Hedgecoe

Weidenfeld and Nicolson
London

Hedgecoe on Photography

A MOBIUS INTERNATIONAL BOOK

Edited and designed by
Mobius International Limited
197 Queen's Gate
London SW7 5EU

First published in Great Britain in 1988
by George Weidenfeld & Nicolson Limited
91 Clapham High Street
London SW4 7TA

ISBN 0 297 79437 X

Filmset by Bookworm, Manchester
Reproduction by Columbia Offset (UK), London
Printed and bound in the Netherlands
by Royal Smeets Offset, BV, Weert

ACKNOWLEDGEMENTS

Associate writer: Kate Salway

Illustrator: Philip Chidlaw

Designer: Dave Goodman

Contents

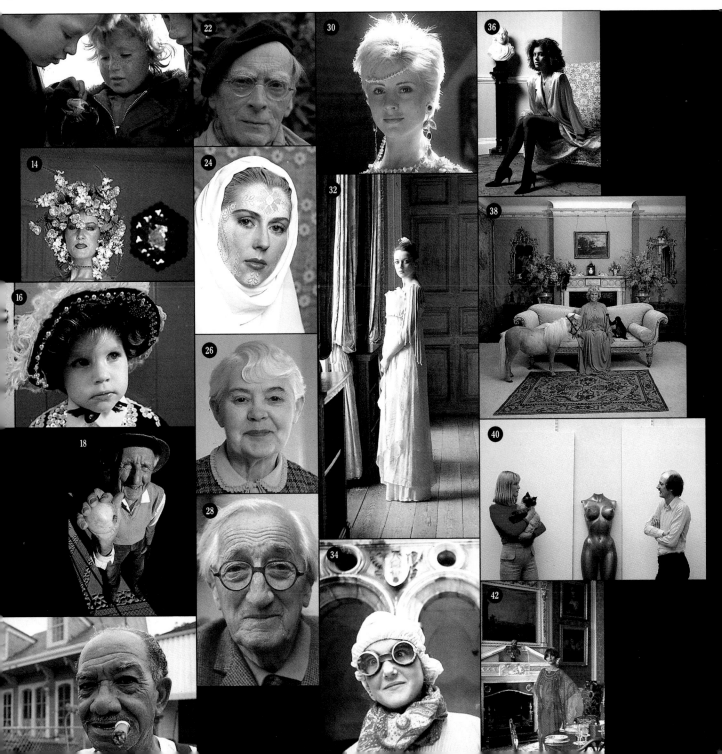

CONTENTS

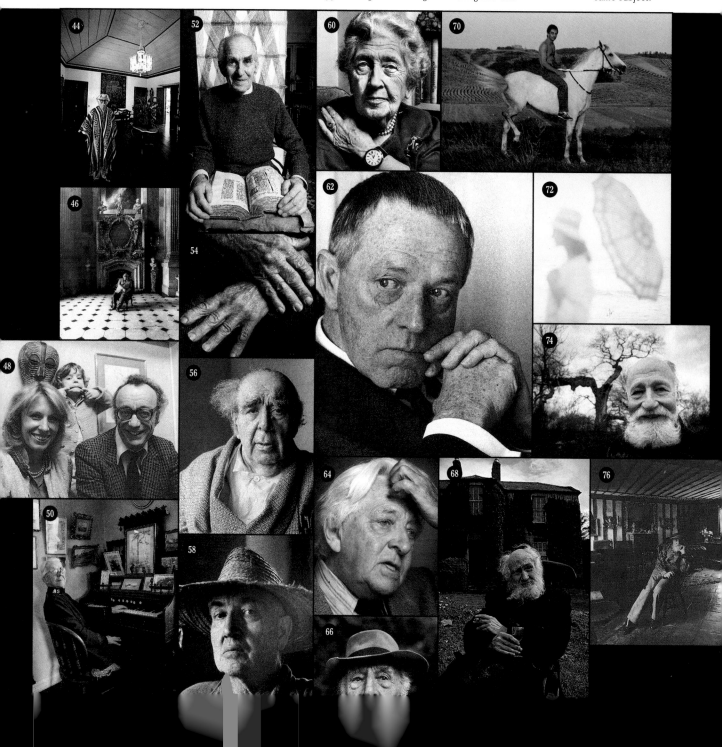

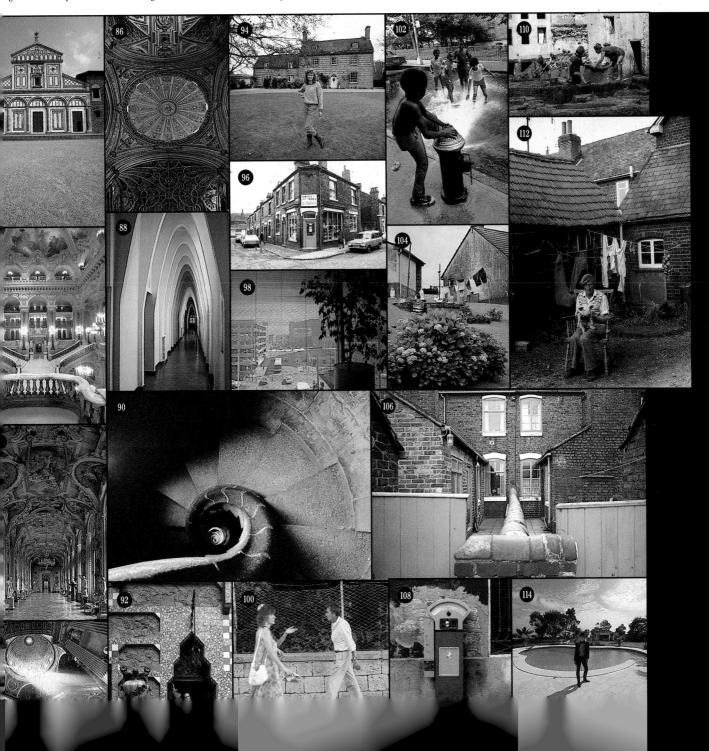

8 | CONTENTS

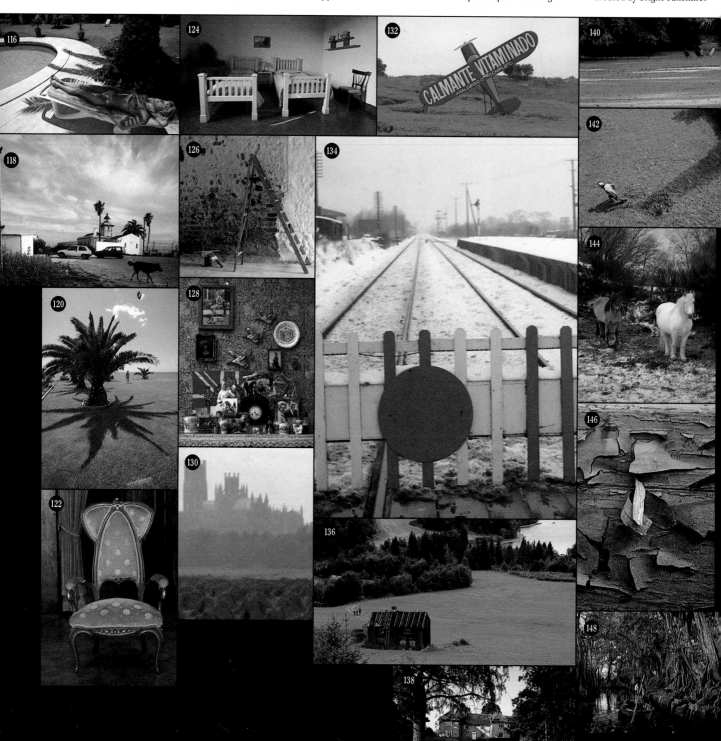

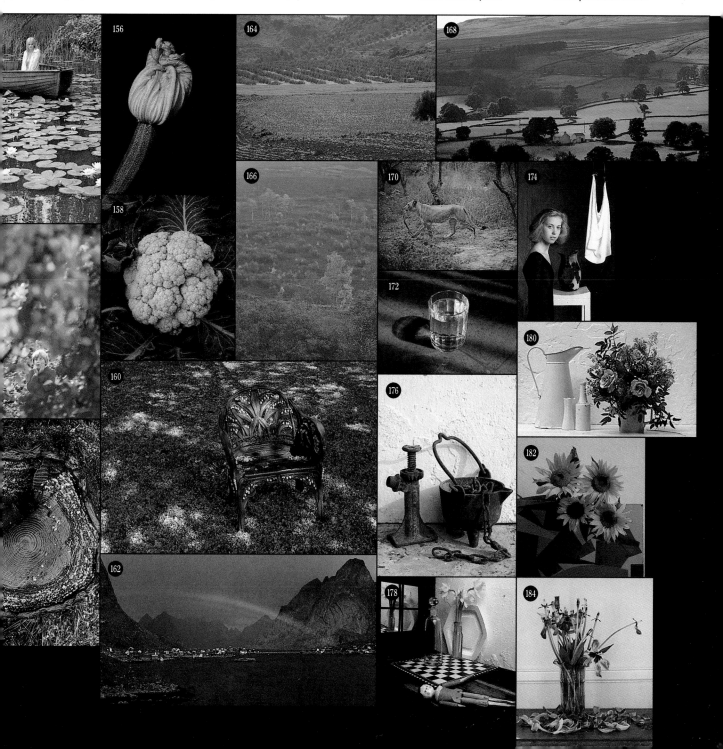

10 | CONTENTS

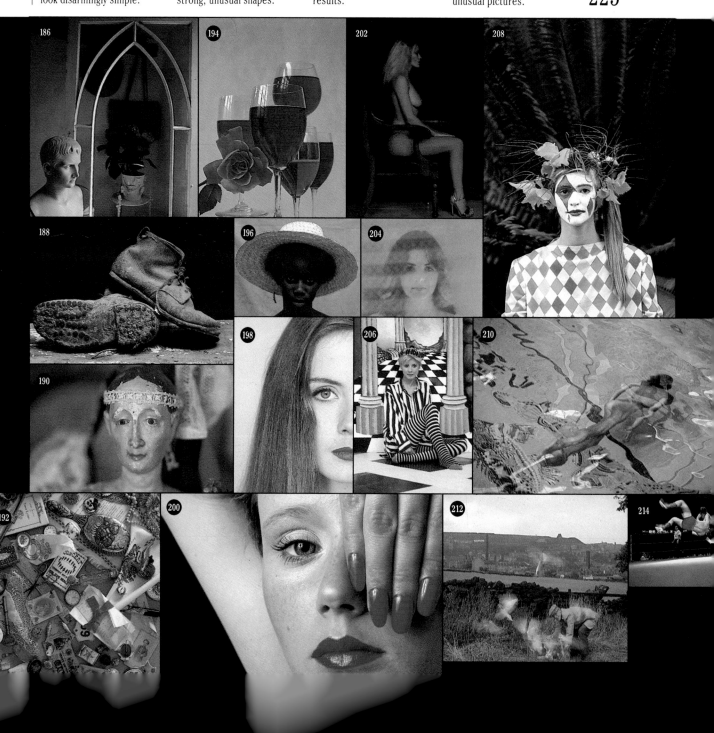

Introduction

Photography is undoubtedly one of the most exciting and enjoyable of the visual arts. It can also be enormously rewarding. When you take photographs you really work for your own satisfaction but, if others can derive pleasure and interest from them as well, that is an even greater reward. The best examples, I find, always do both.

You don't need exotic subjects, famous personalities or great dramas to make interesting pictures. What you do need is a willingness to experiment, to stretch your mind, your imagination and your vision. At first sight, a lot of subjects may not seem immediately appealing or exciting but they can actually make very interesting pictures indeed. As I have tried to show in this book, every subject can give you material, if it is visualized in an imaginative way.

Perseverance, too, is important. If you are interested in a particular subject and can't make the pictures work straightaway, don't give up. Go back again and again. Many very successful professional photographers have returned to a subject many, many times until they have achieved results that pleased them.

You do not have to spend a fortune on photographic equipment to take good pictures. A camera is, after all, just a light-tight box with a lens and a shutter, and a means for transporting the film at the back. All cameras have these facilities, from the cheapest to the most expensive. Comparing cameras is rather like choosing between two cars – they will both take you from A to B, but the more you pay, the more refinements you get. When buying a camera, choose one that you feel comfortable with, that you can hold steadily for slow speeds, and at a price you can afford.

For ninety per cent of pictures taken, three lenses – a wide-angle, normal and long, which could be, for example, a 28mm, 50mm and 135mm – are adequate. Nowadays, the quality of lenses produced by many manufacturers is very high indeed. It is a good idea to use each lens for a period of time to get to know it and its potential. Don't forget that the wide-angle lens, which is so useful for taking landscape shots, can also be used for still-life work; and a long lens can be used for close-ups as well as for distance shots. It is very silly to buy a fast lens and then always use it at f8 or higher. With a fast lens and fast film you can take pictures in the most minimal of light conditions.

The only other essential pieces of equipment are a tripod and a cable release to enable you to explore a greater number of situations.

Expensive equipment is not the key to good photography – imagination and a certain amount of technical knowledge are. Always be ready to experiment – try to stretch your own personal vision as well as your other capabilities. Themes can be a very good idea in this respect – a collection of groups, people or ideas can help you to develop a personal style.

I have assumed that the reader of this book is someone with a great interest but a rather general understanding of photography. Through this book I hope to be able to extend the reader's aesthetic and technical capabilities, enabling them, in a sense, to create their own art, rather than reflecting other people's.

John Hedgecoe

Concentrating the image

Often you want to get in very close in portrait work, excluding any extraneous detail, and the vital thing is to get the right expression on the subjects' faces. Here the children are looking at a crab. To get the intense expression of concentration on their faces I asked them something about the crab – how long they thought the claws were – and while they looked intently at it, I took the picture. If I had asked them to pose for a picture they would have become self-conscious, but by asking for information, the desired expression of concentration was achieved. By getting in close, the light is shut out, so fast film, 200 ASA, is needed. I used a 100mm macro lens.

Fantasy portrait

In portrait photography, the inspiration can come from a certain object or setting. In this case the mirror with the flower-decorated frame was the starting point. I decided to decorate the model using a mixture of real and silk flowers in her hair – the artificial flowers had to be used when special shapes were required. I photographed her in a variety of places – all within the one room – searching for a shot that would reinforce the idea of the flower-haired girl.

The result was nine variations on a theme. I used three different lenses – 28mm, 50mm and 135mm – to produce changing effects, reducing the

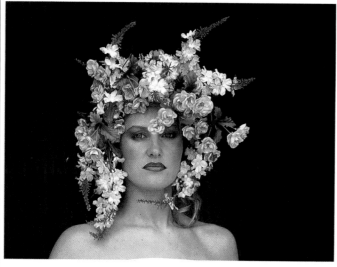
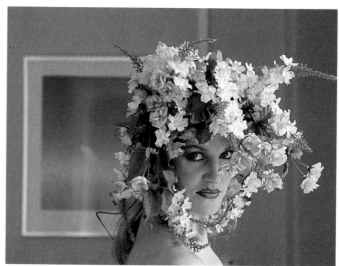
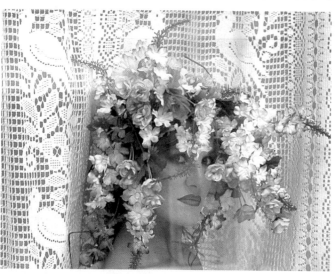
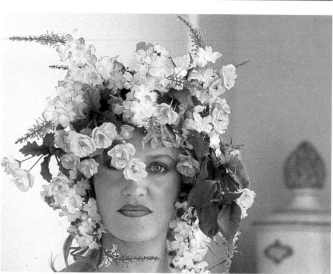
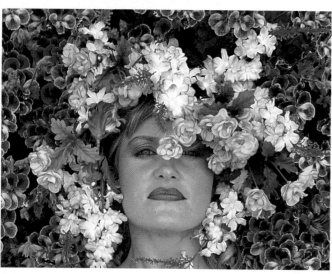
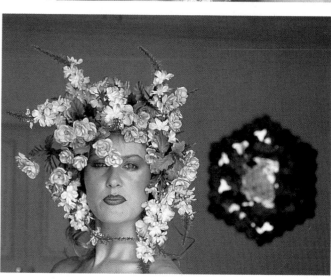

size and importance of the mirror and bringing a slightly different atmosphere to each shot. The distance of the model from the mirror is varied in each, but the size of her head is the same in all of them.

The atmosphere created by the fantasy of flowers for the hair began a train of thought and inspiration. The picture I like best is the one where mirror and hair become an integral part of each other.

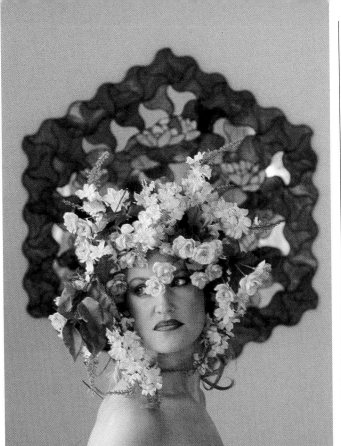

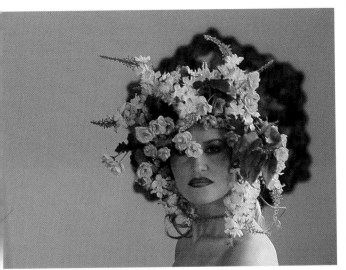

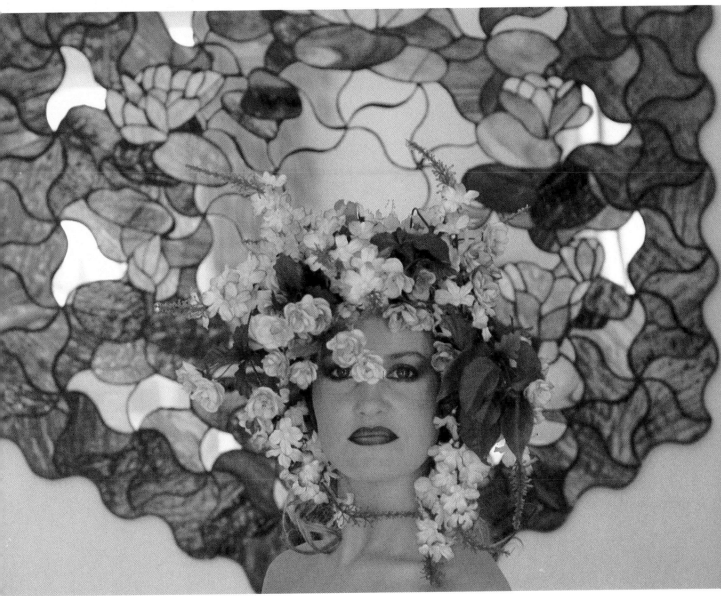

Young and old

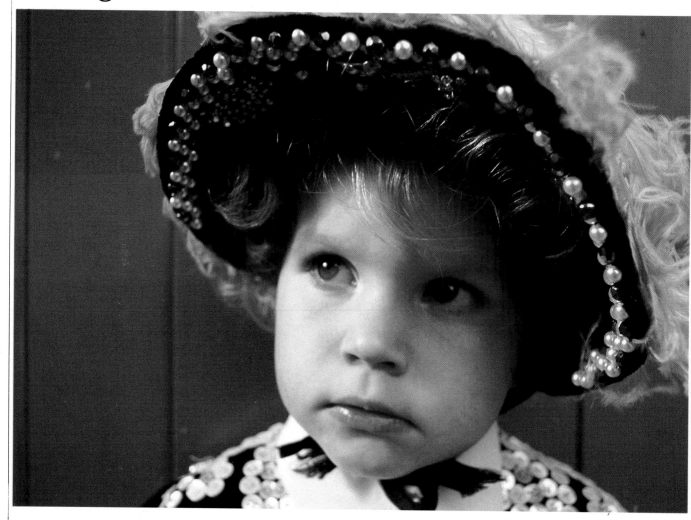

These two pictures demonstrate the contrast between youth and age in portrait work. With children, you must work fast as they cannot hold a pose for long. It is vital to try to catch the moment where the child is looking relaxed and natural. In portraits of older people, you are trying to capture in a certain look or expression the memories of a lifetime, even a whole era.

The little girl, *above*, is the daughter of a pearly king and queen but even in her old-fashioned traditional costume, her smooth skin and wide-eyed and rather innocent expression shine through.

The opposite extreme is the portrait of the old woman, *right,* with very lined skin. There is a great deal of experience and knowledge to be seen in the glint in her eye. Always focus on the eyes, as they are the most revealing of features. Both portraits were taken outdoors, using a 135mm lens on 35mm format.

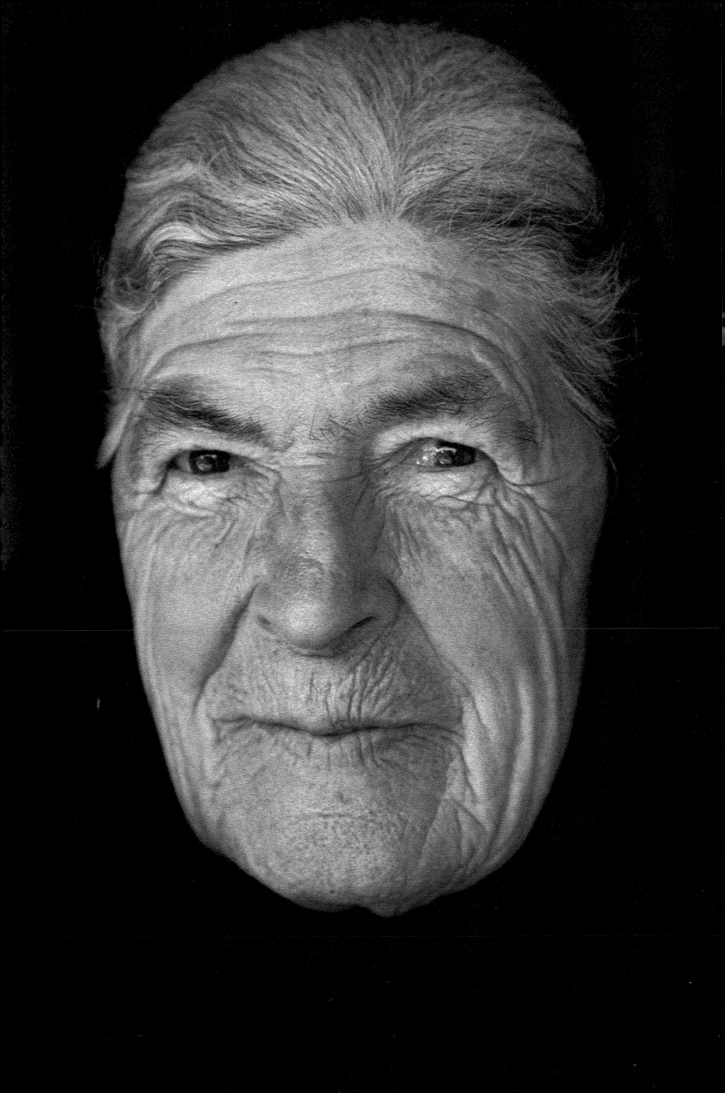

Using a wide-angle lens

A wide-angle lens is anything less than 50mm, normally 35mm, 28mm, 24mm, 21mm, 18mm or 15mm – after that you are into fish-eye lenses. If used carefully in portraiture, and if the model is posed in the absolute centre of the shot, a wide-angle lens does not distort too much.

Below The girl on the stairs is taken with a 28mm lens. This emphasizes the length of her legs, which are thereby made to look more elegant and provocative.
Right This old man has been shot with a 24mm lens; here you can see more distortion than in the first picture. This is deliberate. It is done in order to exaggerate the humorous aspect of this toothless old character offering me an apple. The closeness of his face also gives a feeling of intimacy, the feeling that the viewer is actually there standing close to the subject and that the old man's hand and the apple are reaching out of the photograph.

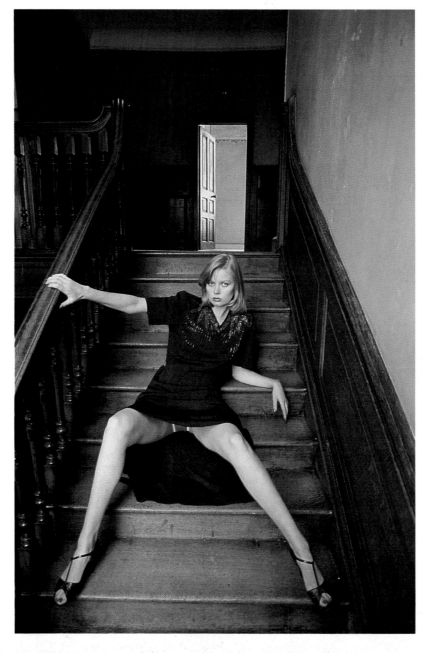

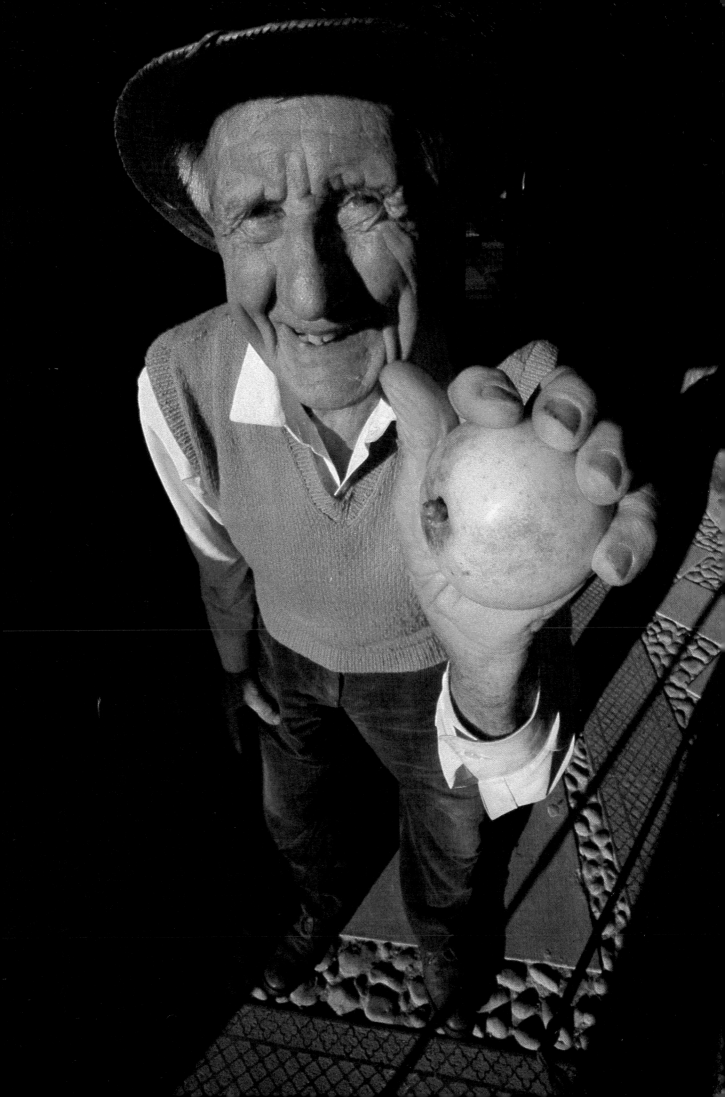

Informal portraits: 1

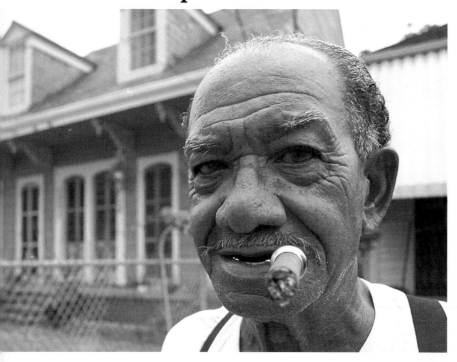

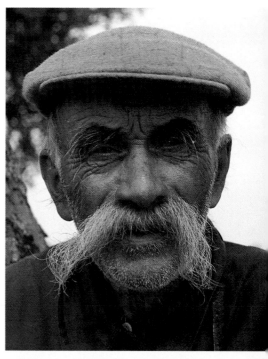

Above left I was photographing the buildings in New Orleans when curiosity brought this guy up to see what I was doing. I was able to include him and his over-large cigar in the picture. The overcast light, which wasn't too good for the buildings, was excellent for the portrait.

Above right The old French farmer, fascinated by my photographing a tree, came to see what I was up to. This enabled me to take his portrait in the light of the sunset, giving his face an added glow.

Right I didn't attempt to overcome the blue cast caused by the dusky light in this portrait of the late sculptress Barbara Hepworth, taken in her garden in Cornwall.

Opposite page Percy Shaw, whose invention of the cat's eye made him a multi-millionaire, sits in the road in the fog. Mist and fog create very good light to photograph in because it is soft and diffused. The faint image of a house in the background is an important element in the composition.

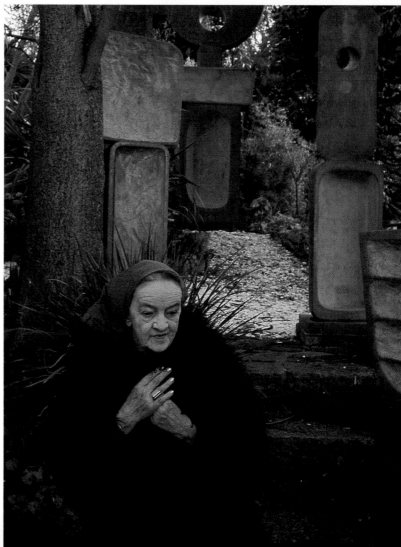

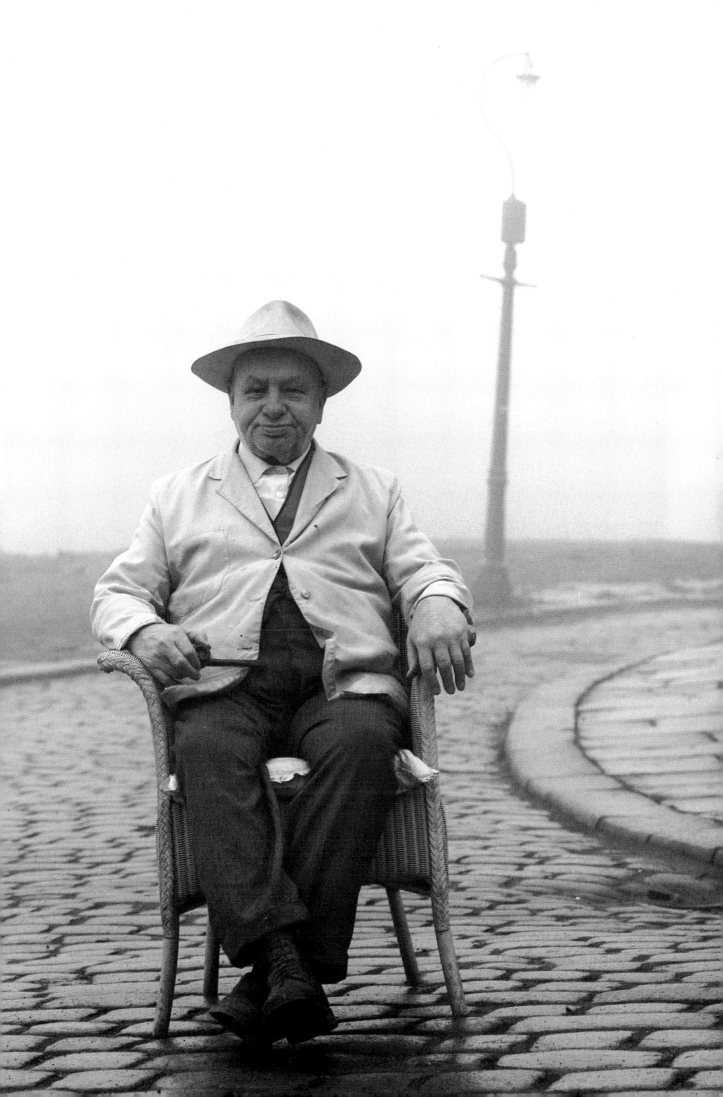

Close-up faces

Close-up portraits are fascinating to do because they give you the chance to examine faces in detail, which you can't normally do in public because it would be considered very rude. A face tells you a lot about people's lives – deducible from the quality of their skin, the glint in their eyes and the shape of their lips. It adds an extra dimension to incorporate an interesting background which suggests something about the nature of the subject, and at the same time it prevents the image from becoming like a high-street studio portrait. Aim at a naturalistic, rather than a posed or even an imagined view of a person. All these portraits were taken with a 135mm lens in daylight. Overcast light is preferable. If it is sunny, I put subjects into a shadow area and use reflectors to reintroduce the sunlight (but not where there are reflections or you get a blue cast, particularly if late in the evening).

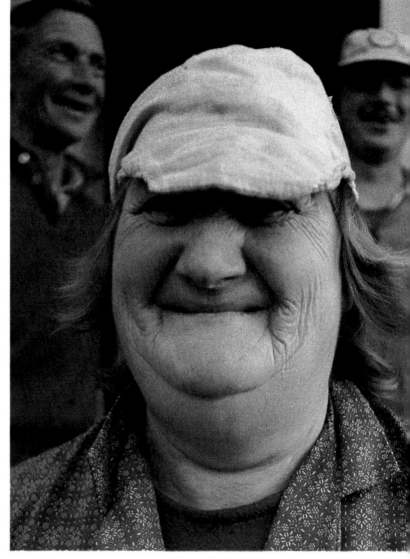

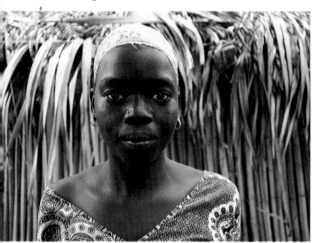

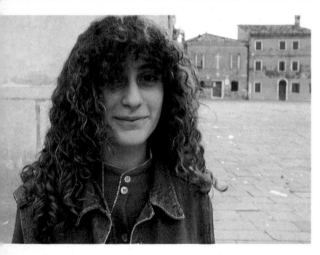

Above left In this portrait of a native woman (taken outside her house as the colours all related so well) there is a wonderful symmetry about her face that I wanted to emphasize.

Above This French farmer's wife did all the talking, so I placed her husband and son behind her.

Left I wanted to get the piazza behind the Italian girl into the picture, as there was a lightness and airiness about the place and she appeared very natural there, as it is where she lives.

Top near right The brown wavy hair, set against the brown rocks, makes the picture almost monochromatic. This sympathy of colour is actually the main subject here, so I did not want the girl to look at the camera. The fleeting, suspicious look is characteristic of her.

Top far right This restauranteur in Normandy has a very telling face; everything about him is good, strong and solid. He sits firmly in his chair and serves good square meals in his café. He has his feet very firmly on the ground, a characteristic of rural France.

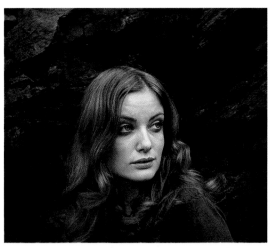

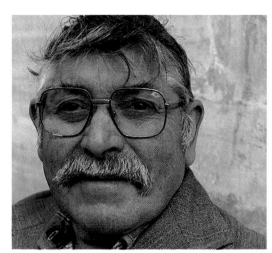

Below The painter Ivor Hitchens has fine and delicate features – a sensitive face, soft and gentle, which reflects his personality. The colours and forms of his paintings are likewise, sensitively chosen and finely balanced.

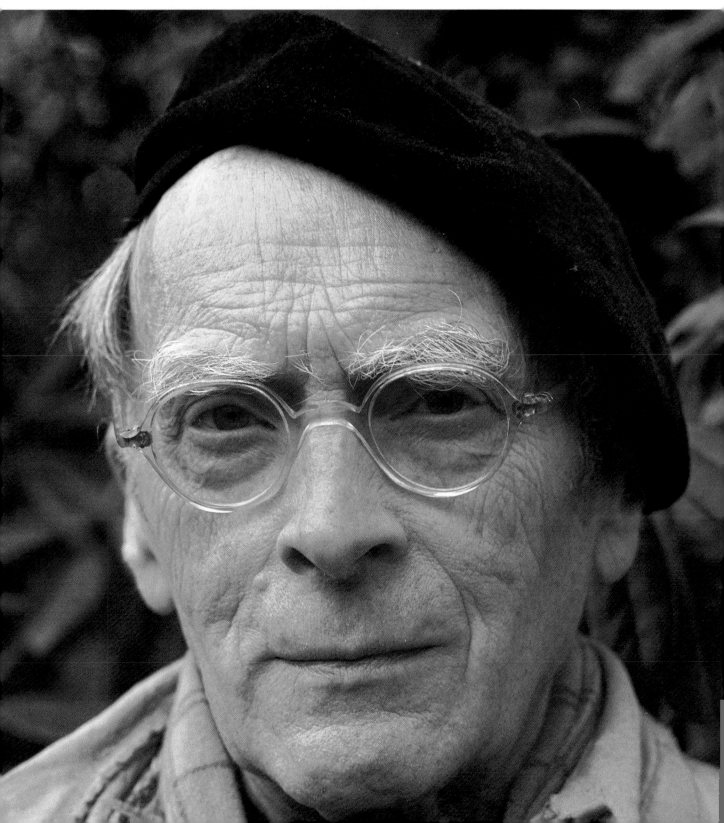

A touch of glamour

Glamour photography usually entails the creation of an overall flawless image – rather than in other types of photography where you try to reveal character. In these pictures, I decided to emphasize the shapes of the faces by framing them, in one case with a shawl, in the other with the model's own hair. The two shots show how the use of ideas can add life to the picture – in this case the ideas were inspired by lace. In one I cut off a piece of lace curtain to make a headband; in the other I used a second piece of lace pressed against the model's face and sprayed with white make-up. Little devices like these make the work more personal. As with beauty shots in general, I have used frontal lighting, overexposed by half a stop to get the pictures as light as possible.

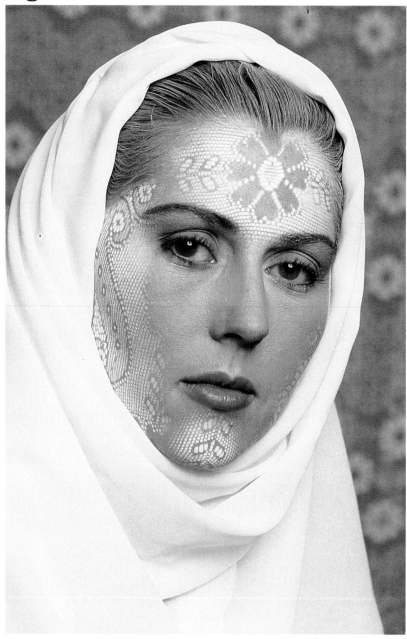

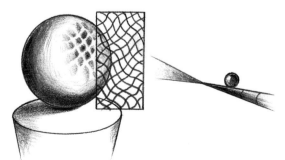

Diagram *Spraying face paint through a piece of lace held firmly against the model's face will produce a very professional looking pattern.*

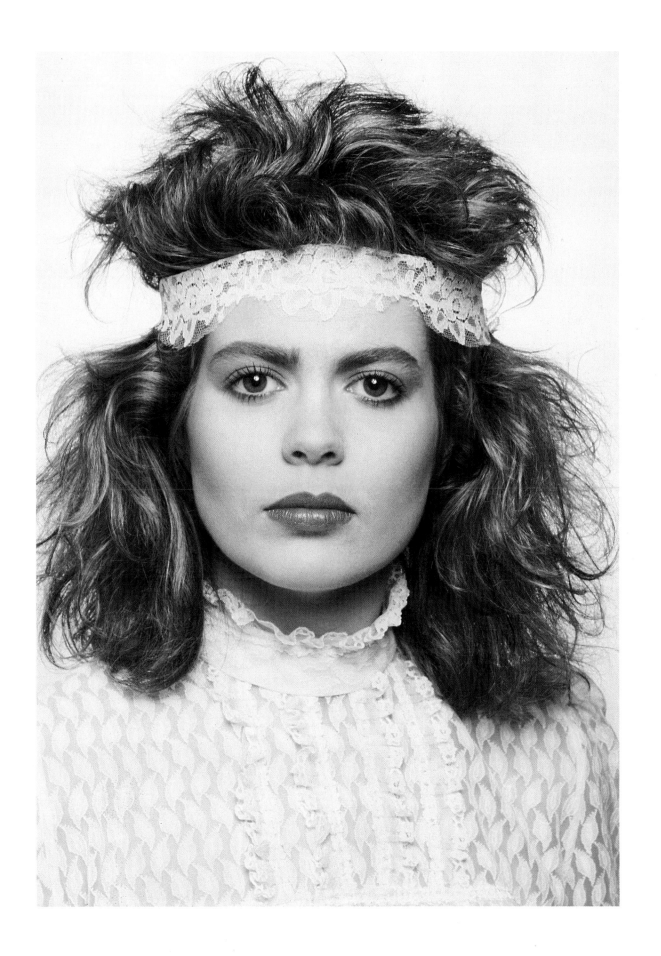

Frontal lighting

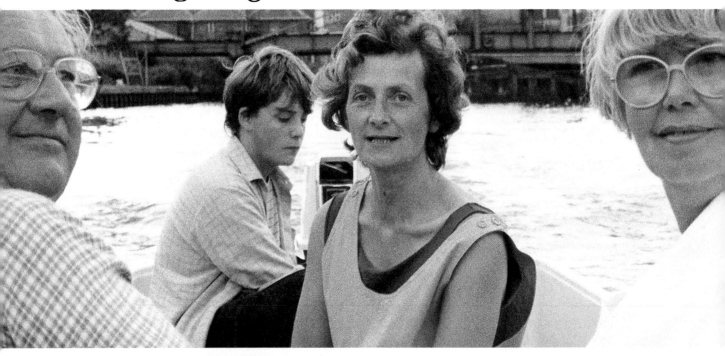

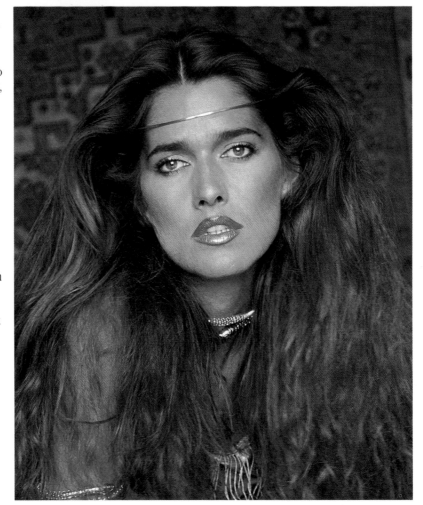

Much favoured for beauty shots in glossy magazines, frontal lighting is both soft and the perfect light to show detail. Naturally, this makes it very flattering when used in conjunction with carefully applied make-up. It destroys the form and creates shadowless pictures, but at the same time reveals all there is to see – unlike classic and side lighting which show form and depth. Its softness can be used to hide lines on the face. Frontal lighting means a bank of lights or one big light totally around or fixed to the camera.

Above This is an overcast day, with the sun totally hidden. It still gives soft directional light that is very even because of the lack of graduation in the shadows. If you keep the picture light, the features will then show up clearly but without modelling.

Left A picture window here gives an intense bright light on an overcast day enabling me to reveal everything. The modelling is introduced by make-up, as is done in beauty shots.

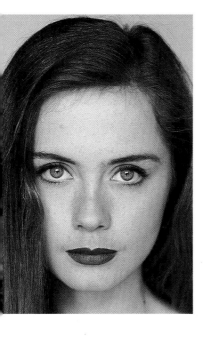

Left With the model facing a large window, which was covered with tracing paper to soften and diffuse the light, a very frontal soft lighting effect was achieved.

Right The classic painter's north light, used here to reflect its unchanging top light onto the subject, has revealed all the features while at the same time giving detail in the highlights and shadows. Soft frontal and overhead light has allowed the silver jacket to throw up a luminescence onto the face.

Diagram *Frontal lighting entails either several lights near the camera or one big light fixed to the camera and directed straight on to the subject.*

Left Here winter sunshine is diffused by net curtains. The pastel-coloured walls of the room act as a softening reflector.

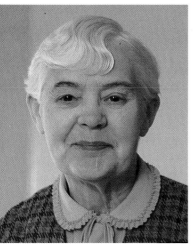

Left This portrait was taken in Norway in very bright light, softened by the use of frosted glass. The combination of these two factors has produced a delicate, flattering light.

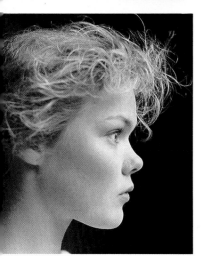

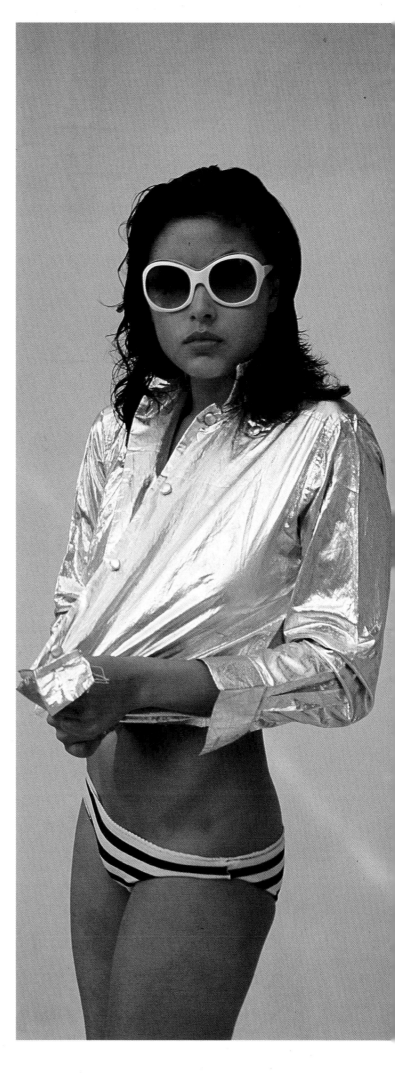

The classic lighting

Classic lighting can be hard or soft but the intention is to obtain a lighting that gives the maximum three-dimensional form to any face. The way to do this is to have the light at an angle of 45 degrees to the model, midway between the camera and the model (*see diagram*). Also the light usually should originate from a height one-and-a-half times that of the model – i.e. at 9ft (2.7m) if the model is 6ft (1.8m). Shining down, it highlights one side of the face

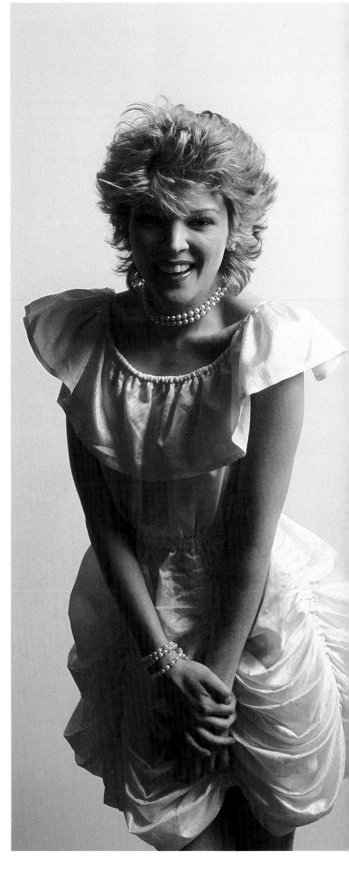

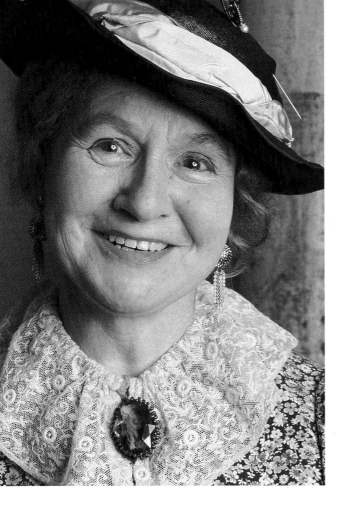

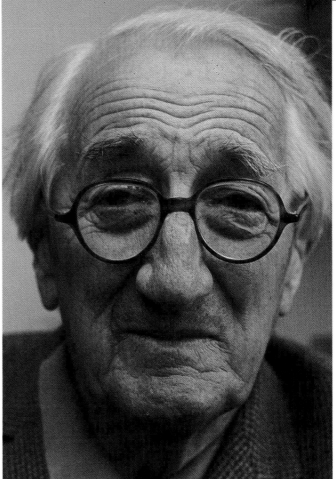

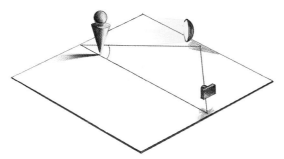

while the other gradually goes into shadow. This is akin to mid-morning and mid-afternoon sunlight and gives the maximum form to the subject's face.

In all these portraits I have used soft, directional light, reflected or diffused, sometimes through a window. Using classic lighting you will get better shape and form for the cheeks and nose and a more symmetrical roundness of the face than with any other lighting. A reflector is used to lighten detail on the shadow side.

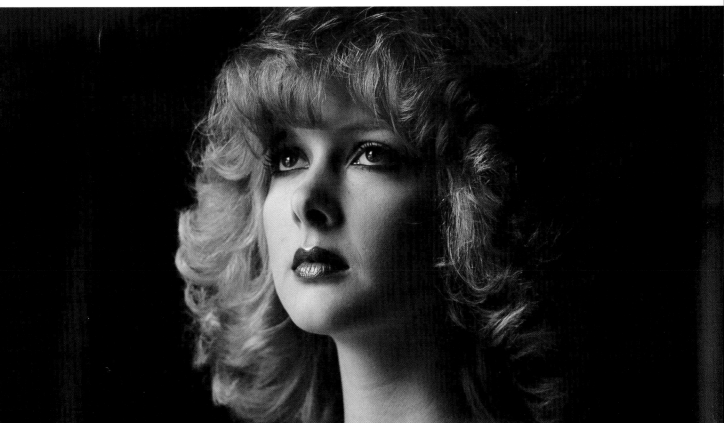

Portraits using reflectors

When using daylight it is usually absolutely essential to also use a reflector to fill in. These reflectors can be professional or home made.

Right Here I've used a mirror to reflect light which is very strong. You can actually reflect back an image that is almost stronger than the light itself, using the mirror like a spotlight. With a glass mirror you can redirect the light to be either a fill-in or a main light source and it is the most effective form of reflector you can use.

Below For this girl I used a silver paper reflector about 30 x 20in (76 x 51 cm). Take ordinary foil, screw it up and paste it on a card to make a soft rather than a harsh reflector. If you are doing close-up beauty shots it needs someone, as here, with very good skin.

Opposite page This subject is backlit and I have used two reflectors to catch some of that light and throw it onto the face (*see diagram*). This technique is used quite a bit for beauty shots.

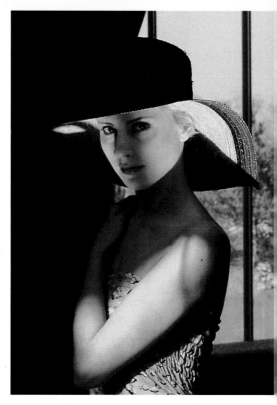

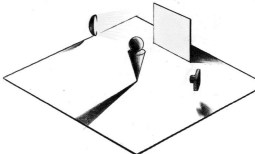

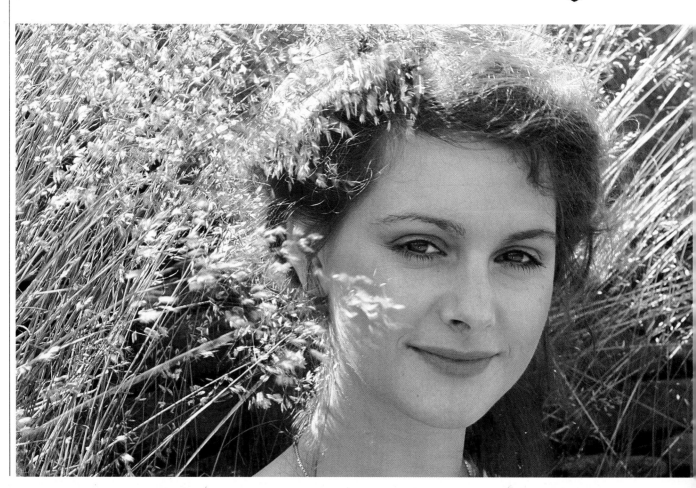

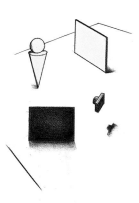

Diagram *Here two reflectors have been used to catch back lighting and redirect it on to the model's face.*

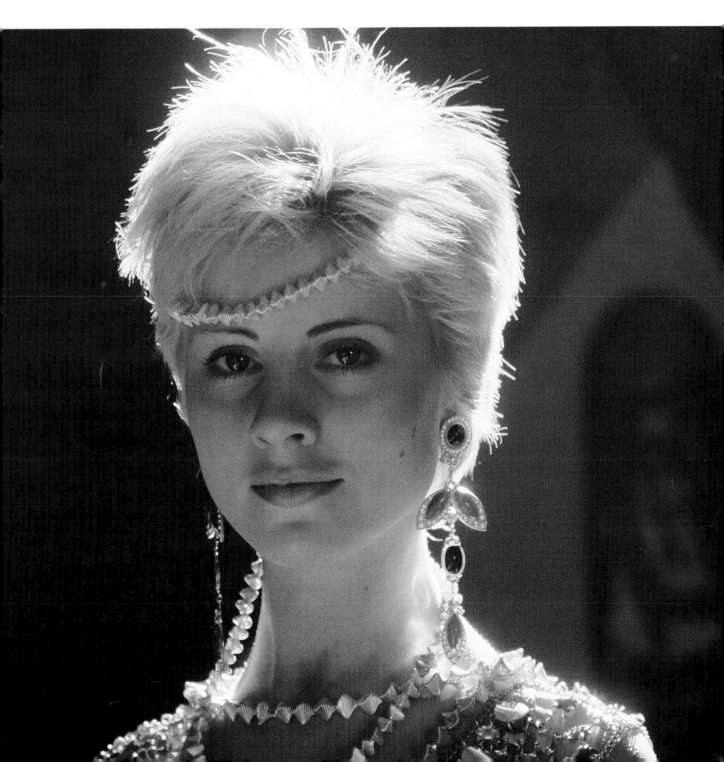

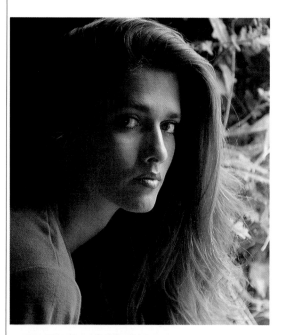

Side-lighting

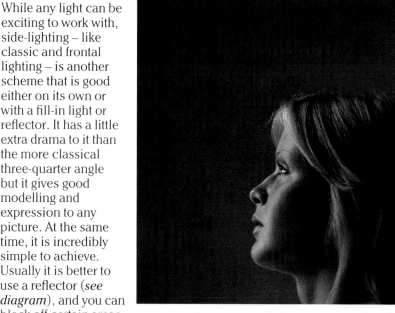

While any light can be exciting to work with, side-lighting – like classic and frontal lighting – is another scheme that is good either on its own or with a fill-in light or reflector. It has a little extra drama to it than the more classical three-quarter angle but it gives good modelling and expression to any picture. At the same time, it is incredibly simple to achieve. Usually it is better to use a reflector (*see diagram*), and you can block off certain areas of daylight with blinds, black paper or a series of cards. Lighting faces from one side gives a graduated tonal range from highlights to shadows, but it is stronger than the 45-degree angle lighting, in which one has a very long range of tones.

Here we go from highlight to shadow more quickly, increasing the drama and excitement, without becoming melodramatic or theatrical. You can reduce the drama with reflectors, a fill-in light or flash. The system is simple, leaving you free to concentrate on other elements, such as facial expression and composition.

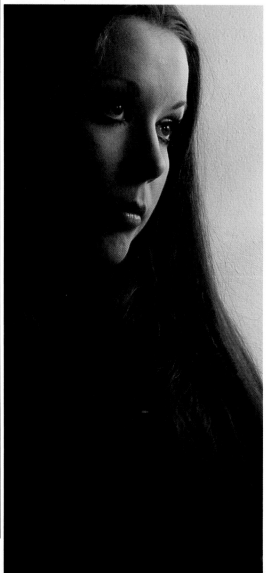

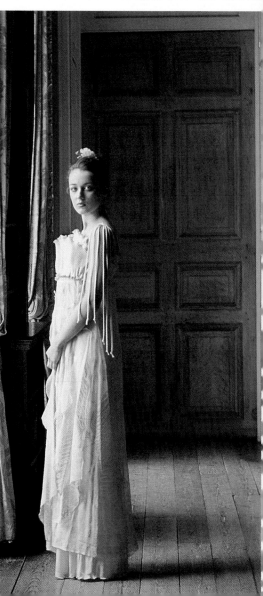

Diagram *When you have a situation where light comes in only from the side, it is better to use a reflector in order to balance the light falling on the model.*

Informal portraits: 2

I always go about with a camera when travelling and am constantly coming across people, usually children, who ask me if I will take their picture. I never refuse. I love these rather formal, posed portraits because they are very expressive. Whatever the subjects' circumstances they are always proud to be the centre of attention for a while, and I usually let them pose themselves wherever they are comfortable.

Right All eyes watch the camera.

Below left This native woman's clothes create a wonderful colour harmony against the background of her house.

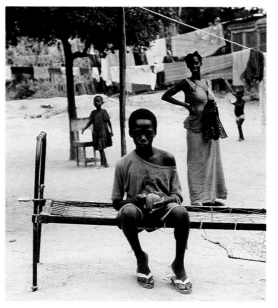

Opposite This girl was working on the restoration of a building in Venice and the shapes of her protective goggles echoed those in the building behind her.

Below This boy, although ragged, appears incredibly happy. He followed me around carrying my camera case and, just before I left, asked for his picture to be taken, standing proudly while the other children looked on.

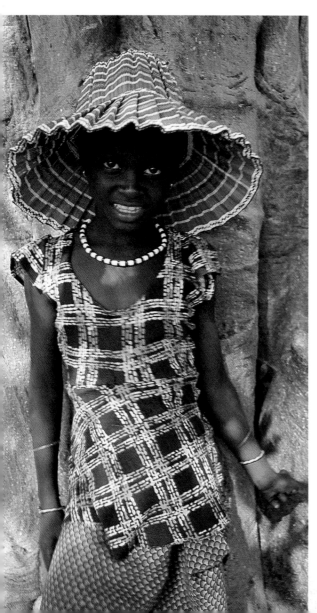

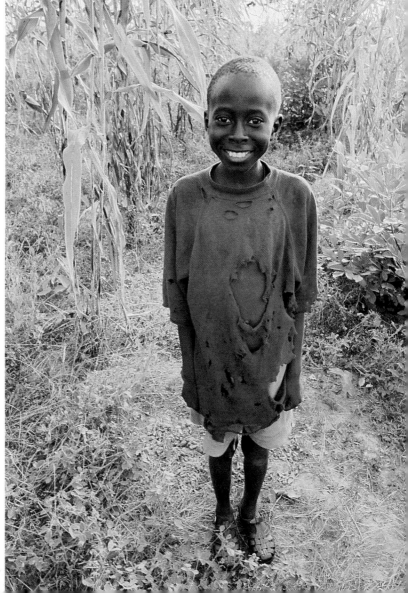

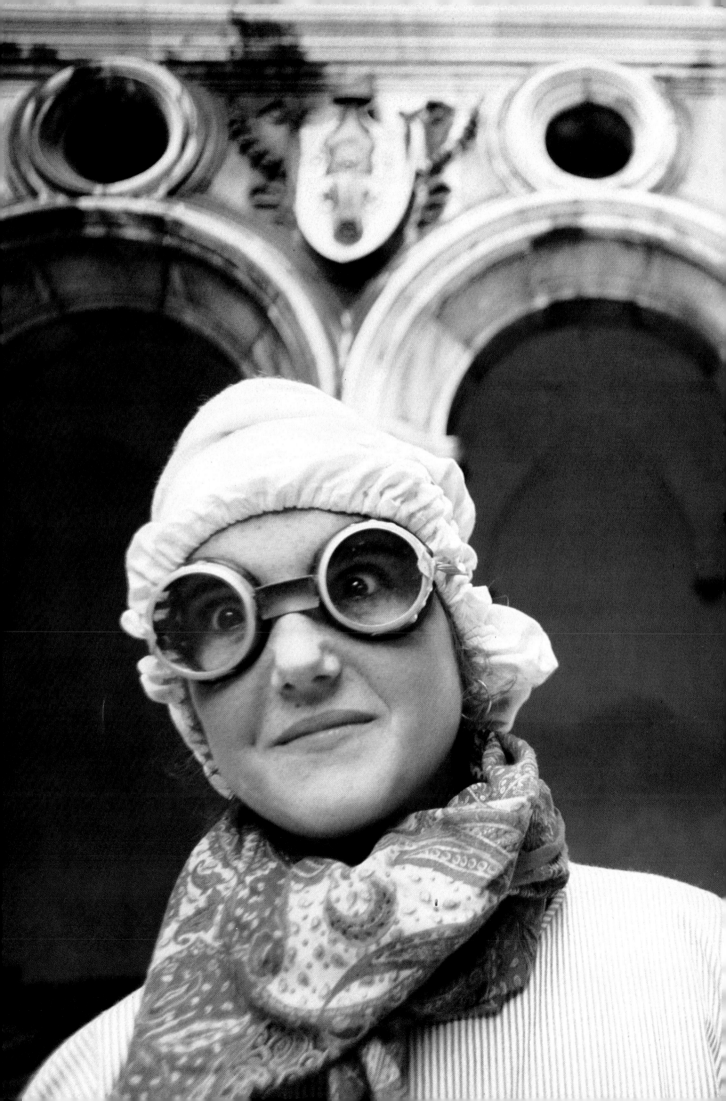

Simple poses, simple lighting

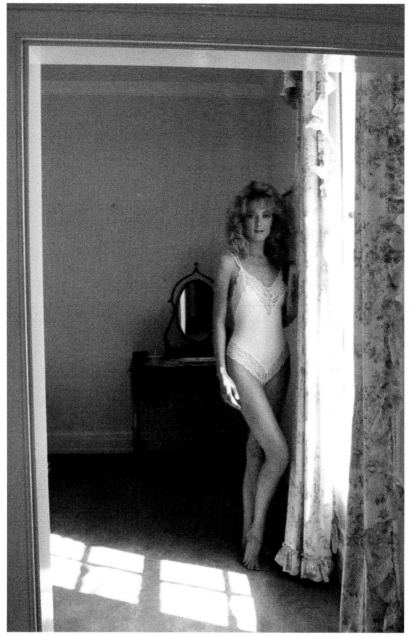

For these two indoor portraits I've used sidelighting; in one daylight and in the other, flash. In each case it was one light source, shining straight from the side, on to the subjects who adopted their own quite natural poses.

For the daylight shot, *above,* of the girl standing by the window I have used Scotch 1000 ASA film. For added interest, the furniture and the room have been included. The picture of the seated girl, *right,* demonstrates that you do not need elaborate poses, lighting or room sets to create good portraits.

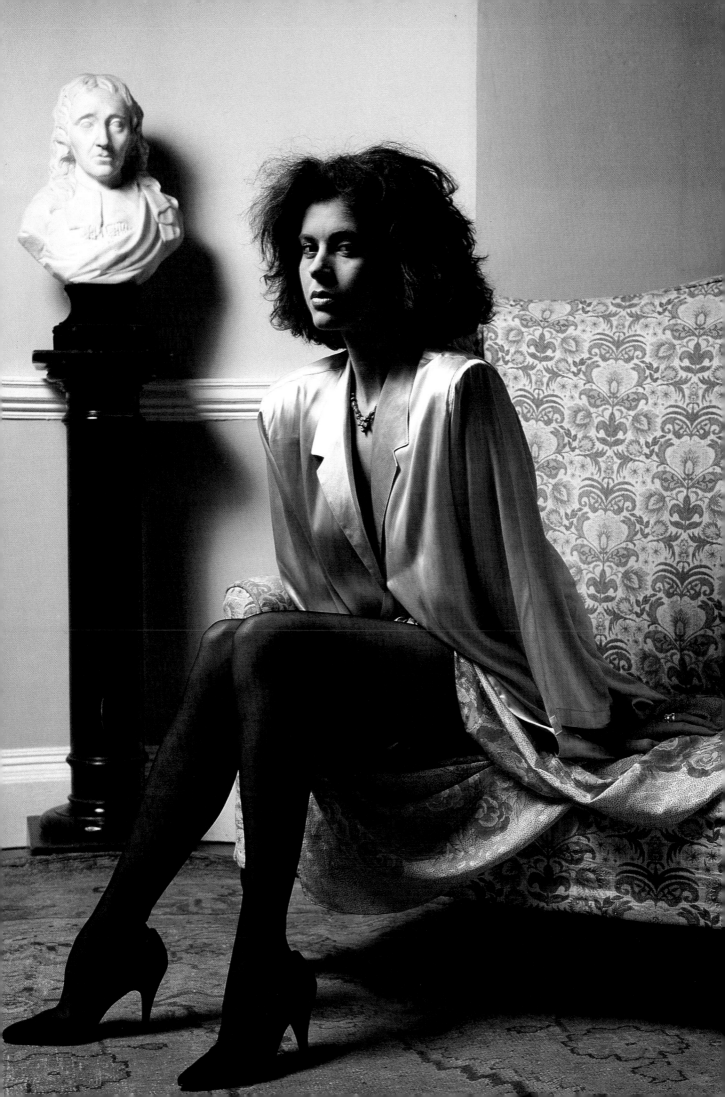

People with their pets

In posing portraits of people with their pets, you are making the pets an integral part of the overall design of the picture. In these portraits of Lady Diana Cooper with her chihuahua dog (*right*) and Rosamund, Lady Fisher, with her pony and monkey (*far right*) the main problem lay in keeping the animals still. You have to pose the person first and get them to pose the animal. You have to keep talking, pose the subject correctly then make noises to attract the pet. It can be difficult to get them both exactly right at the same time! Flash is essential to arrest any movement. In both portraits, I bounced two flashes off the white ceiling, and used one light direct at a forty-five degree angle to the group (*see diagram*). I posed Lady Diana Cooper in front of a theatrical mural at her home and used a 120mm lens on medium format camera. For the group with Lady Fisher I used a 60mm lens on medium format, with 100 ASA film.

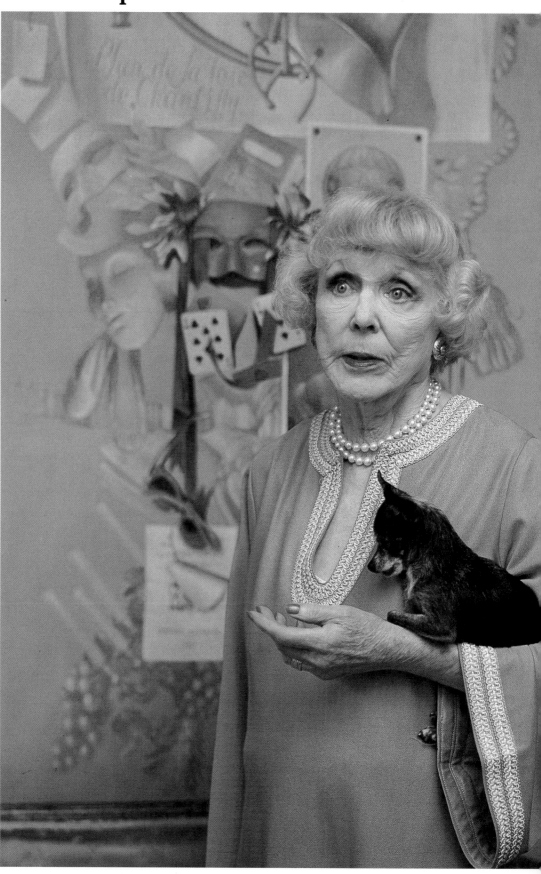

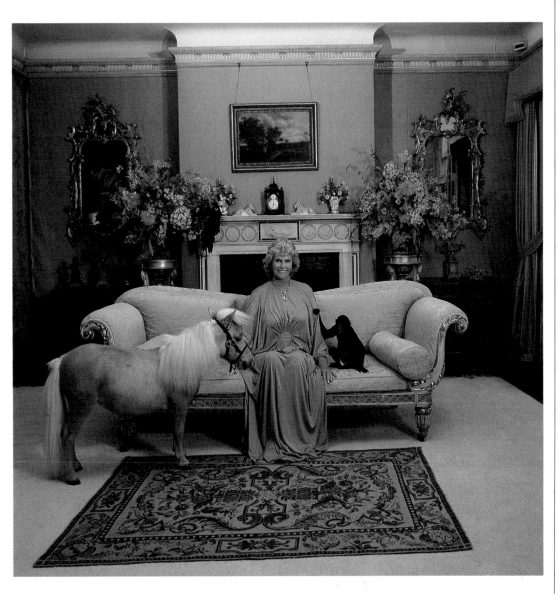

Diagram *Two flashes were bounced off the white ceiling and used with the classic lighting of one light used on the group at a forty-five degree angle.*

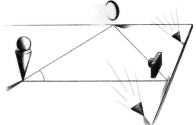

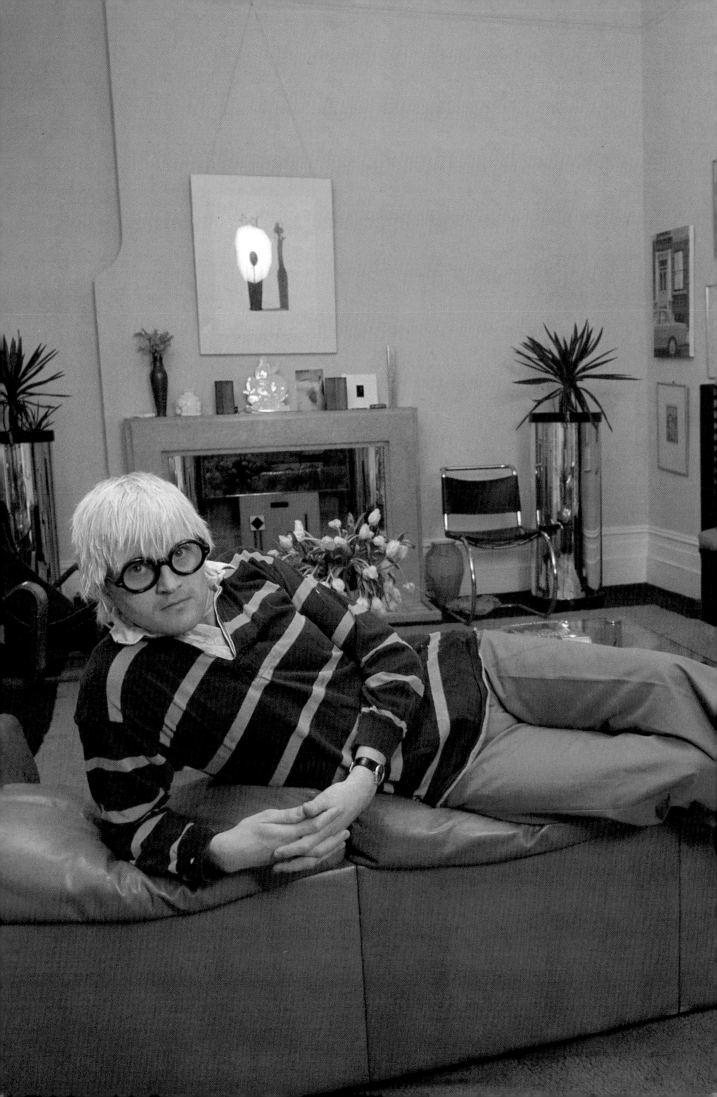

Informal portraits: 3

These three portraits of artists were all unposed. All differ in mood and style.

Left When I took this shot of David Hockney, he was relaxing and watching me set up my equipment. I quickly turned round and took the picture. One wouldn't normally pose people in such a casual way, but catching him by surprise in this way made an unusual shot.

Bottom This photograph of Duncan Grant was taken as I was just leaving. Turning to wave goodbye I saw him leaning on the gate in a rather wistful fashion. I went back and snapped a quick portrait which turned out to be the best of the whole photo session – full of character and atmosphere.

Below This picture shows Allen Jones talking to his wife in his studio. This is a more formal arrangement than the other two, but all three are typical attitudes of their subjects. Often the best pictures arise after you've packed up and are ready to go, so it's always a good idea to have a few shots left in the camera – just in case.

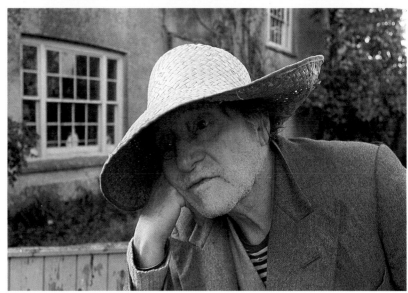

Portraits in interiors

Whether you are taking pictures of people in their own rooms or in hotel rooms, it is always a good idea to pay attention to the environment since it can add a great deal of interest to the picture. Always choose an angle or position where the people become part of the room so that the shot becomes a happy marriage of the two elements. Position the models so that they relate to the setting and use a wide-angle lens.

I almost always work on a tripod for interior portraits because there is not usually much light.

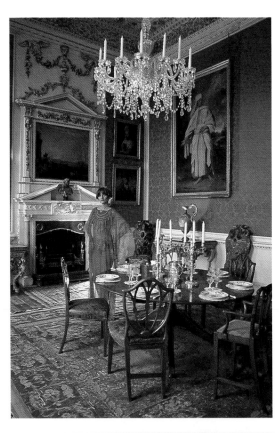

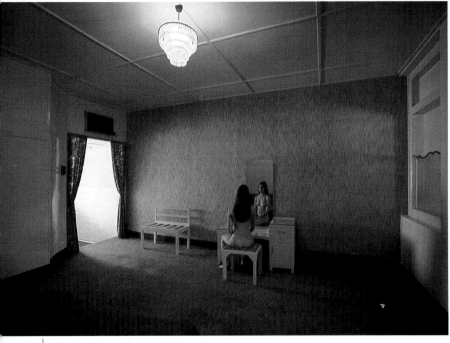

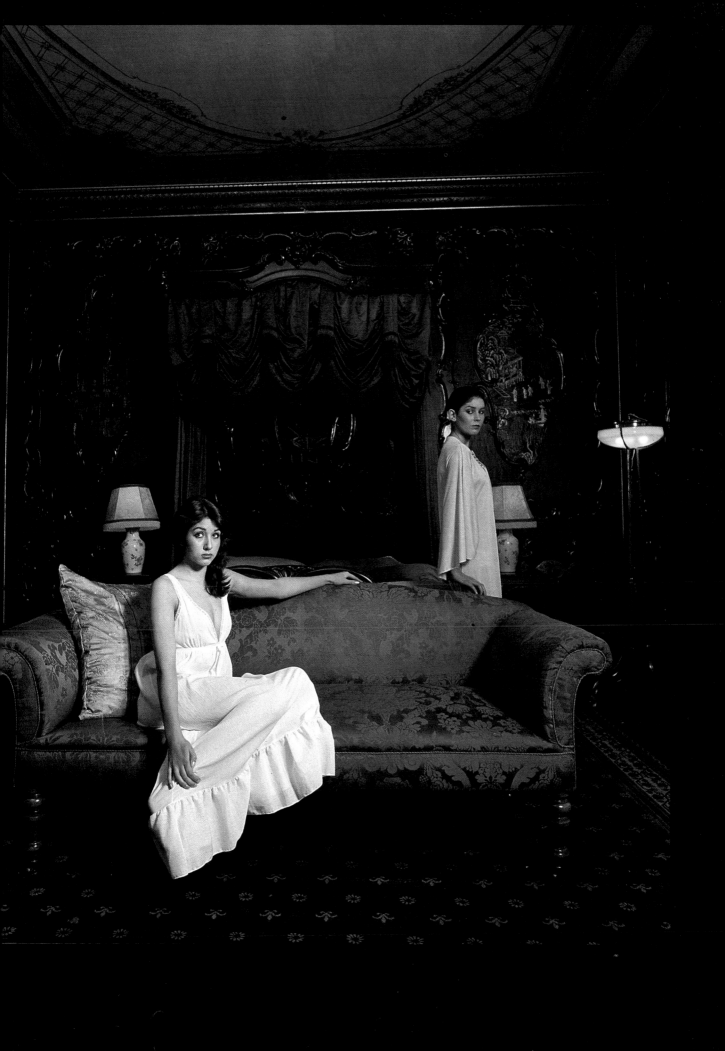

Artists in their houses

In all these pictures I have tried to show something of the environment of the artist as well as the artist himself.

Being creative people, they tend to surround themselves with objects – whether practical everyday things or rare pictures – which act as inspiration for their work. And it is these very objects and paintings that can give one's photographs their flair and originality.

In all cases a wide-angle lens has been used to get as much in as possible.

Opposite The architect and painter Burle Marx stands in his spacious home in Brazil. Since he is also a great gardener, the house is full of orchids and exotic blooms.

Right Roland Renrose is posed with his collection of surrealist and cubist paintings in his home in Sussex.

Below John Piper and his wife Myfanwy are in the kitchen of their home where they spend a lot of their time.

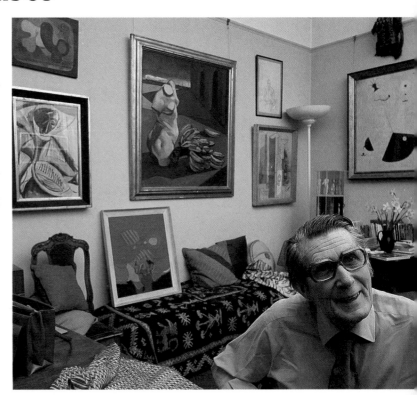

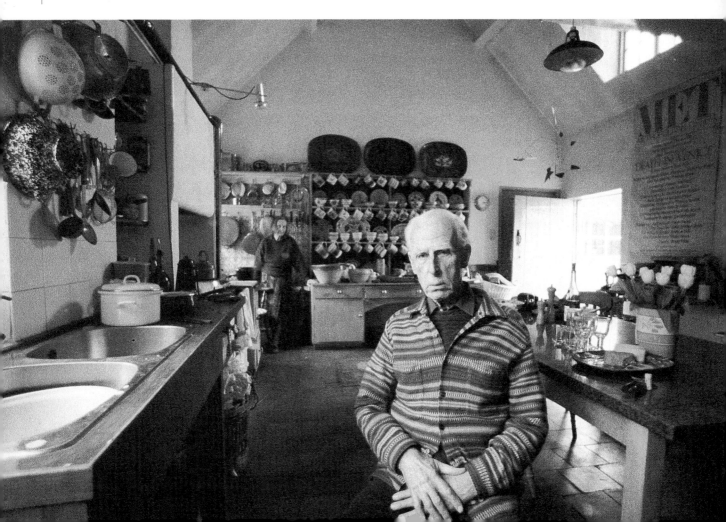

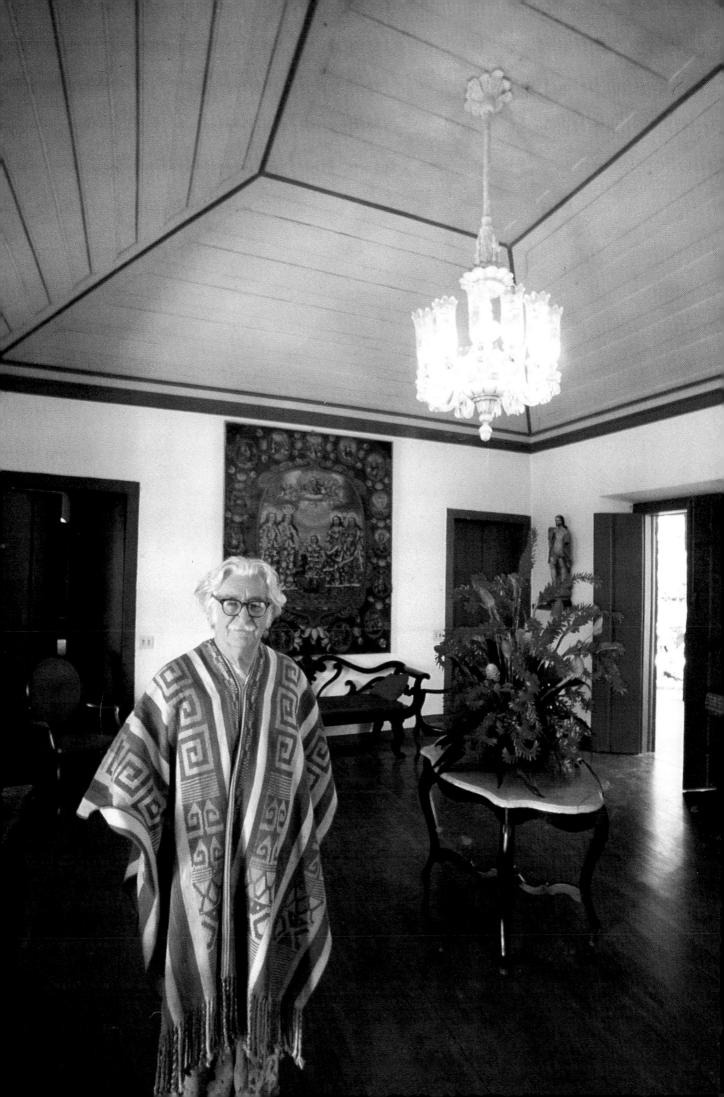

Including the setting – the casual approach

The unposed portrait has a much more spontaneous atmosphere about it than a formally posed one; it also links the person to their surroundings better. These informal pictures have all been taken while engaged in a formal portrait or session, and I've just told the subject to 'hold it' while relaxing back in a favourite chair or throwing on a comfortable robe.

Below In this shot of Lord Howard in the Vanbrugh Hall at Castle Howard, I had been working on a shoot and he was sitting watching. I turned round and photographed him as he was in the existing daylight, using a 60mm lens on a medium-format camera.

Right top and bottom When I was shown into these rooms I asked the subjects of these two photographs to stay where they were. In the round turret room in a Welsh castle, I used a 28mm lens. I wanted both to capture the sparseness and shape of the room and to link the couple together.

Likewise, I wanted to convey the contrast between the glamorously dressed girl and her everyday circumstances which are very unglamorous indeed. The unusual shapes of the birdcage, the mirror and the girl's outline create a strange atmosphere in the shot.

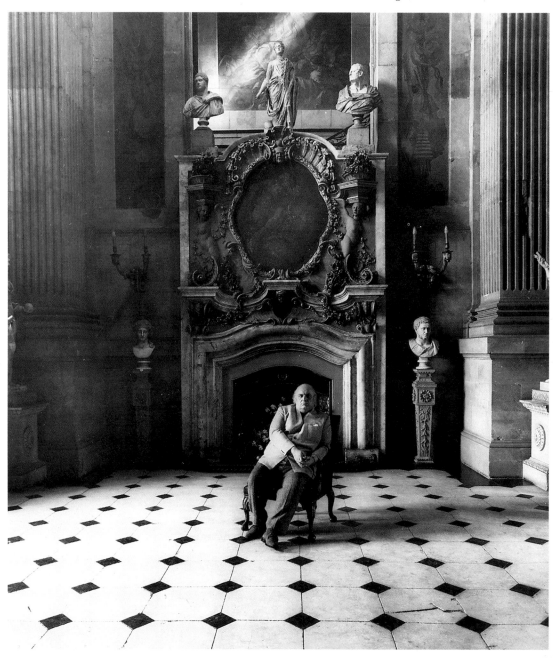

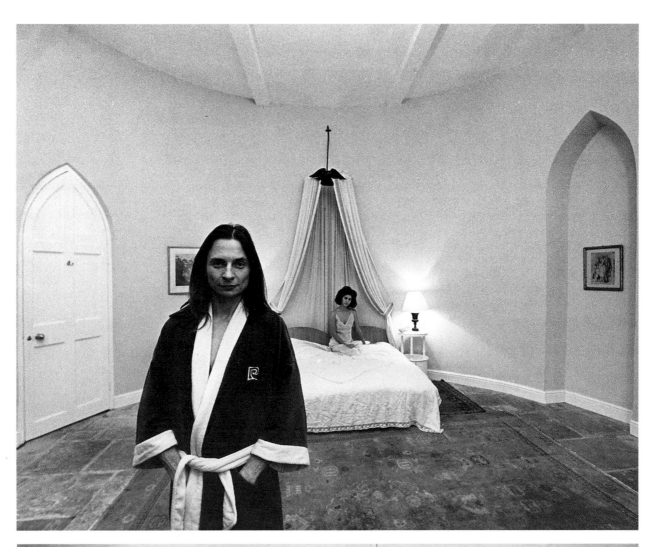

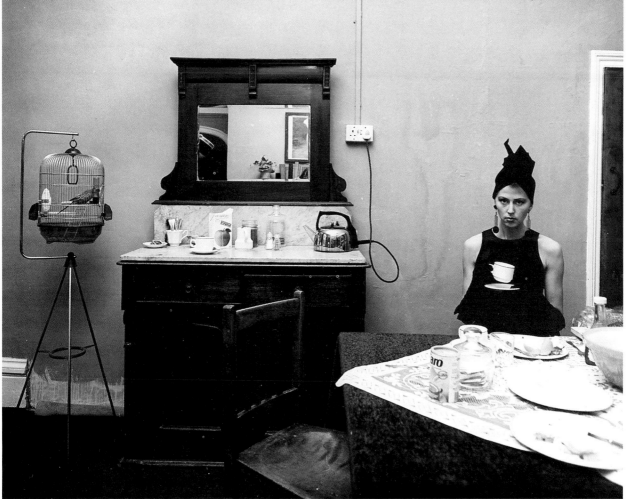

The casual and the formal

This set of portraits shows two different aspects of the celebrated pianist, Alfred Brendel. During the course of his profession, he has developed great stage 'presence' and it was this, together with a sense of the characteristic emotional depth and intensity of his playing, that I hoped to convey in my series of very different portraits of him.

Below Here is a very straightforward and formal portrait of Brendel, taken in existing light in his own music studio. It is quite a revealing portrait, posed against a plain background and highlighting his startlingly blue eyes and his taped fingers. The other formal shot is taken in the Albert Hall (*opposite below*) just before a concert.

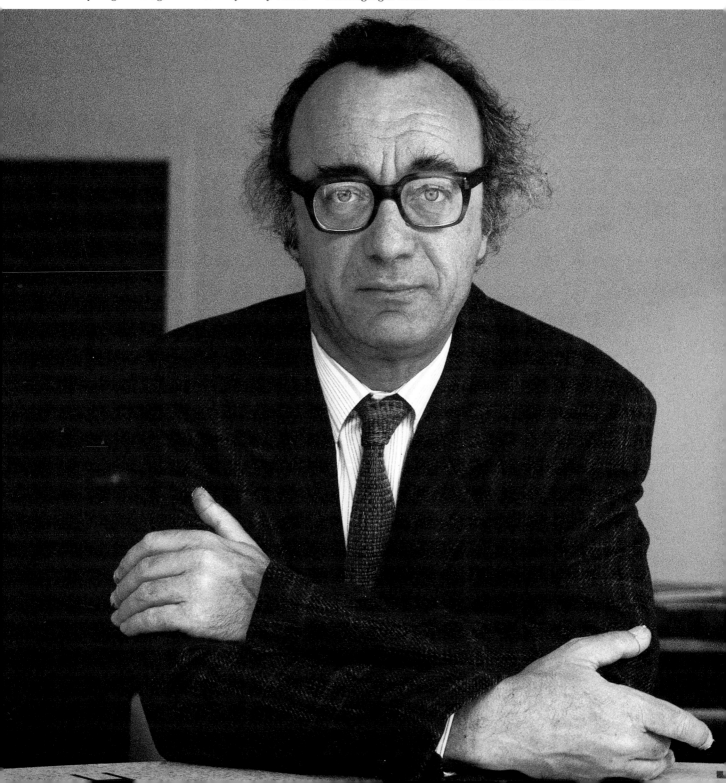

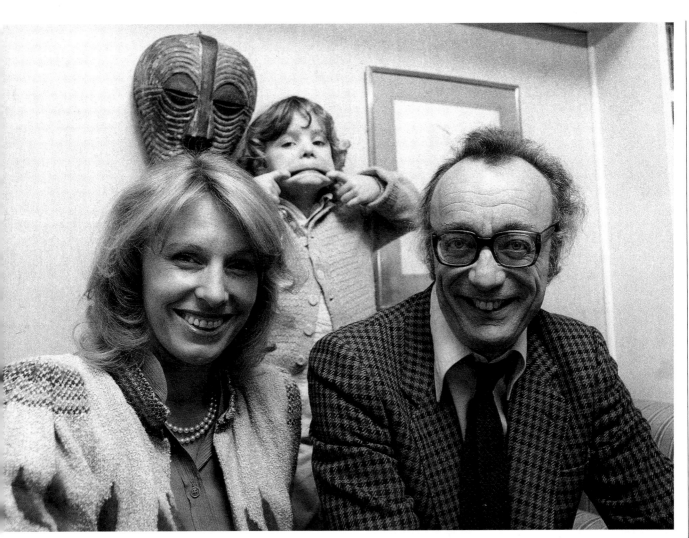

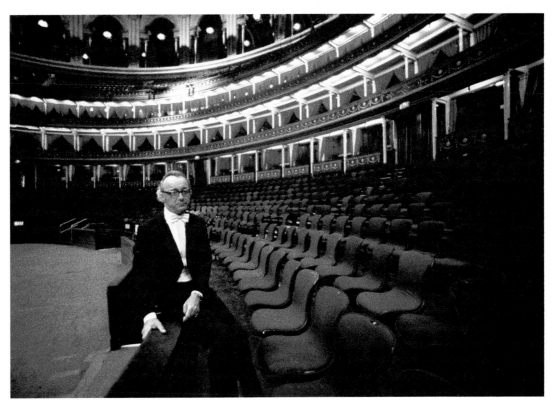

Above This casual portrait, of Brendel at home with his wife and child, is quite different. He is relaxed, and the child's spontaneous gesture made me laugh. That made them laugh, even though they couldn't see the movement I thought was so funny. If you get a chance like this, always go with it. Often you can't compose the picture exactly as you would wish, but it is better to shoot rather than to allow your fear of the unexpected to ruin the portrait.

Capturing atmosphere 1

Here are two studies of Commander Bramwell-Booth, an amazing woman now aged 105. Although I knew I wanted to include the 'Blood and Fire' banner, I didn't suggest any poses but rather let her set the scene. The Victorian atmosphere of the room, particularly evoked by the pictures hung with string from picture rails, comes across very strongly. Both photographs were taken in existing light, using a tripod. I set the camera up, used a cable release, and talked to her rather than hiding behind the camera, with the result that she looked at me rather than at the camera. I worked very quickly; elderly people and children get tired and bored easily, so it is a good idea to try for as many poses as possible in a short time – otherwise you risk exhausting them in an overlong photographic session.

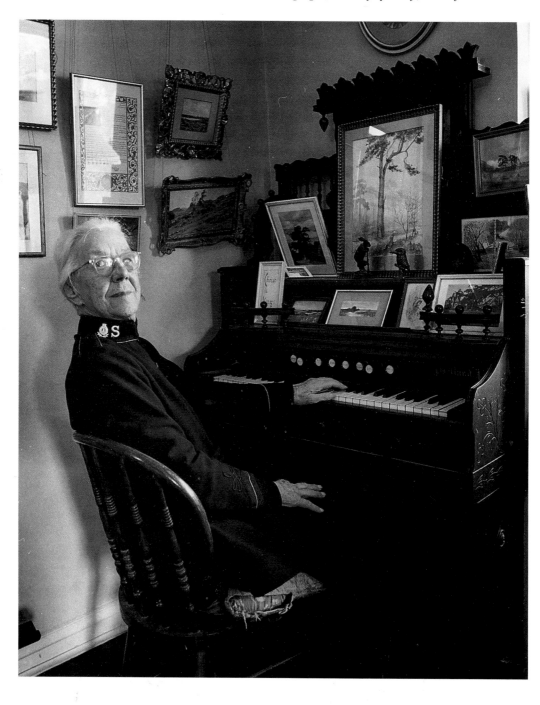

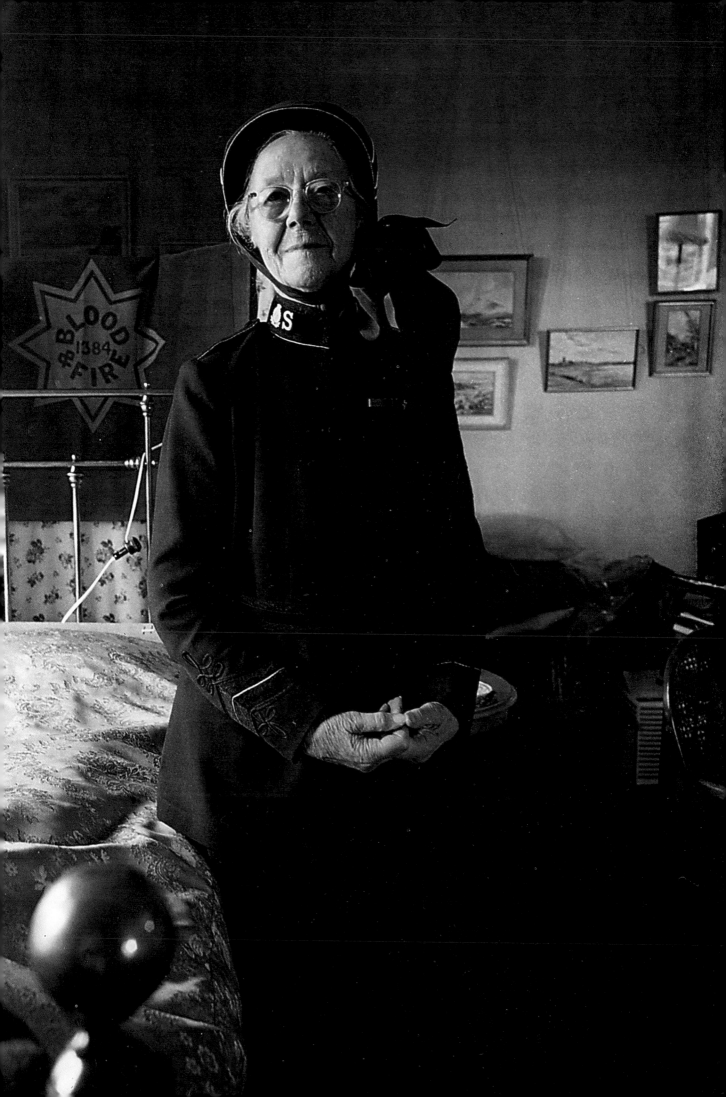

Wide-angle portraits

In these four portraits I have used a wide-angle lens in order to show the subject within his environment.

Above right I wanted to emphasize the book in the portrait of Sydney Cockerell the book-binder and illuminator because he had just finished restoring and rebinding it. Photographing close up to it, I attempted to capture the spirit of the man, showing his skill and craftsmanship by contrasting the delicate work in the book with his huge hands.

Below right Sir Roland Penrose, the surrealist painter and writer, worked in this very cluttered environment filled with fine paintings from his friends. Again, I wanted to capture the ambiance of the room rather than the man alone.

Opposite above David Kindersley, the great letterer and stone-carver, is pictured in his office, looking a bit like Moses. He was standing like this when I walked into the room, so I asked him to stay there. Dramatic lighting suited his personality and his almost physical intensity. Using a wide-angle lens I centred him in the picture to avoid distortions and he comes across as someone totally dedicated to learning and thought.

Opposite below Julian Huxley, the zoologist, never stopped talking. He was very volatile and that was the characteristic I tried to convey. Avoiding the posed shot, I caught him in the act of appearing to question me. The result was a portrait which isolates his vitality against the background of his cluttered room.

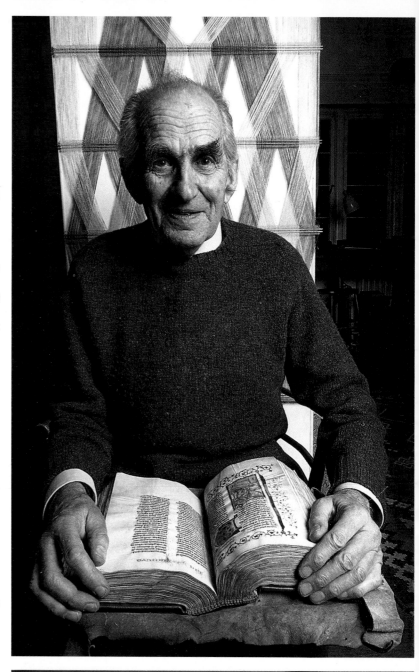

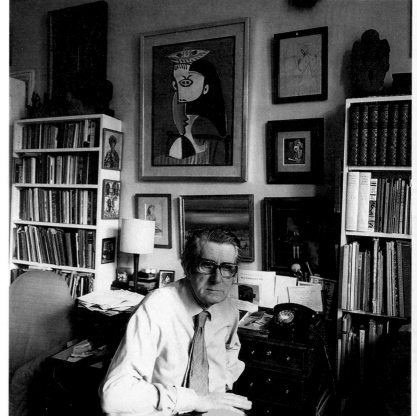

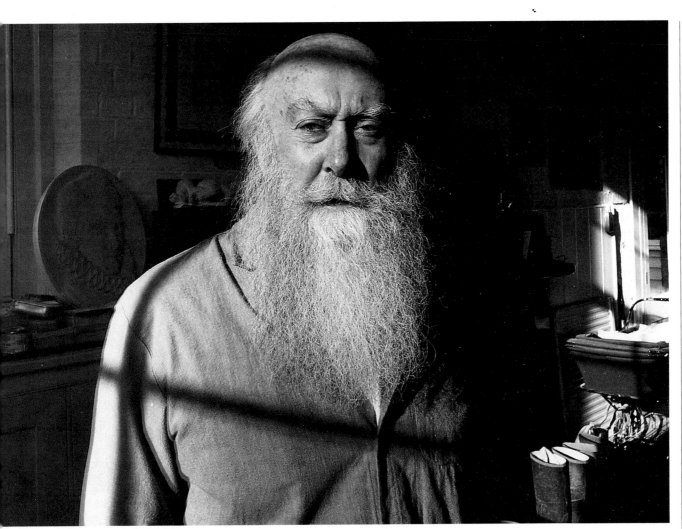

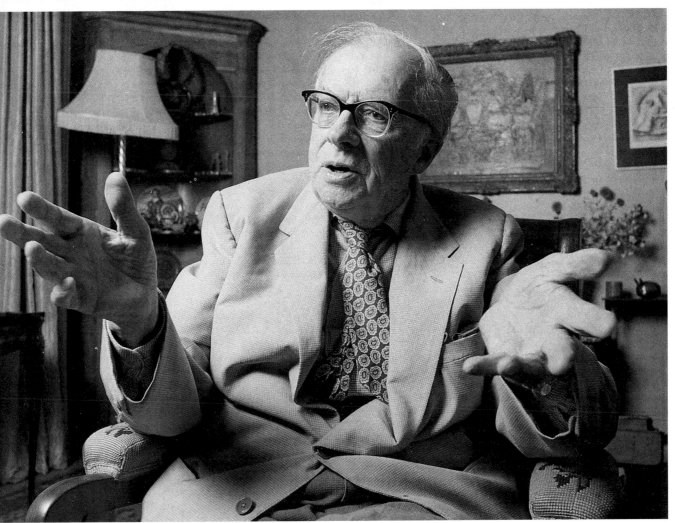

Hands

After the face, the features which are most revealing of character in a portrait are hands. The sculptor Henry Moore once said to me, 'Hands are, like the face, one of the most obvious vehicles for expressing human emotion.' People tend to notice hands and their mannerisms, the ways in which they are used to express feelings and ideas. Some people use their hands in a very elegant way, others are rather clumsy. Happy are those blessed with long elegant fingers, since they are easier to photograph than short stubby ones.

You would expect long elegant fingers on a concert pianist or a glamorous model. A child's hand has a kind of purity about it; its fine skin, with a clasp which shows that he's exploring, touching surfaces for the first time. Elements such as these can be expressed by photographing hands on their own, or in conjunction with the face. Hands can be so expressive, it is always good to show them in a portrait. In fact I sometimes find a pair of hands as interesting as a face. By the texture and weathering of the hands in the picture, (*right*), the sitter is obviously a man of the soil. At the same time they reveal gentleness and kindness. Oblique lighting from a window on the right has been used to reveal these facets of texture, character and form. I have used an 85mm lens and isolated them against a darker background.

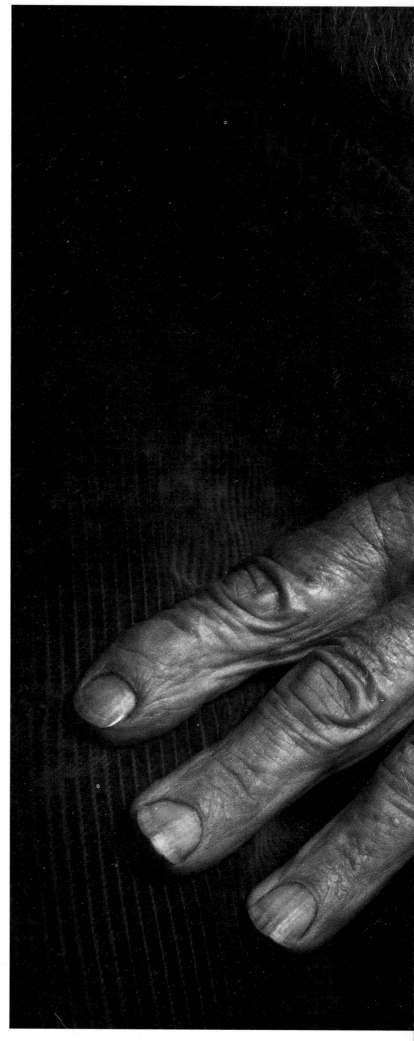

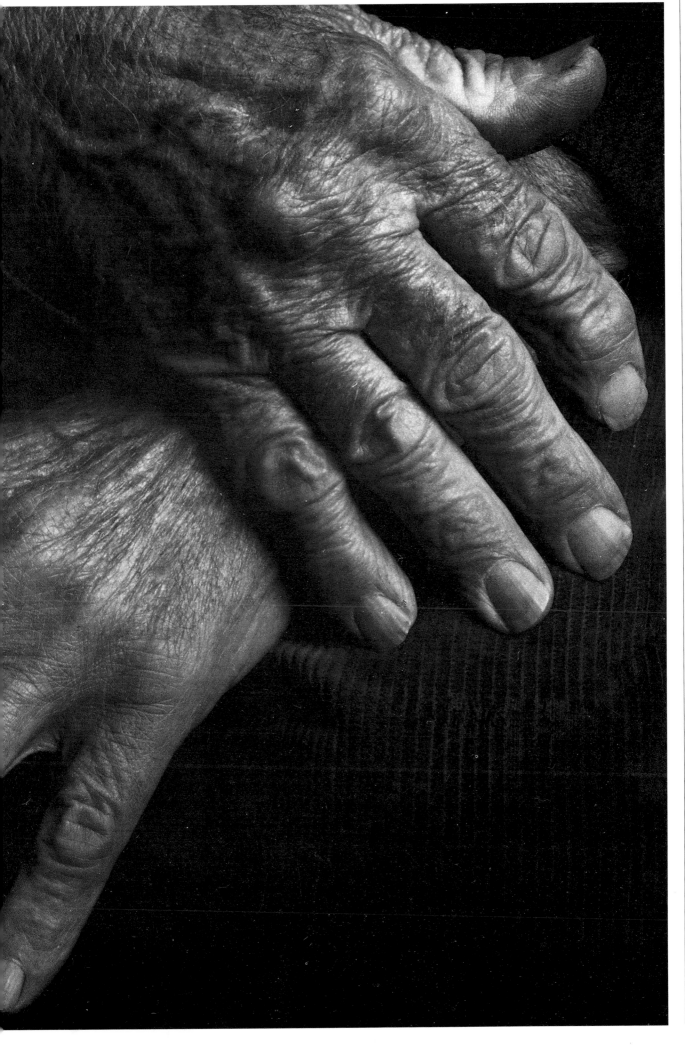

The individualists

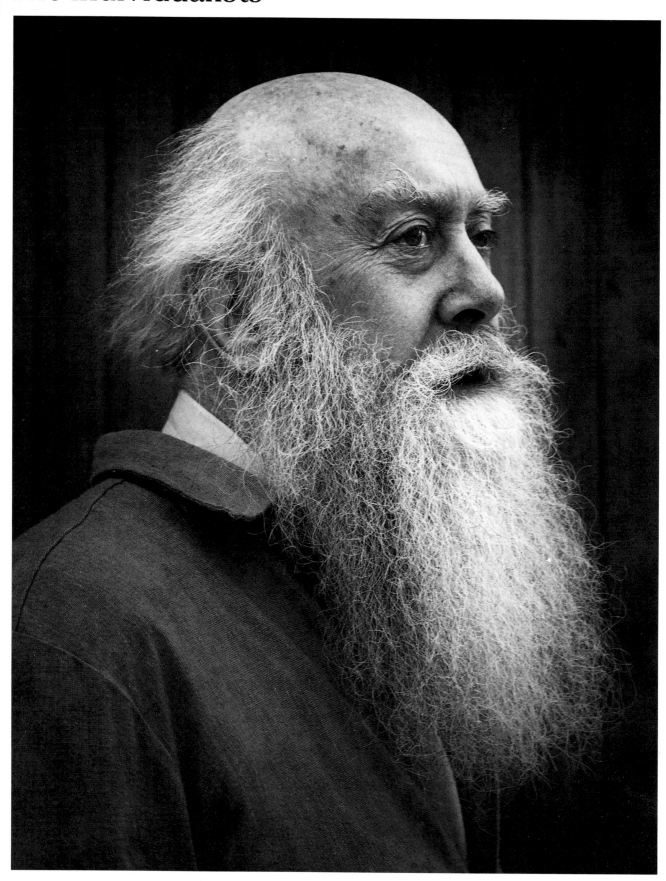

The unposed portrait might not be as flattering as a posed one, but it often sums up personality better. Both David Kindersley (*below left*) and Lord Goodman (*below right*) have interesting faces. They look like Victorian characters or old sages, definitely not 'of today'. The viewer is struck by their strong individuality, a trait I've tried to capture, rather than attempting a factual or flattering shot. Though David Kindersley was shot outdoors and Lord Goodman indoors, I have used existing light and a medium-format camera for both portraits.

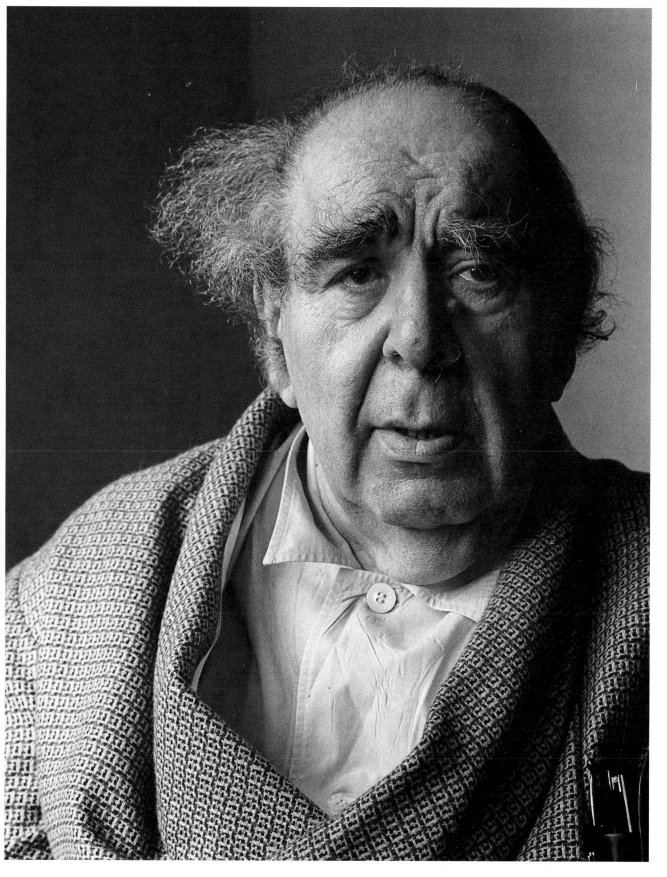

Two poets

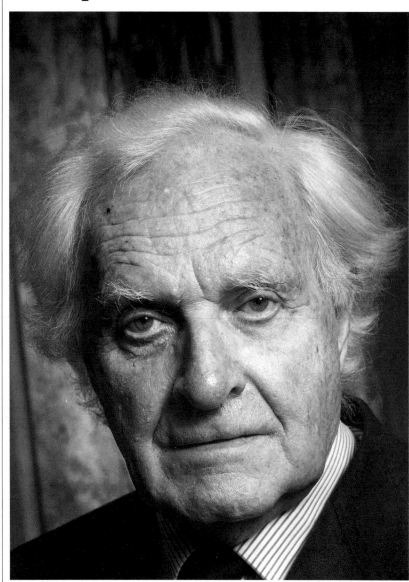

It was very difficult to photograph these two, as Stephen Spender is so shy and Robert Graves such a very strong character. Neither of them really looks like most people's idea of a poet – I think the romantic idea of poets like Byron and Shelley is, alas, a bit of a myth. I hoped to convey their literary stature, and reflect the power of their writing.

Left Spender looks very gentle and he is very taciturn. But he's a tall and imposing figure, and I wanted that to come across. The photograph is lit with daylight, giving a soft atmosphere, and was taken with a 135mm lens on 35mm hand-held camera.

Right Graves, however, was more flamboyant. He never stopped talking and, indeed, was almost aggressive. He too needed the appropriate mood to convey his sombre powerfulness. Using a medium-format hand-held camera, I shot upwards with sunlight catching him from behind, giving a somewhat theatrical air to the portrait.

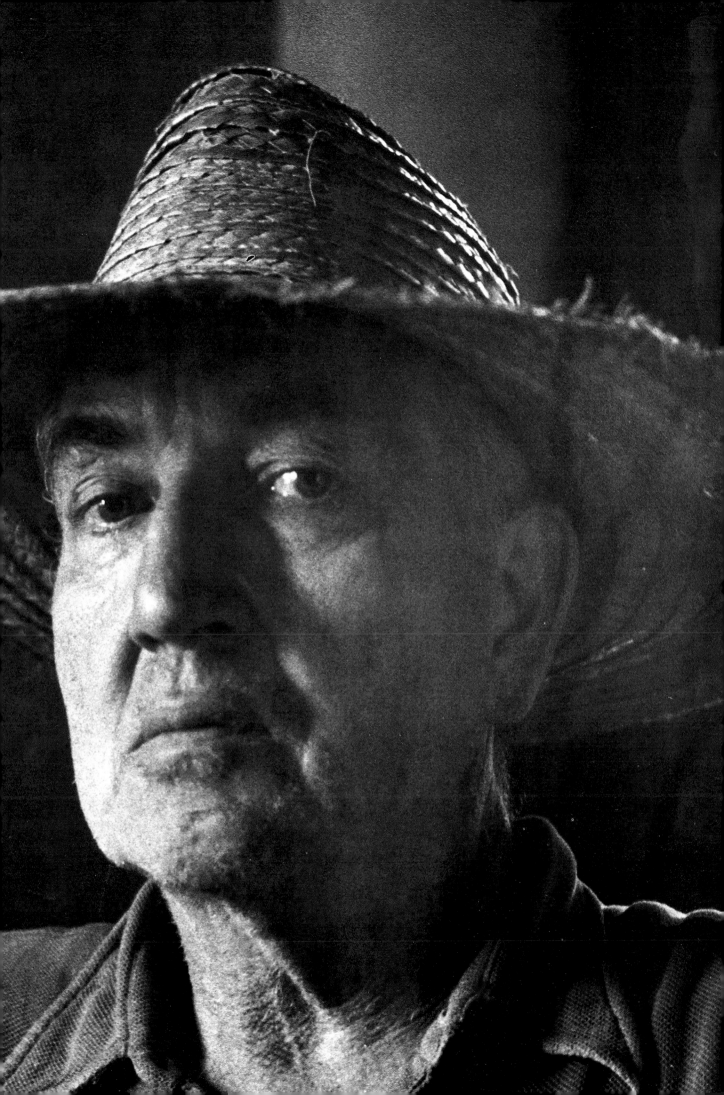

The grand dame

In photographing older people, particularly those who are well known for their accomplishments, it is important to establish a rapport. This is usually quite easy, since they have seen so much of life and have experienced so much that they have a lot to say. Communication with your sitters, encouraging them to talk, creates a relaxed atmosphere so that poses happen naturally, rather than artificially.

I didn't pose Agatha Christie in this portrait (*right*), but let her take up her own comfortable position. It was the first time she had allowed herself to be photographed for forty years, and I found her to be a very kind, gentle but firm lady. I used a 150mm lens on a medium-format camera for this portrait, but in such a session I try to take pictures with three lenses – close-up with the telephoto lens, head and shoulders with the standard lens, and a wide-angle shot to include the room as well. Always focus on the eyes, attempting to catch the moment when they light up with a smile. Shoot from different angles, and watch for characteristic movements and mannerisms of the hands.

On the *left* is a portrait of Anna Maria Wilhemina Sterling, patron and friend of the Pre-Raphaelite group of artists. Taken shortly before her hundredth birthday, the photo managed to capture a relaxed and smiling expression. I put her at her ease by getting her to talk about her fascinating life and times and the treasures in her house, now a museum.

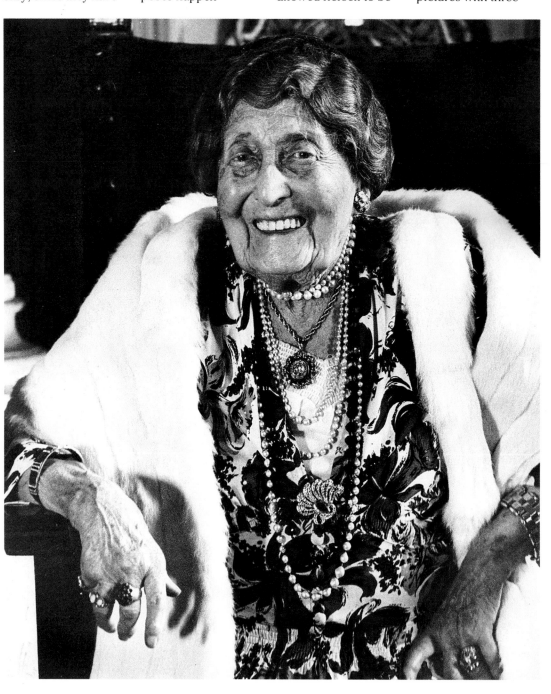

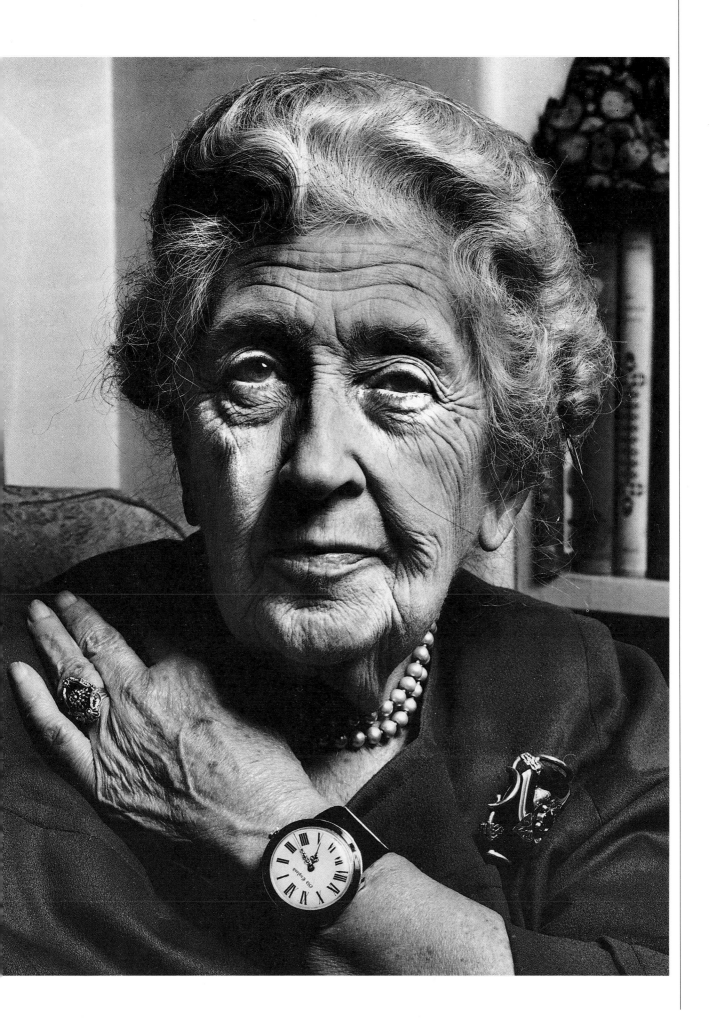

Fast film, poor light

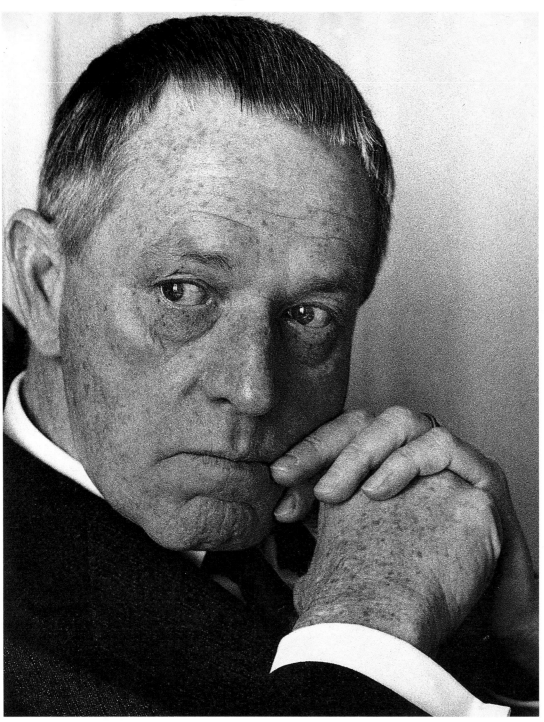

In these portraits, fast film (TRI-X 400) has been rated at 1000 ASA, to shoot indoors in poor light. I prefer to do portraits in existing light if possible, rather than set up a studio flash. So it always pays to take a selection of film because you never know what the light level will be indoors, particularly if it is dark or overcast outside.

While taking these portraits – of American novelist Erskine Caldwell (*left*) author of *Tobacco Road* and *God's Little Acre* and *(right)* composer Havergill Brian – I tried to be as unobtrusive as possible, and to get them talking. I always focus on the eyes.

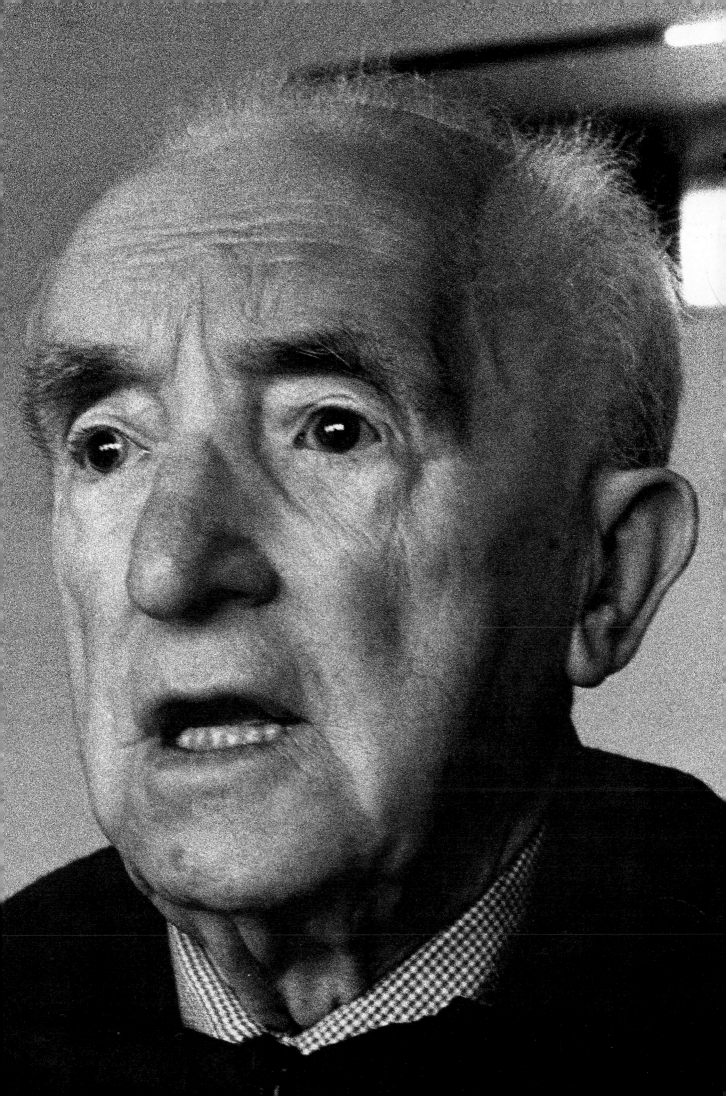

Portraits with flash

In these portraits of writer Angus Wilson, I used a flash not just because of the dark room. He was so animated that I wanted to reveal this quality in a series of pictures catching his fast-moving gestures. So, as one would with children and animals, I decided to use flash. I wanted to capture this lively spirit without artificial studio lighting. With a 150mm lens on a medium format camera, I stopped down to f11, and bounced the flash in an umbrella. This gave the necessary sharpness and deta to his face, underlining his personality. The sho reveal his strong features with their dramatic lines together with his expressive hands.

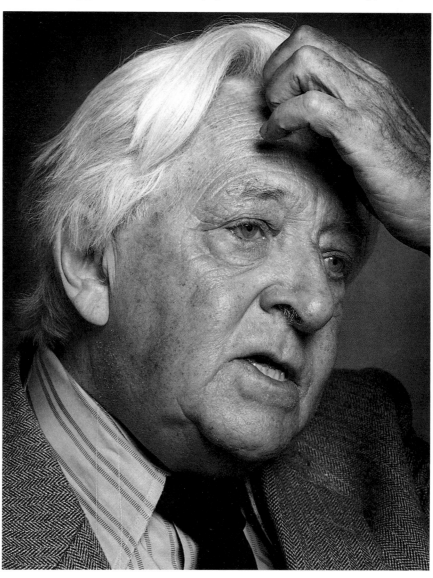

Diagram *A white umbrella is placed beside the camera, and the flash bounc into it to diffuse it.*

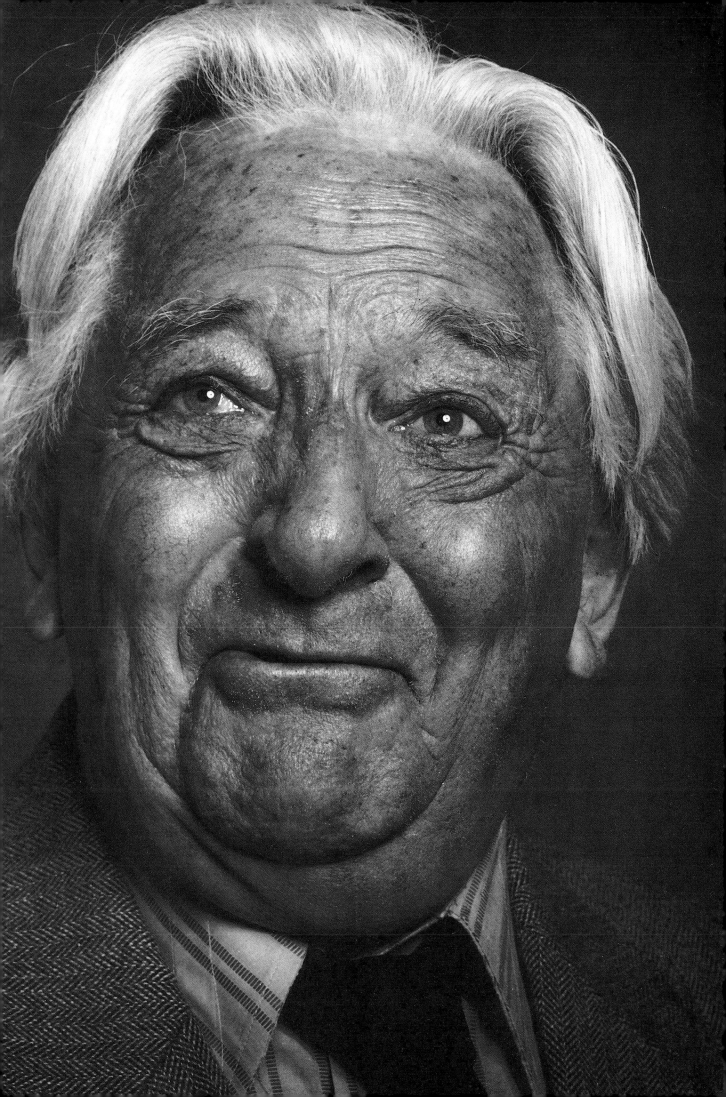

Long-lens, soft daylight

In both of these portraits I was dealing with people who have been photographed many times before. Both are known eccentrics and had the confidence to pose themselves.

If you go to photograph a well-known personality it is a good idea to know something about their recent work – discussing it can help to bring them out. Overcast conditions outdoors give a good light for older people; a long lens (150mm on medium format) is best. You must move quickly, assessing different angles, so it is essential to use a hand-held camera. Use backgrounds that are harmonious, even though with a long lens there will be quite a shallow depth of field, so that the background will be out of focus. With such interesting faces, one doesn't need to go for gimmicks – they are fascinating subjects in their own right.

Right Malcolm Muggeridge, writer and broadcaster.

Below The Welsh architect Sir Clough Williams-Ellis, best known for his Portmeirion village.

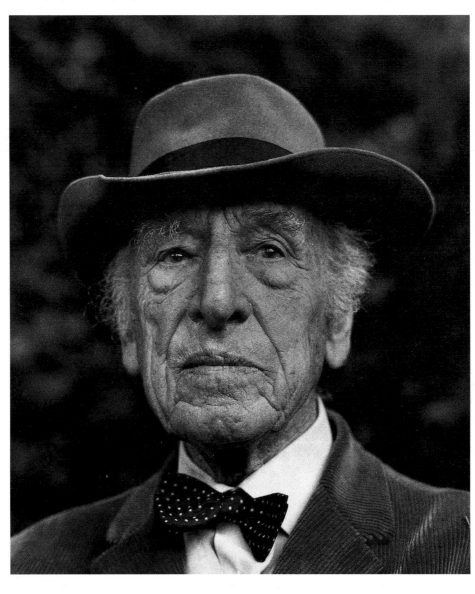

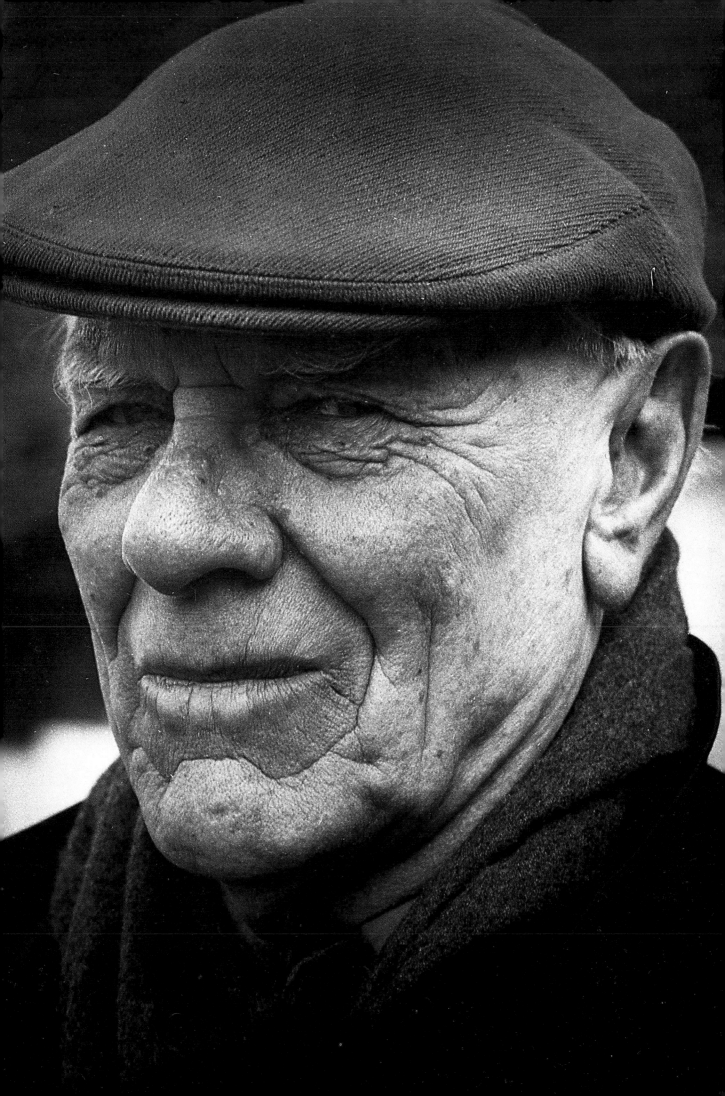

Art and artisan

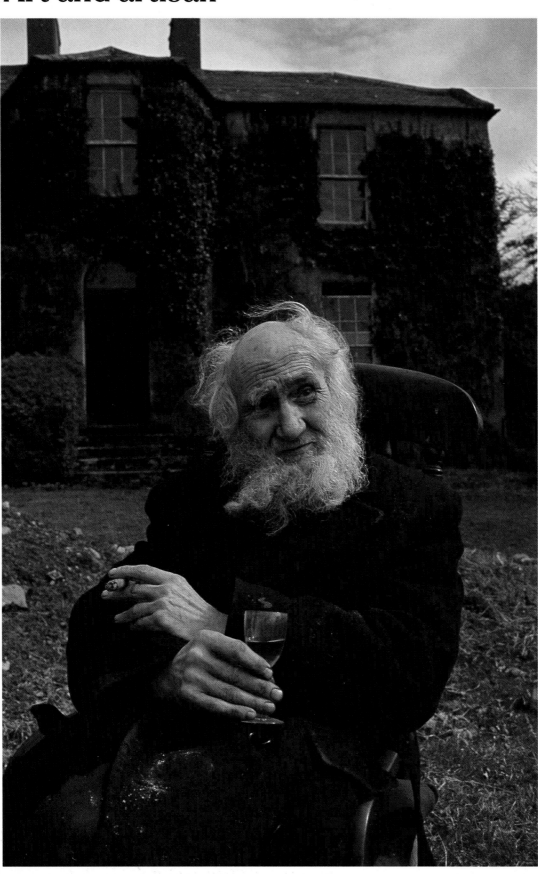

In this set of portraits I was trying to capture something about these personalities by portraying them in typical poses but looking at the camera.

Left An impecunious gentleman poet, sitting in the sun in front of his lovely Georgian house in Ireland, is a rich character, full of life and humour. He claimed that all he needed to keep his muse going was a good whiskey and a cigar. What is luxury for others is a necessity for him, as they are the tools of his trade.

Right The Peruvian farmer also carries the tools of his trade – for thatching houses from straw grown on his land. He has a marvellous face, very similar to the poet. They are so different as people, yet in some ways to quite alike in the simplicity of their lifestyles and their needs and wants.

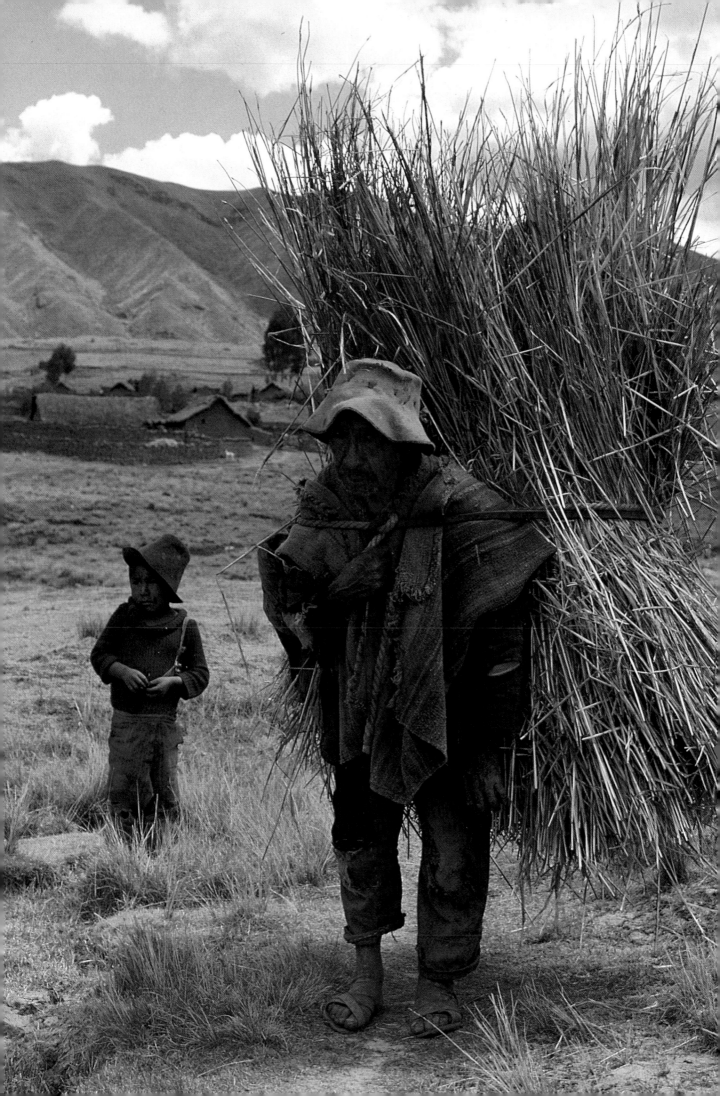

Using the setting sun

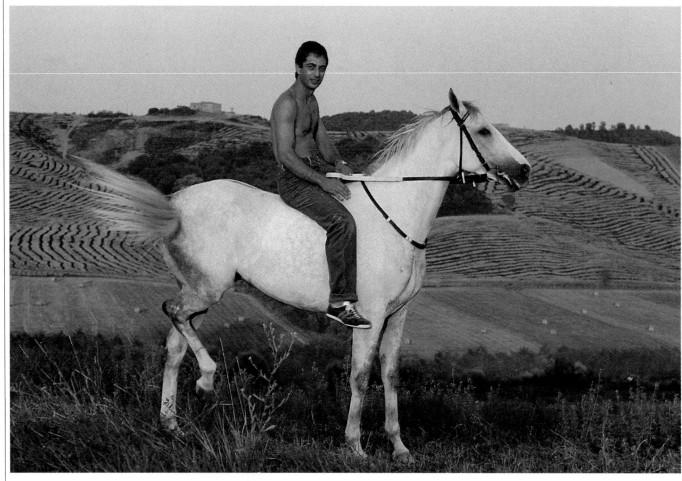

The setting sun gives a very flattering light to the model as it adds a warmth like a sun tan to the face and a golden glow to the hair.

Above The use of the setting sun in a portrait gives modelling to the features, greater warmth and a richer dimension of colour. In this equestrian portrait taken on the Tuscan hills, the light gives a translucent impression to the picture, imparting a stronger force than that given by ordinary daylight.

Left centre and below Both of these portraits ooze warmth. One has been shot as a silhouette against the light of the setting sun, the other with the model looking into the rays of the sun.

Opposite This girl is indoors, leaning against a mullion window. The bars, the rays of the sun and the glass create the distorted shadows and highlights on her face, giving a slightly sinister effect.

Overexposure for effect

In using overexposure to create a special effect, you alter by photographic means what you see in front of you. To do this you need to be able to visualize the result. You will therefore need a fairly strong image in the first place, and you have to be able to imagine what it would look like perhaps five degrees lighter. A portrait is a strong image and is a good topic to choose when experimenting with overexposure. The main image (*opposite*) has become very delicate and pastel-like by overexposing first two stops. The girl in the red scarf (*below*) is five stops over in an image made much more ethereal by this lighting technique.

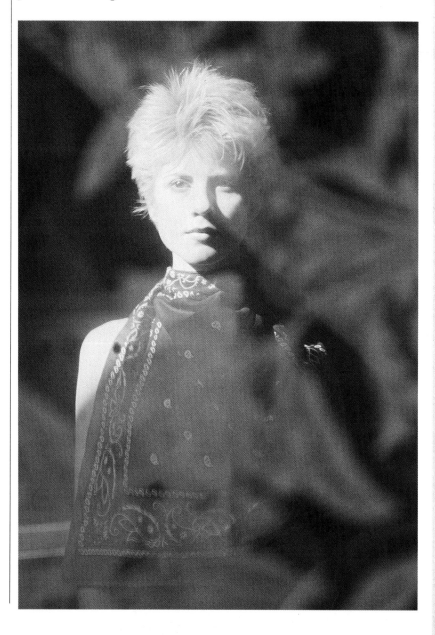

Shooting round the subject

Angus McBean has such an interesting face that it makes him a rich subject to explore photographically.

He is not only a great photographer himself, but also a great raconteur, designer and personality. With such a person, you can be overwhelmed with ideas for composing different portraits. If you have the luck to get such a subject, ask him or her to arrange a situation in which there are a lot of creative possibilities, both indoors and out.

When taking portrait shots outside a studio, give yourself extra time to spend getting acquainted with the surroundings. Explore the house and garden for ideal positions to suit your subject.

Right Here I photographed McBean in close-up, using a medium format camera and TRI-X 400. I chose to pose him in front of this tree because it looked like a piece of stage-set scenery, echoing his work as a theatre photographer.

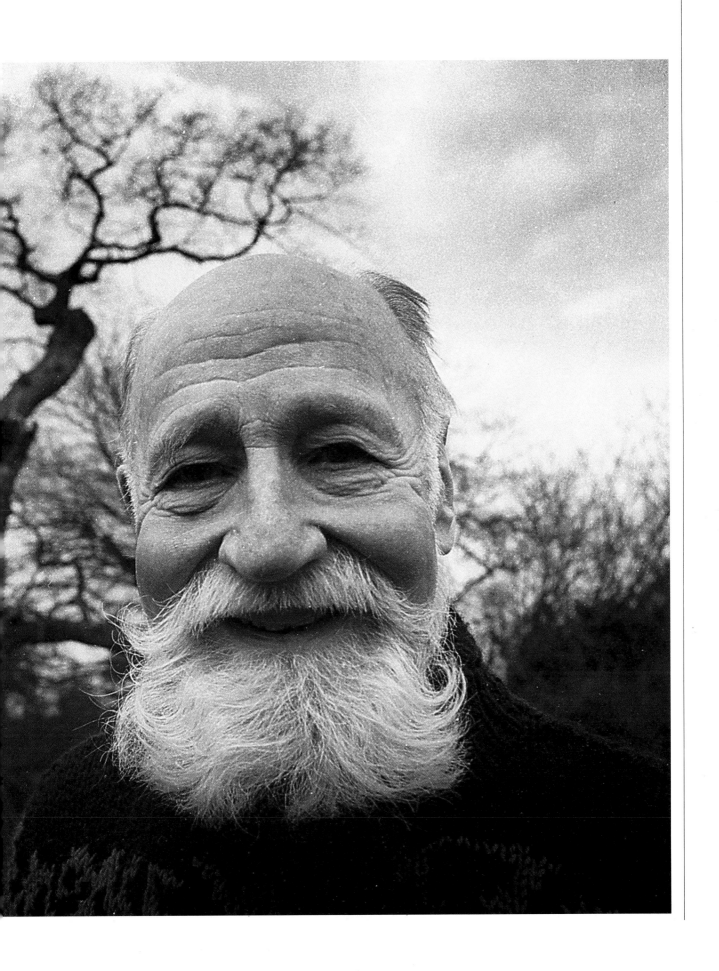

Variations on a theme

To get variety into a series of pictures, I needed to go from close-up to the distant view, including, at the same time, as many different scenic items as possible to suggest his working environment, as well as to accent the complex aspects of Angus McBean's personality. He is enormously elegant, designs his own clothes, furniture and interiors, and is a man of great style, full of captivating stories.

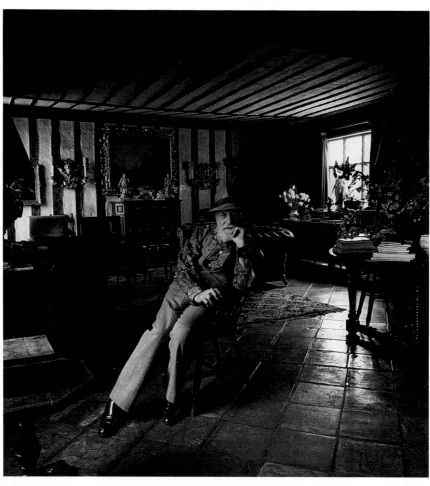

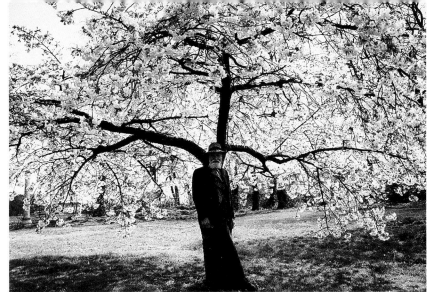

When the
photographer gets
such a rich and
colourful subject, it is
a challenge to try to
capture all these
aspects. The secret
lies in working fast;
and for speed,
daylight is best. I did
rely on a tripod for the
interior shots for,
though one wants to
explore all the
possibilities, in the
end quality is worth
more than quantity.
Try to shoot as many
positions as you
possibly can in the
time that you have.

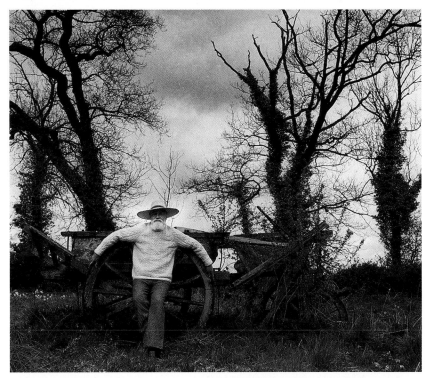

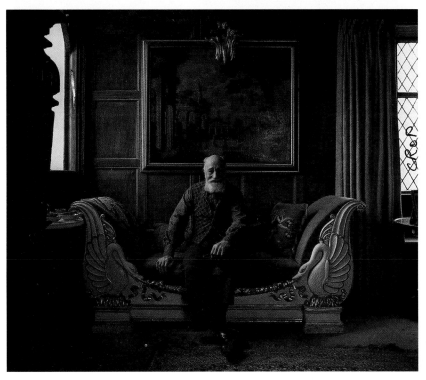

Inside, outside

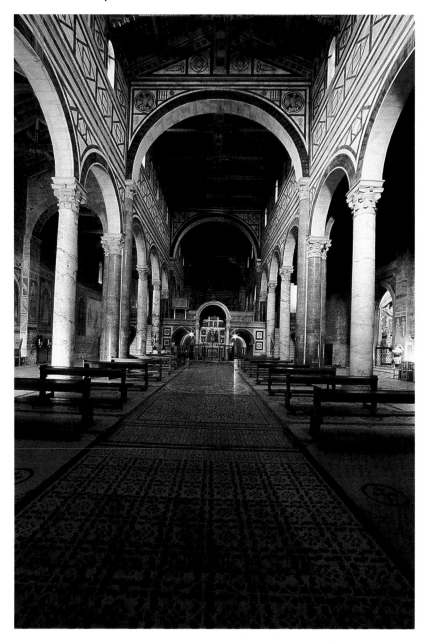

Choosing your time carefully to photograph a building results in the best shots. In these pictures of the church of San Miniato, Florence, I went very early in the morning for several reasons. The sun is lower in the sky and its rays shine into the church. It is also before all the tourists come. If you are lucky, and for a small fee, you might get the verger to open the massive front doors as I did for this inside shot, enabling me to take it hand-held rather than the time-consuming task of setting up a tripod – also, tripods are often not allowed in historic or religious buildings.

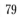

Decorated interiors

A shift lens has been used to take all these pictures. It is basically a 28mm lens, constructed so that its optics can be slid off-centre by up to about 11mm. It is primarily used to compensate for converging verticals in buildings in architectural photography, but can also be used to lower your viewpoint, as well as moving from side to side. Ceilings and floors can, therefore, also be emphasized by the use of a shift lens.

The shift lens has made it possible to capture the richness and splendour of the Paris Opera House (*right*) and the dining room of the London Ritz (*below*). Using daylight film, with the camera mounted on a tripod, and by carefully balancing daylight and the existing artificial lighting, I have warmed the overall colour effect of both.

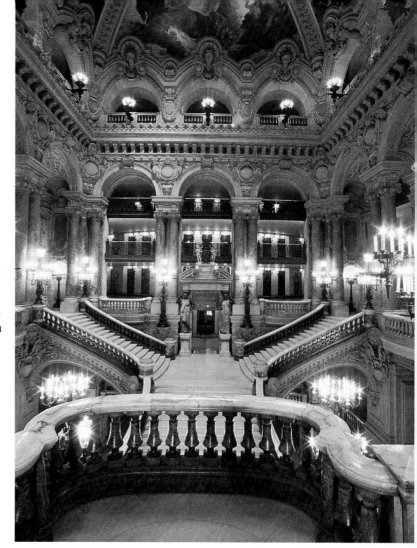

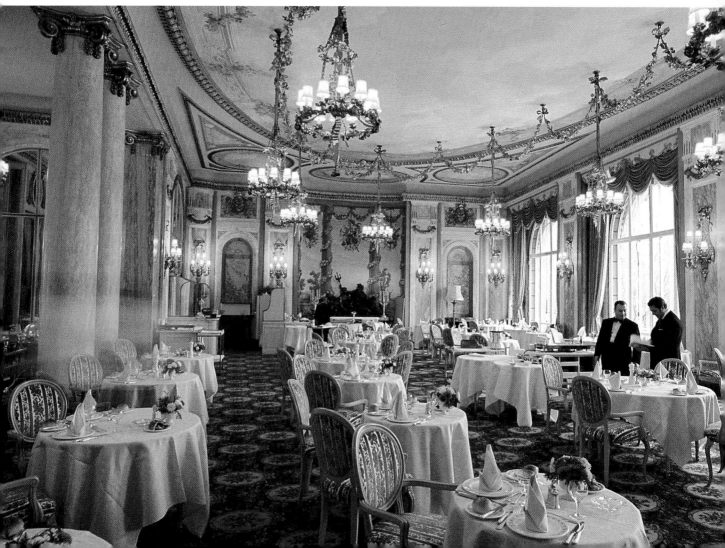

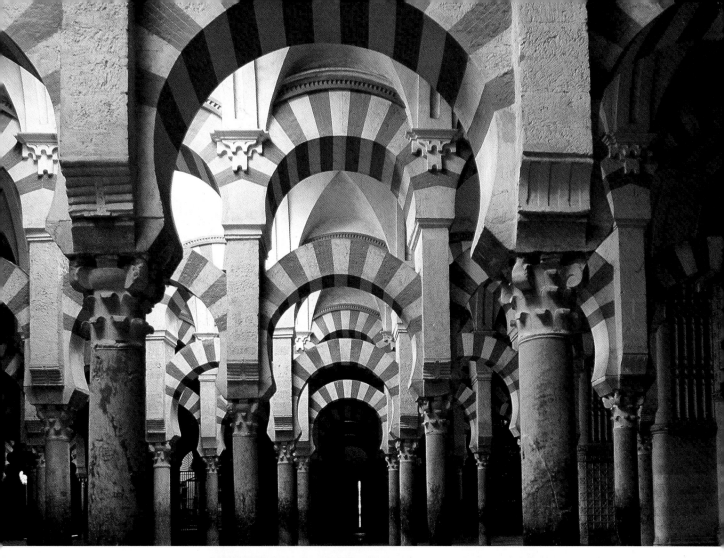

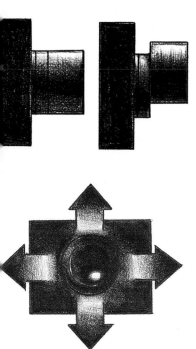

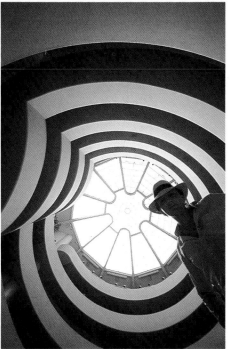

The shift lens can be lowered to emphasize a magnificent floor such as this, *far right*. *Also, see diagram, top, showing the movement of the shift lens.*)

The shift lens can also be used to get a centralized view, as in this shot of the Guggenheim Museum ceiling, *above.* Even by leaning over the stairway balcony you cannot get dead

centre with a normal lens, but you can move the shift lens outwards to achieve this. (*See diagram, below, showing how the lens moves to the side.*)

The interior of the Great Mosque at Cordoba, Spain, *top,* has a forest of arcaded columns. Here a shift lens, moved sideways, enabled me to get the shot I wanted of this complex interior.

The grand hall: 1

In photographing a large interior that contains a great deal of detail, unevenly lit, it is possible to use multiple flashes to supplement the daylight – a technique called by architectural photographers 'painting with light'.

For the picture (*right*) of the Gallery of Mirrors in the Palazzo Doria Pamphili in Rome, I used twelve flashes to illuminate the rich Baroque detail in the shadowed areas. The camera was loaded with slow film, and positioned on a tripod for a long exposure, during which I fired off bursts of flash between the sculpted figures down the right hand side. This balanced the strong daylight coming from the windows on the left. The exposure was long enough both to do the flashes and prevent anyone registering in the picture. How long the exposure and how many flashes are needed is a matter of taking light readings over the whole area and estimating it; the technique can take a bit of practice.

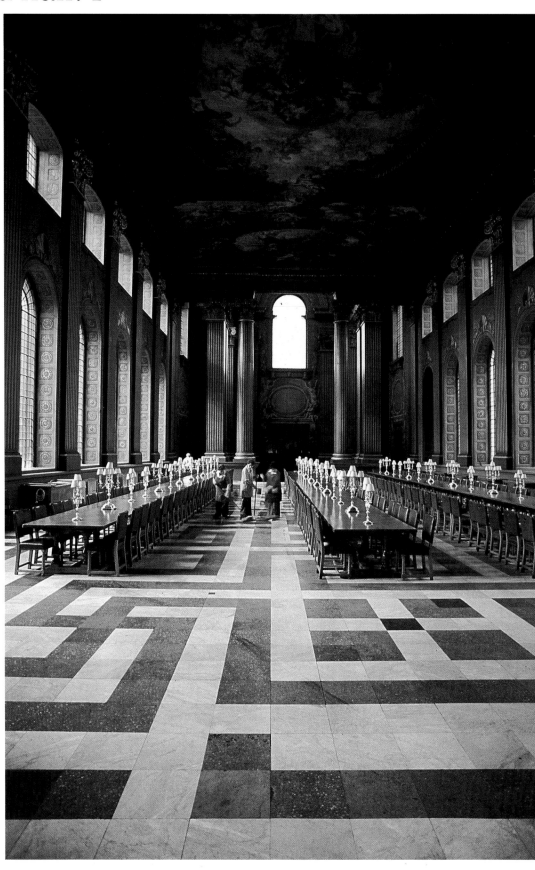

Below The Painted Hall at Greenwich. Here I used two flashes to illuminate the ceiling, but kept in a group of people preparing a banquet because they gave the picture a sense of scale.

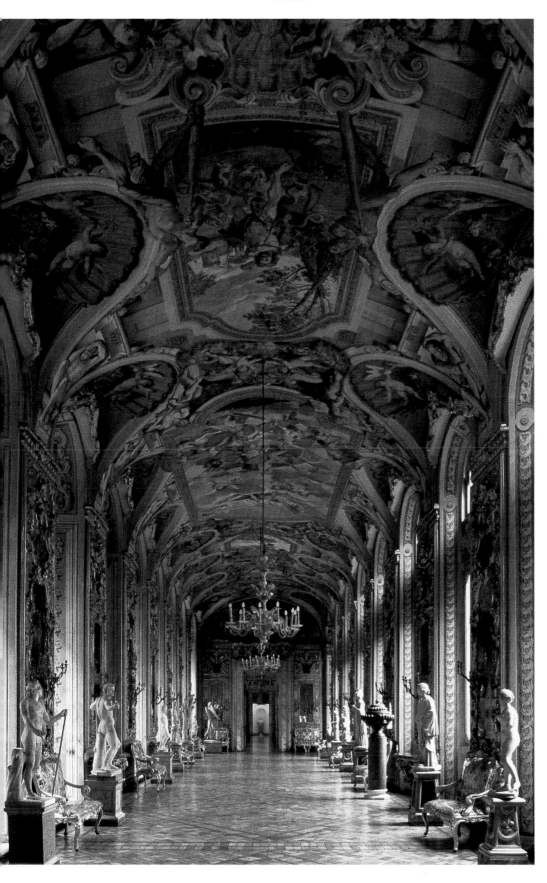

Great ceilings: 1

Right By using a 28mm shift lens on an SLR I have captured the heart-stopping beauty of Michelangelo's dome in St. Peter's, Rome. The down-pouring floods of light, together with the up- surging lines of the building and the detail in its shadows, have been achieved by slightly overexposing. You can anticipate dramatic shafts of light like these by making preliminary visits to the building.

Below The same effect has been achieved but by looking vertically up. To do justice to such interiors, it is very important to wait for the right time to take your shot.

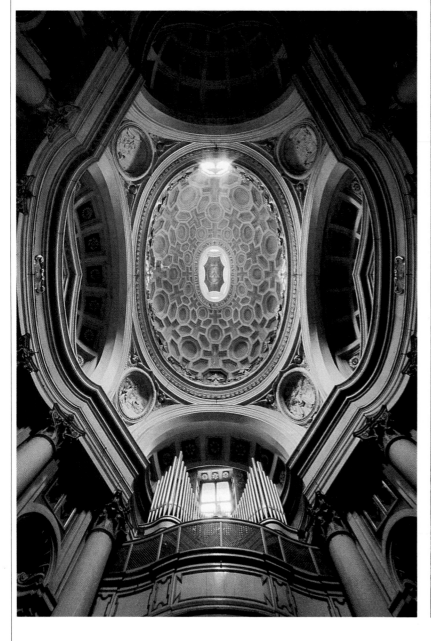

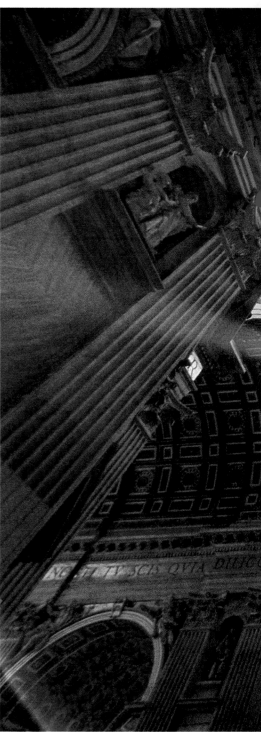

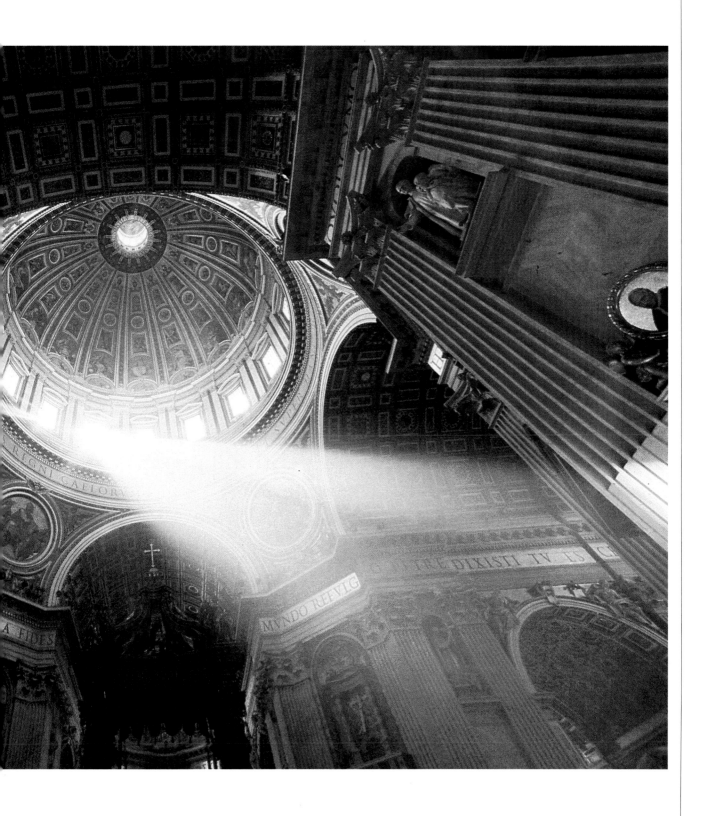

Great ceilings: 2

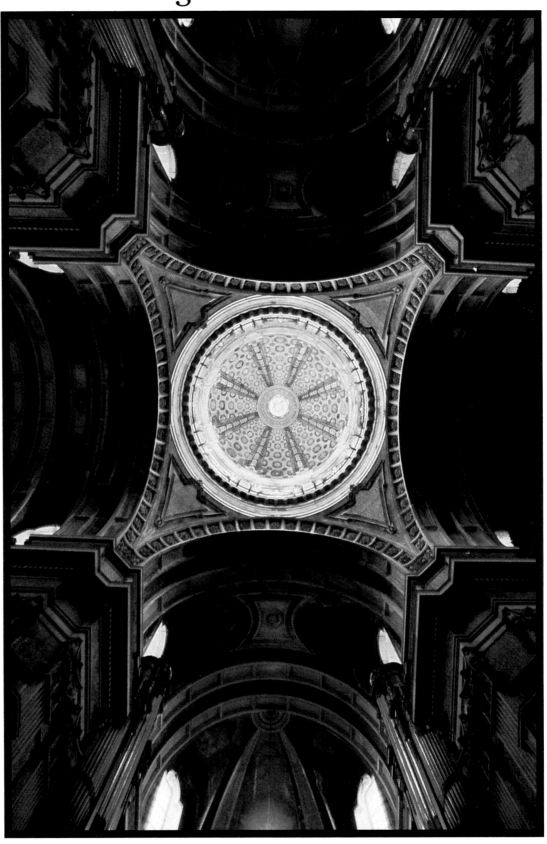

When you go into a church or cathedral, the idea is that you should lift your eyes up to heaven. For this reason the ceiling is often the most dramatic aspect of the building. A wide-angle lens, 28mm or even wider in some cases, is best for ceiling views that look absolutely vertically upwards. My own technique is to place the camera flat on the floor pointing upwards. I put it on automatic or a worked-out long exposure, stopping down to f8 or f11 depending on the light, and set on infinity. I use a long cable release, laying the camera on a piece of velvet to stop sliding.

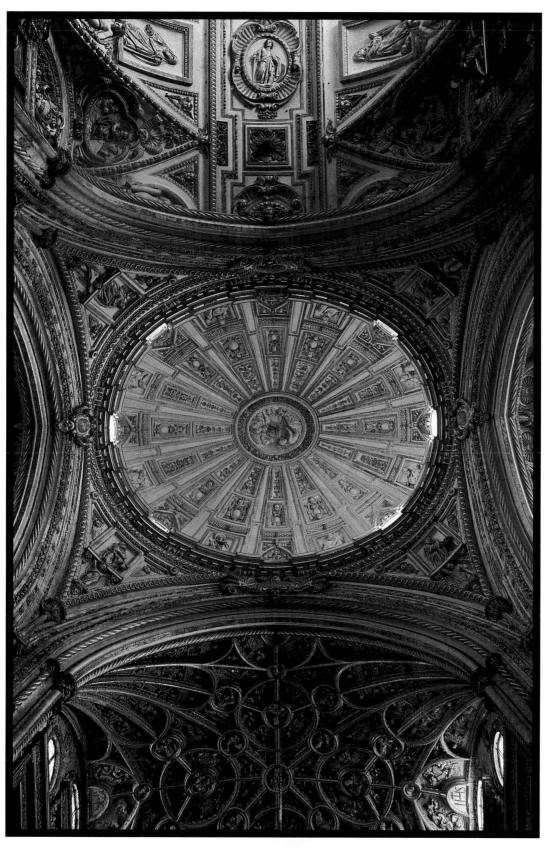

The grand hall: 2

To photograph a large interior space that has sufficient natural light and does not need fill-in flash, it is important to choose the right time of day. This is when the light gives an even balance and full tonal range. Both pictures are almost monochromatic in their simplicity. This gives an air of great tranquility to both shots.

Right A corridor in Palladio's Monastery of San Giorgio Maggiore, Venice, photographed in late afternoon, when sunlight streamed through the high windows. I used a 28mm lens with the 35mm camera on a tripod.

Far right A corridor in Gaudi's Theresian Convent, Barcelona. I chose to photograph it when the light was shining strongly through the windows along the corridor, illuminating each of the simple arches in a different tone.

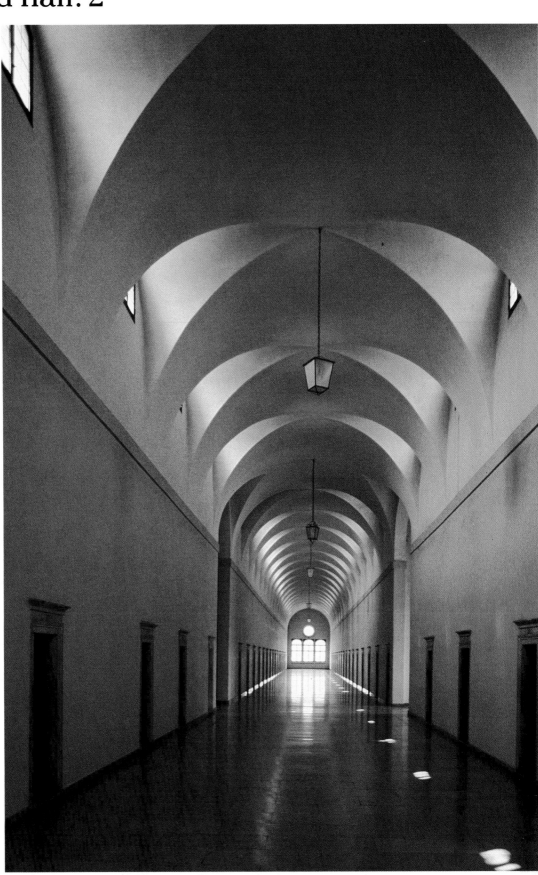

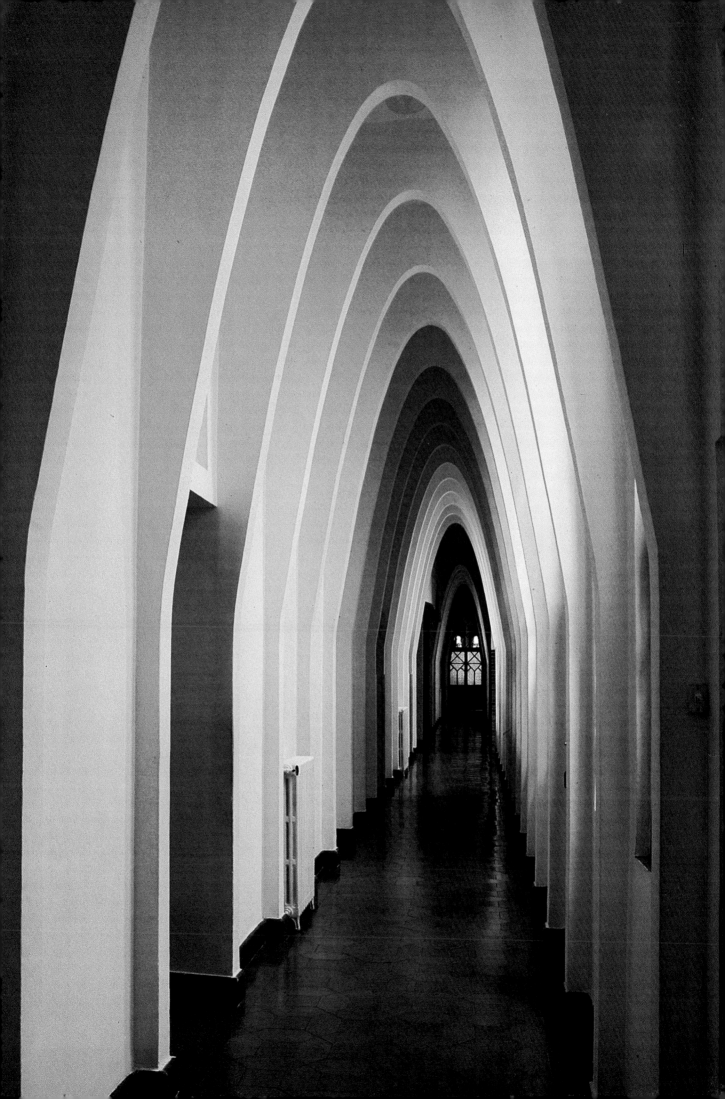

Staircases in architecture

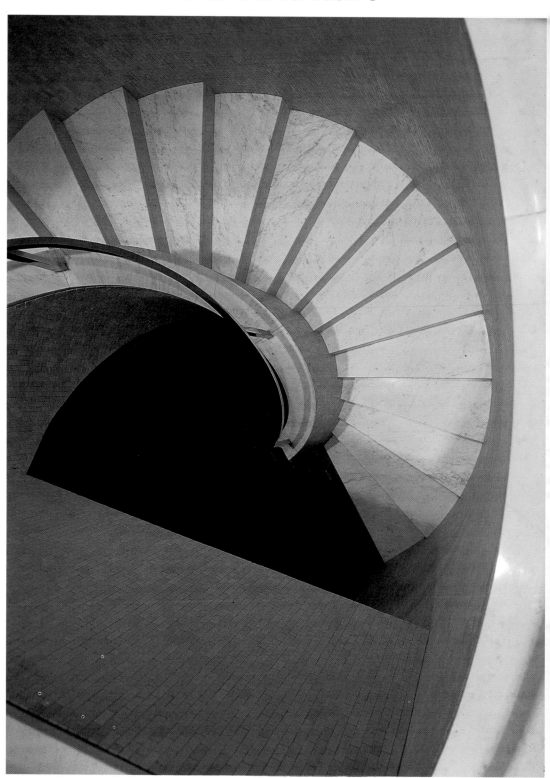

The one area of a building that architects like to spend a great deal of time working on are staircases. They see them as rather special features, worth the great deal of effort put into them at the design stage. There are several angles from which they can be viewed, giving an impression of their grandeur in the building, but these then become purely architectural photographs. If one takes the more

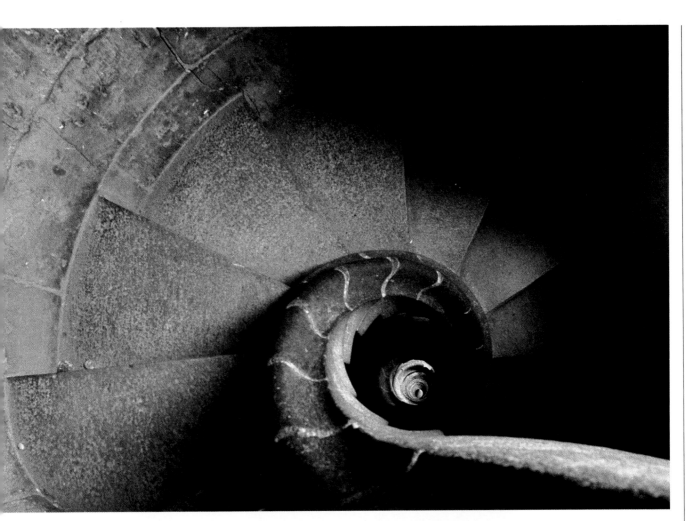

unctional view,
ooking up or looking
lown, and gets the
symmetry right,
ogether with the play
of light on the stairs,
exciting pictures that
einforce the
architects' decorative
ntent can be found.

eft This is a
staircase in the Royal
College of Physicians'
building in London.

Right and above
The two views on this
bage were taken
ooking up and down
a staircase in Gaudi's
Sagrada Familia
Cathedral, Barcelona.

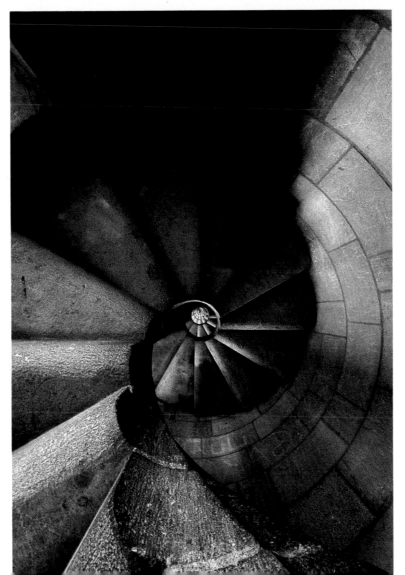

The grand entrance

First impressions are very telling in every aspect of life – even with buildings. Architects design entrances to look impressive or inviting or tantalizing and you can use this vital feature to give your pictures the feeling of the character of the place.

Opposite Sumptuous marble, ceramic tiles and brass decorative surfaces make a doorway fit for a king: this is one of the doors from the palace of the King of Morocco. A shift lens has kept the verticals from converging.

Below A doorway makes an excellent setting for a portrait. This is in one of Gaudi's houses, the Casa Vicens in Barcelona.

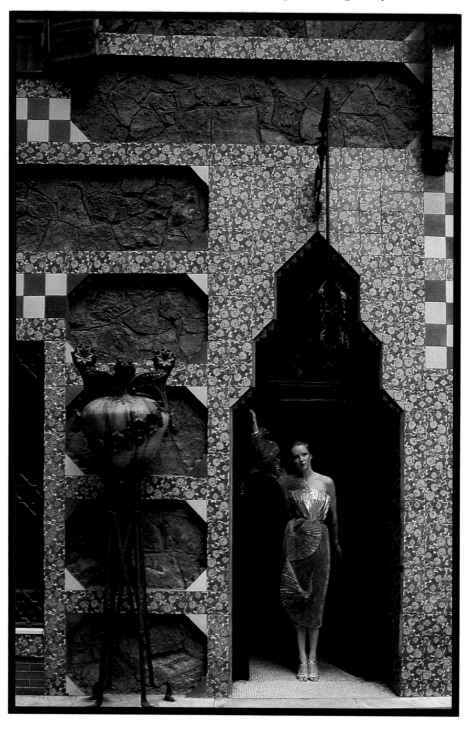

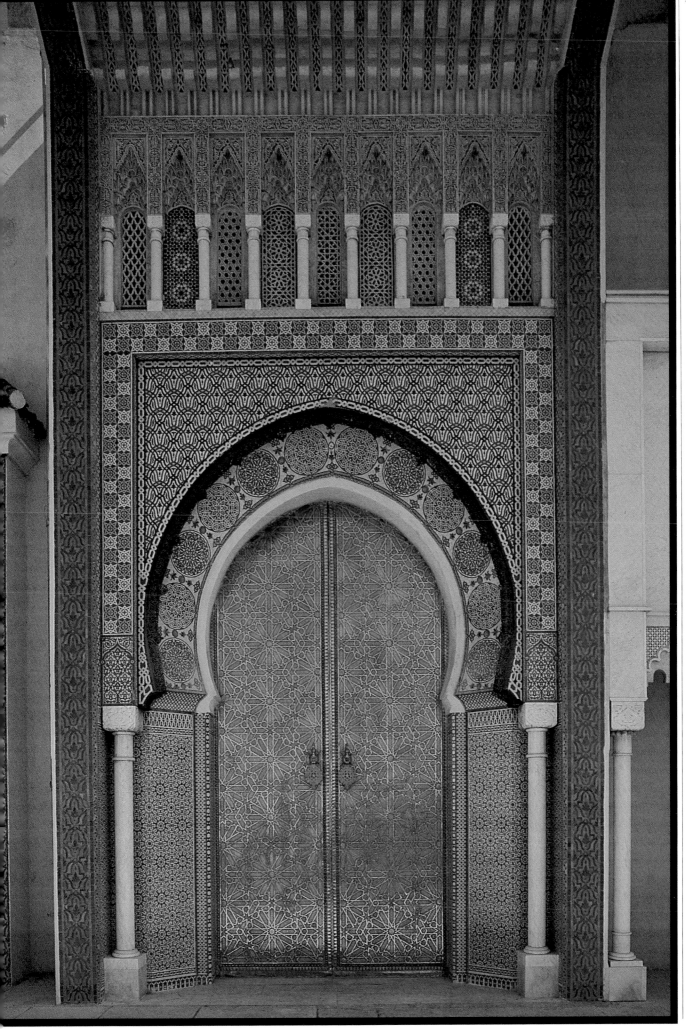

People and their houses

People are often very proud of the houses they live in, particularly if they are either very unusual or if a great deal of creative effort has been put into them. Houses or gardens with their owners can be very revealing — either emphasizing character or contrasting with it.

Below The man in the background here is the furniture designer, Gordon Russell, who built this garden. He was very proud of it, so it has been made the focal point.

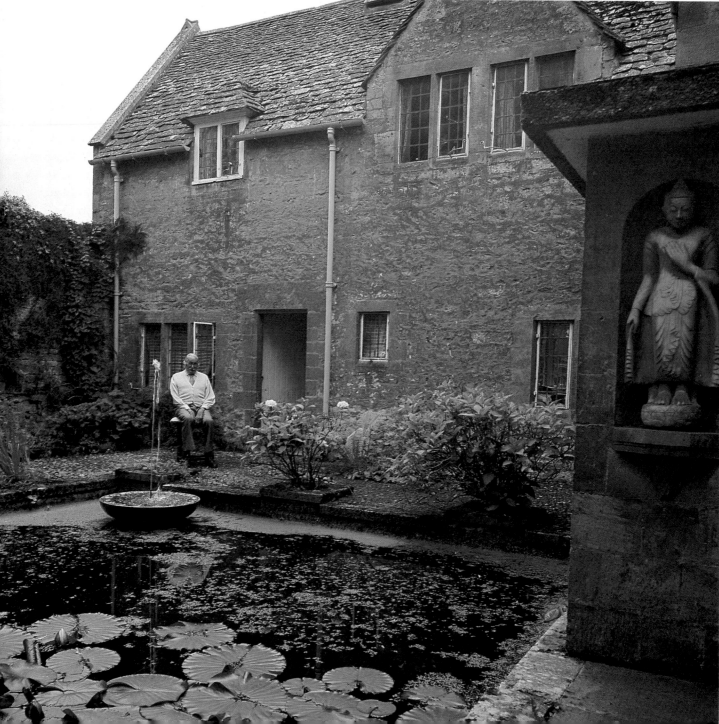

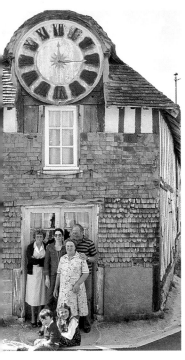

Far left This couple pose in front of their extraordinary house in Ootacamund in India. Built in the days of the Raj and English influence, it was one of the hill stations peopled by tea planters and was known at the time as 'Snooty Ooti'.

Left A French family bunch together for their portrait, but I used my wide-angle lens to take in their whole house with its amazing clock — giving the building rather than the people the lion's share of the picture.

Below A young English girl poses confidently in front of her family home. To include the wealth of detail of both girl and house, a wide-angle lens was used.

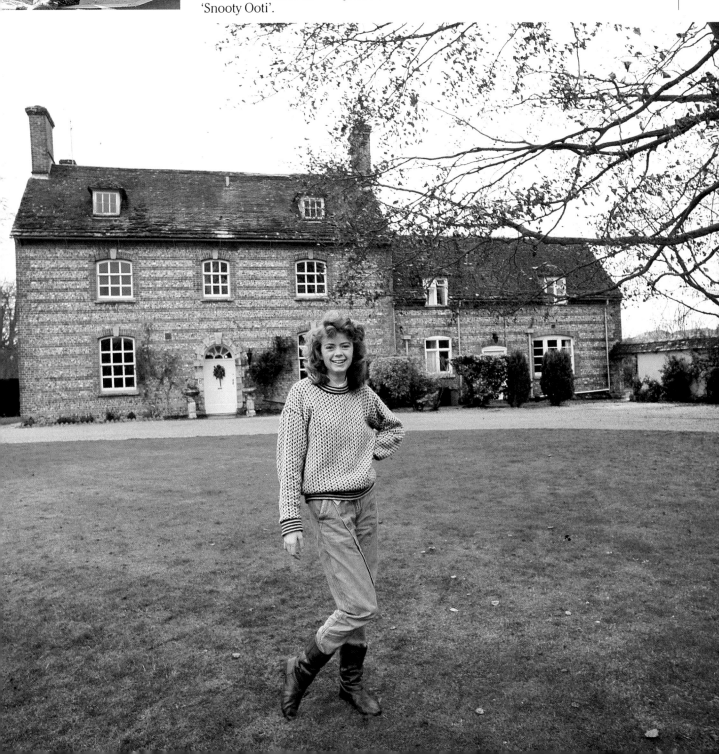

Street scenes: 1

One of my favourite things when photographing street scenes is shooting round corners. Place yourself at a vantage point across from a building which has streets either side of it. It gives you a privileged view that the people in the picture can't see. They are coming down one of two streets, quite unconnected and unaware, and only you know that they are going to meet. The potential for humour, a sense of narrative or the chill of suspense is great in such pictures. Producing a series of photographs on this theme extends these possibilities still further.

By shooting from such a vantage point you can also often juxtapose strikingly different styles of architecture.

Slit screens

In these two pictures (*below*) shooting through screens, I first focused on the roof of the buildings at open aperture, so that the screen went out of focus and doesn't show. I then stopped down and got both the building and the slats very sharp. Connecting the inside with the outside in this way is a good device to use; it adds spatial connotations to an otherwise uninteresting scene. It is a trick favoured by film-makers in linking shots, allowing the audience to follow a character outside to see where he's going or, perhaps, to indicate that he is being watched. So such shots have an inherent drama in them.

This technique also imparts an element of voyeurism, of seeing without being seen. It adds a sense of place, the knowledge that you are indoors, looking out over the city buildings.

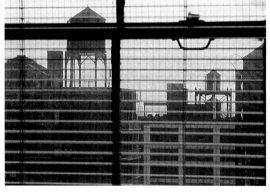

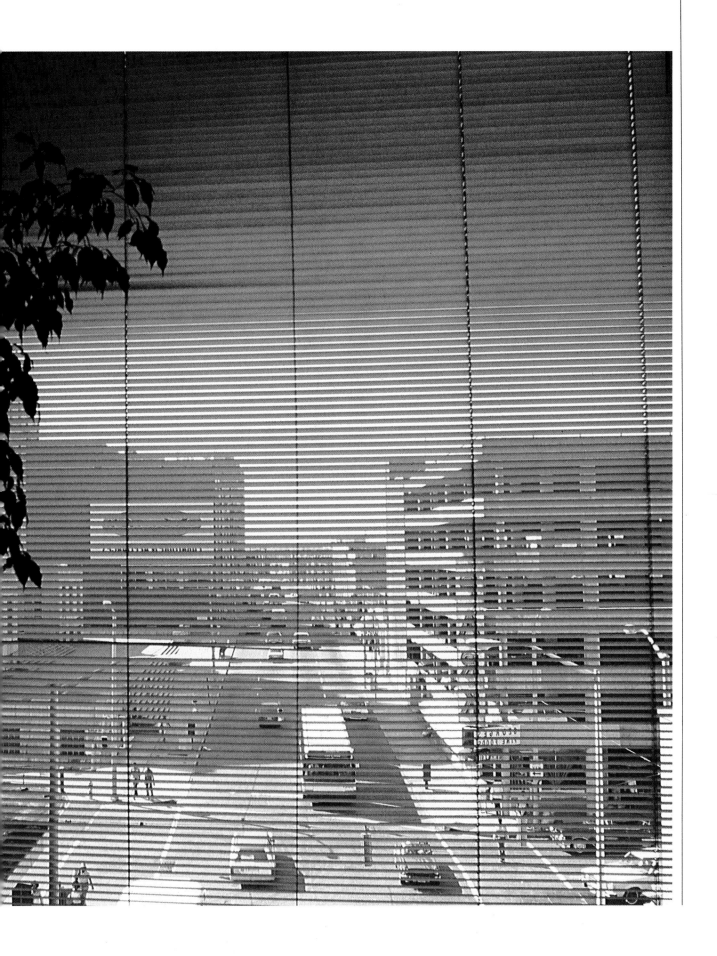

Street scenes: 2

One of the most interesting – and often surprisingly bizarre – places to take photographs is on the streets of any city. The bigger the city, the more opportunities you will find, it's merely a question of looking. There are many unusual shots to be had out of the juxtaposition of people and objects and their relationships to buildings. The best way to get to know a city is simply to walk around. The bigger cities, such as New York, Amsterdam or Hong Kong are very colourful indeed both by day and by night. They are, therefore, a very rich source of exciting street pictures. People are usually incredibly friendly and tell you about places to go and what to find. Once you start looking, whether you are attracted by portraits or general scenes, doorways or shop windows, the combinations are endless.

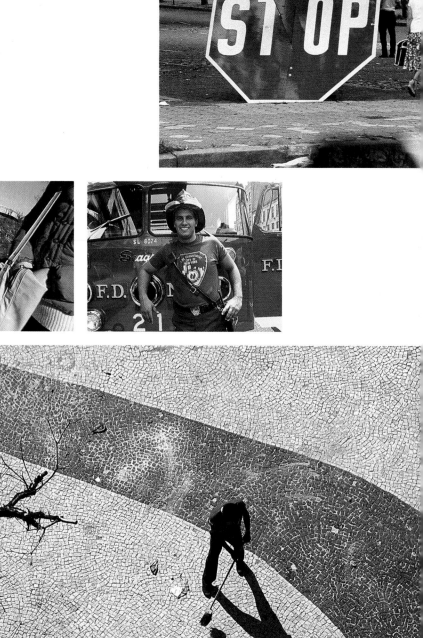

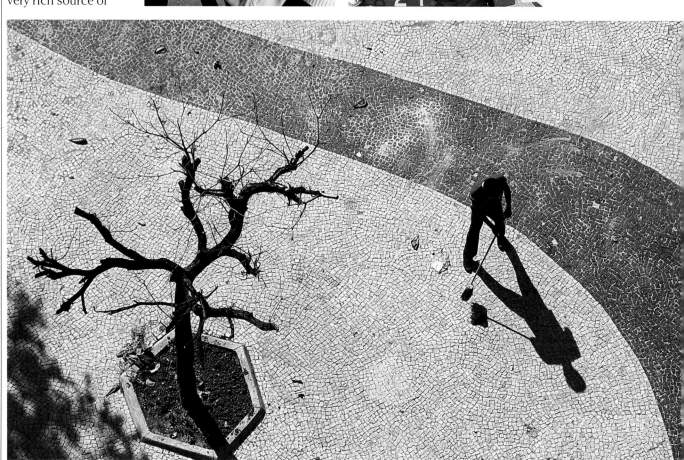

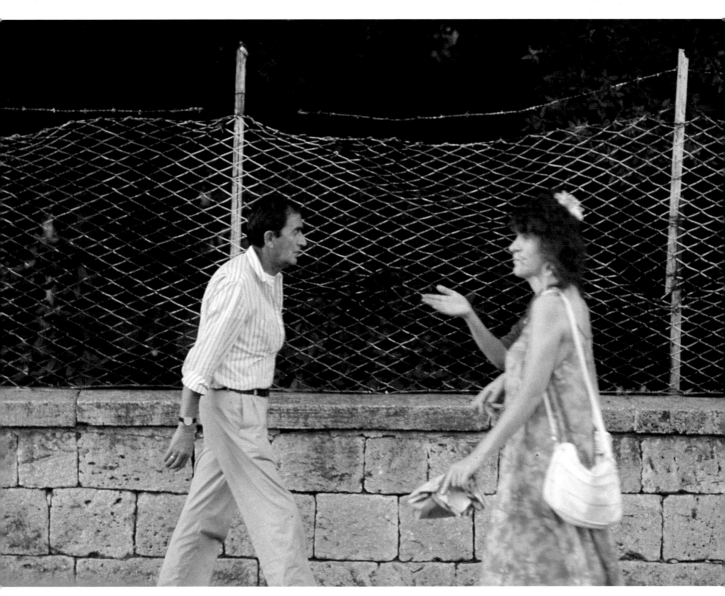

The atmosphere in a city changes throughout the day. Very early in the morning it is quite relaxed – people jogging and walking dogs – but as it gets nearer to the work hour, the pace quickens. There is a sort of hiatus at lunchtime, then it seems to relax a bit by mid-afternoon. Towards evening the activity and tension mount as the streets become crowded. Whether you do posed shots, snatched shots or a combination of both in your portrait of a city, you will need a variety of lenses – in particular a wide-angle lens to capture fast action – and plenty of fast film.

Street scenes: 3

When you go to foreign cities you tend to look more closely than you would in your own town where things are more familiar. As you walk around, it's a good idea to photograph *everything* rather than taking a theme such as people or doorways. Attempt to photograph everything that you respond to, because then you will have a portfolio of pictures – perhaps for an audio-visual show – that brings the place alive. One doesn't have to go far to find a whole wealth of interesting shots: here I have used a mixture of people, places and buildings. Fast film and a wide-angle lens are a good idea in these situations.

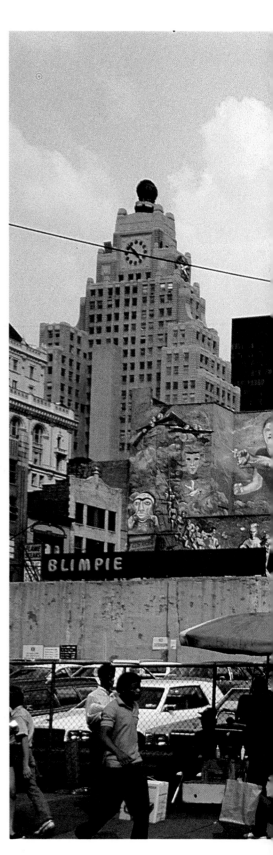

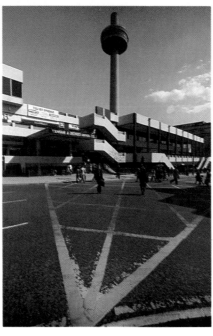

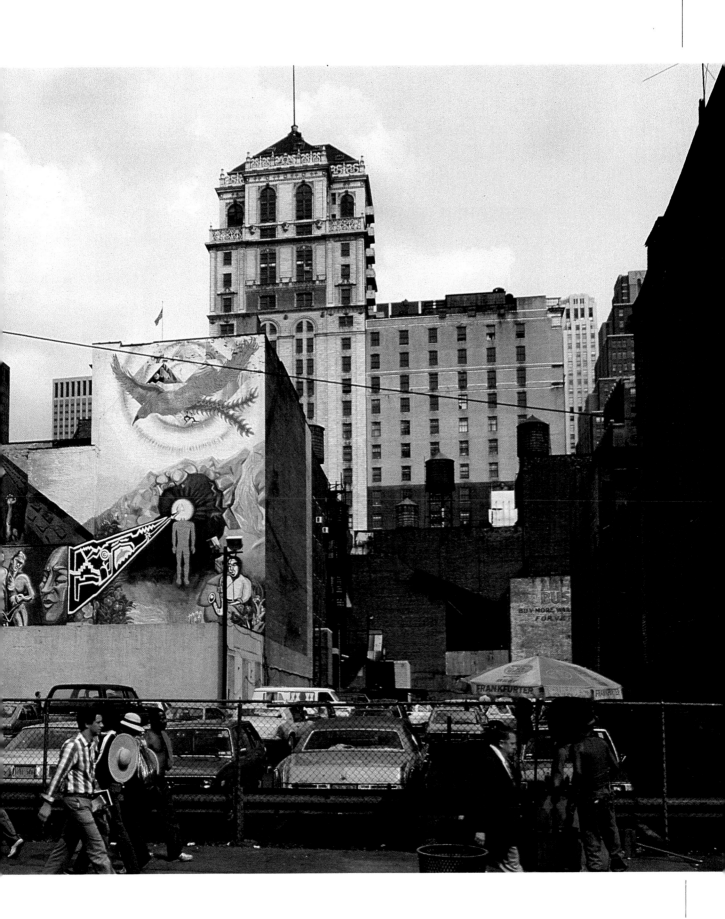

Viewing the other side

These two shots of backyard and backgarden are about exploring your subject. It is usually the front of the house where people put on their best show with a grand front door but, to the inquisitive photographer, round the back is usually much more interesting. So when exploring a living environment, it is important to look there.

In the same way back gardens seen from the train may appear raw and exposed, their owners' lifestyle revealed. Here too the evidence of individuality is intriguing.

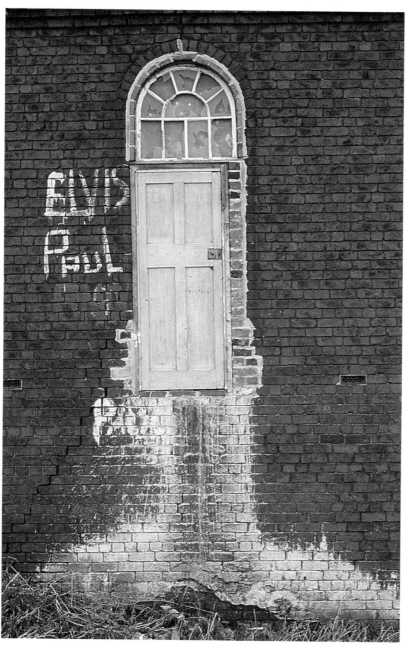

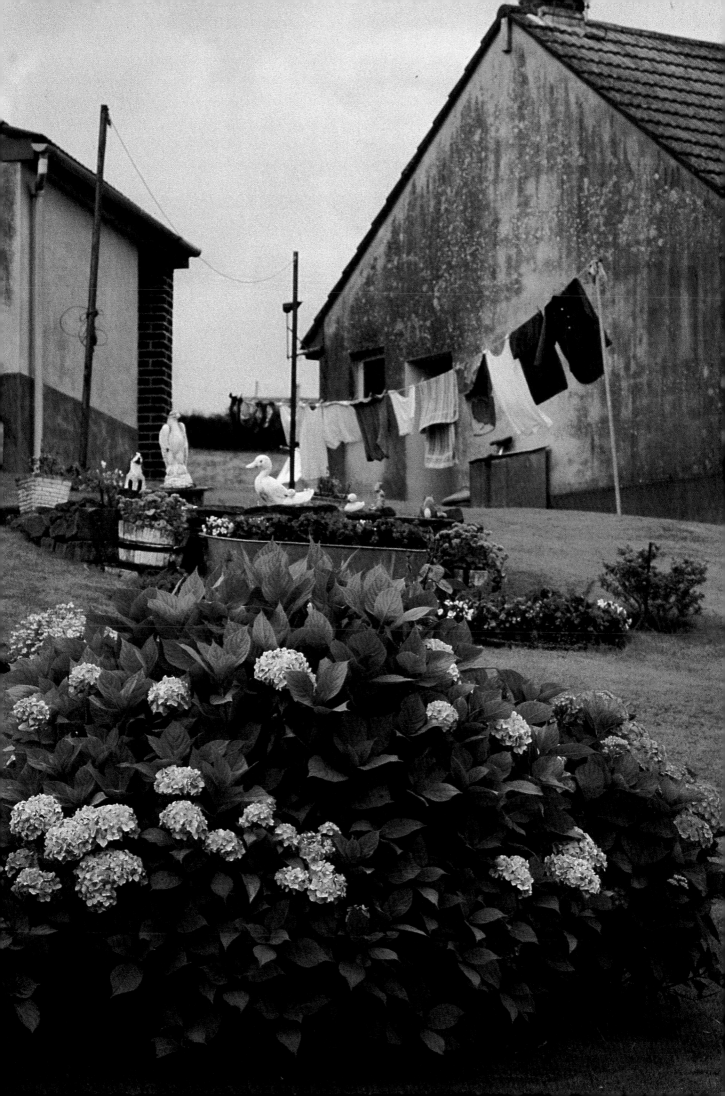

The symmetrical approach

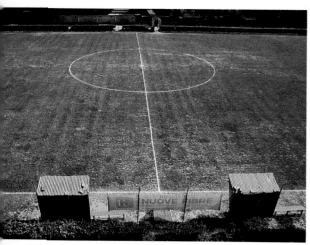

People love order and balance, because the resulting harmony brings a sort of contentment and security; we have a natural preference towards order rather than disorder.

In the big picture (*right*) the architect created a symmetry in his design of these houses. The people who live there have tried to alter this with the individuality of the different coloured paints. But in fact the colours balance in tone, so they remain symmetrical after all.

Even an empty football pitch (*above*) can be an interesting subject because of its pleasing, balanced design. Both pictures were taken with 35mm lenses on a 35mm camera in order to include the whole scene but with minimum distortion to the perspective.

Street scenes: 4

These street scenes are more like found still-lifes or stage sets. One I have shot from a distance as I came upon it (*above right*). Then I moved in on the group and became more selective (*below right*) taking a slightly higher vantage point, from which the tyre seems to merge into the wall.

There is a richness of both colour and detail to be found in the picture of the old weighing machine (*opposite*) found on a city street. I used a 50mm lens on a hand-held 35mm camera. This is the most useful lens to use when shooting on city streets.

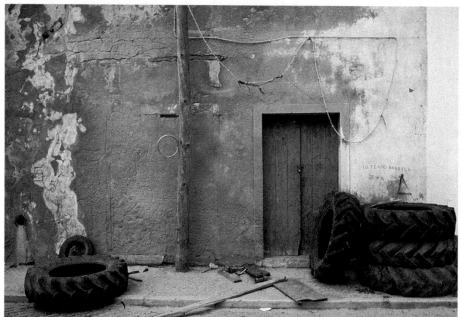

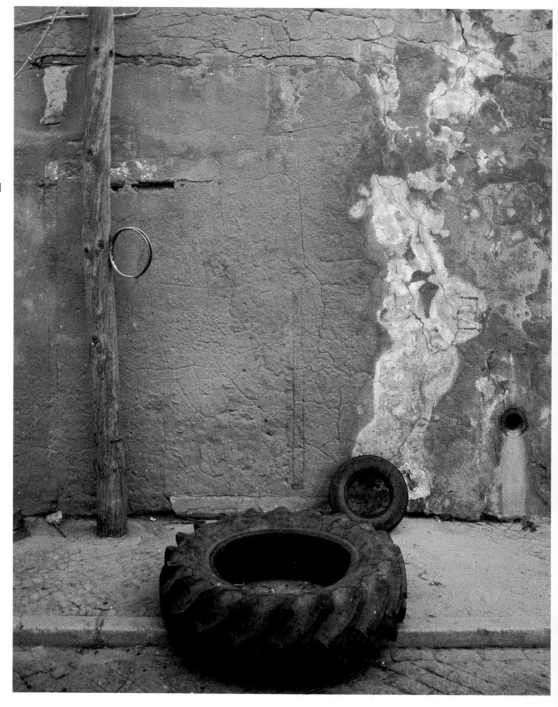

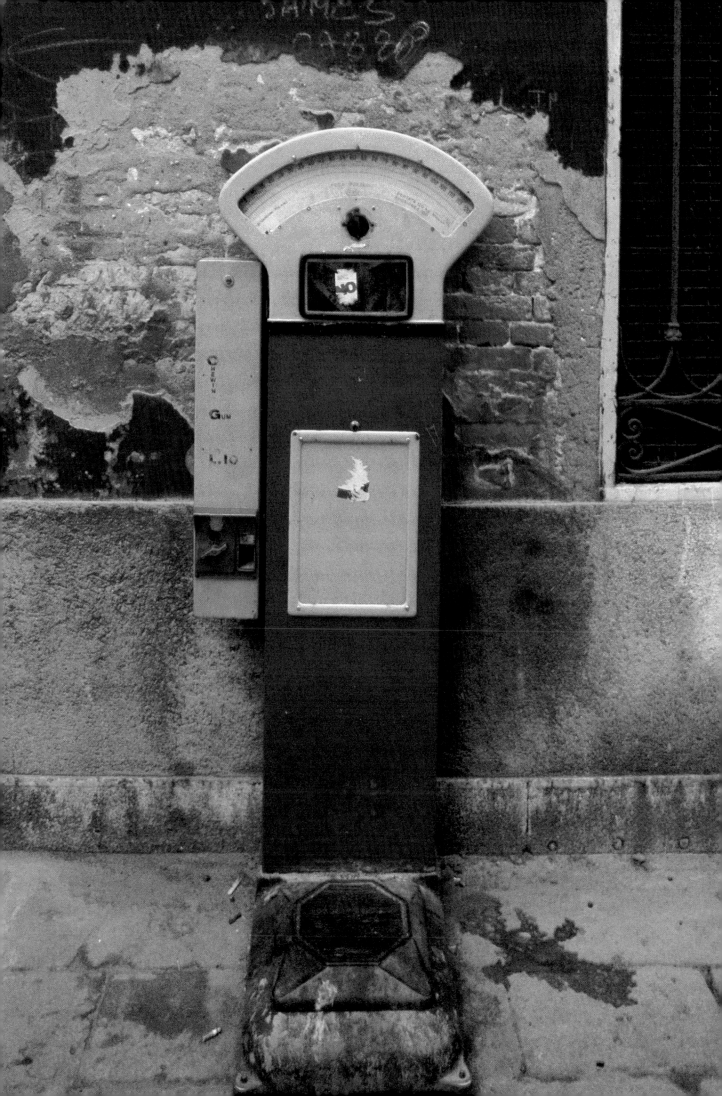

Capturing unusual activities

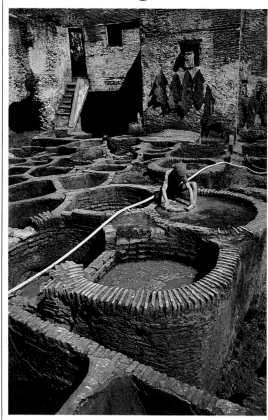

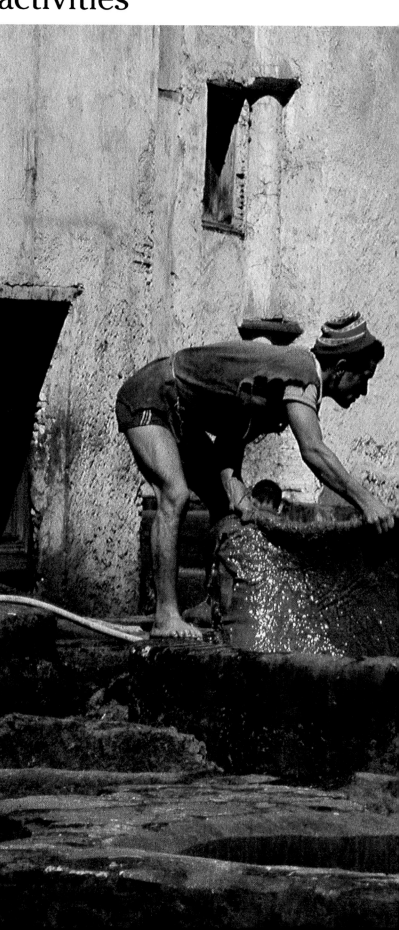

If you come across scenes like these – of dyeing skins in Morocco – it is actually worth spending a lot of time photographing them properly because, very soon, such places and skills won't exist any more. Whilst the people are important, it is the activity of dyeing the skins that it is essential to capture. In the intense light and heat, it looked more like a medieval torture chamber, emphasized by the blood and earth colours, and the extraordinary figure of the man at the back. As such scenes are becoming rarer and rarer, they are well worth recording. You will need a wide-angle (28mm) lens for shooting hand-held in harsh light.

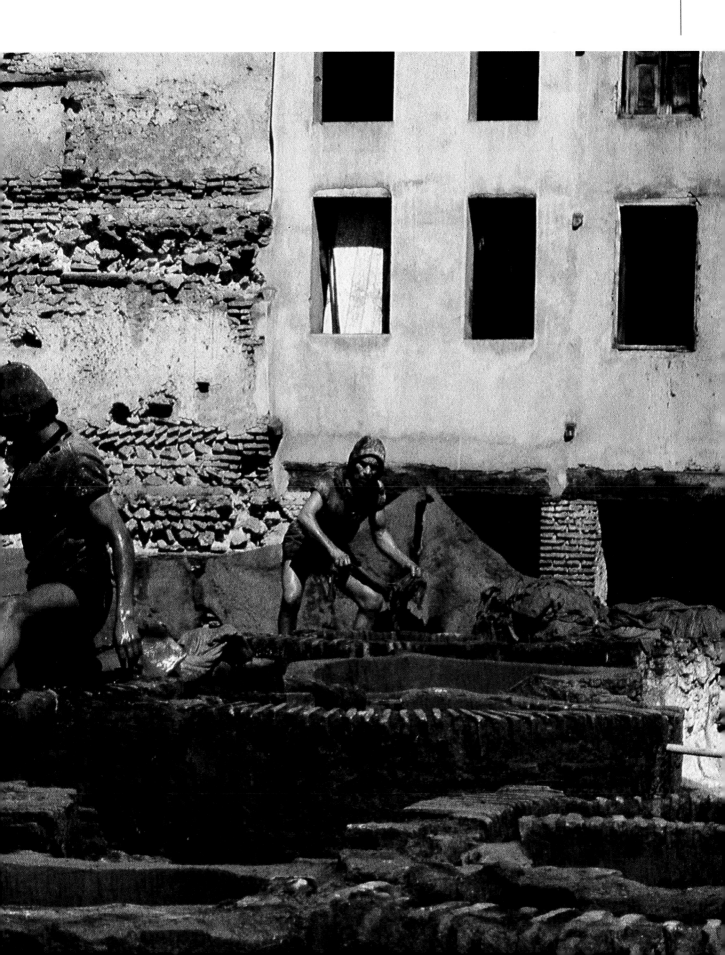

Capturing atmosphere: 2

Right This is a portrait of a farm's pig man and, although it is very tempting to get up close for such a subject, much more atmosphere has been brought to the picture by standing back. The washing line, the old doors and roof of his house evoke a strong atmosphere which enrich the picture and also explain it. He holds one of the delicate piglets from the litter, which he brings up on his own at home, away from the sty. The hand-reared piglet sits on his knee like a child.

Below This is a farmer's wife as I first saw her when I arrived. She had a rather inquisitive look, wondering what I was doing. I liked the gentleness she conveyed, and this gentleness sets the atmosphere of the picture. Her pleasure is in her garden, so its inclusion was important.

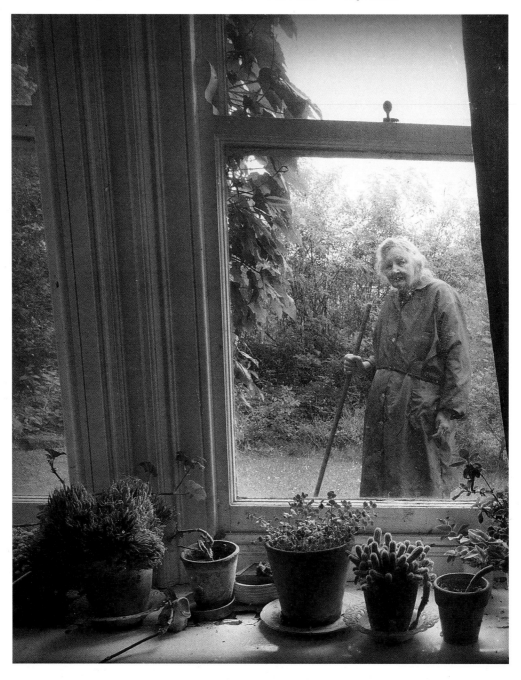

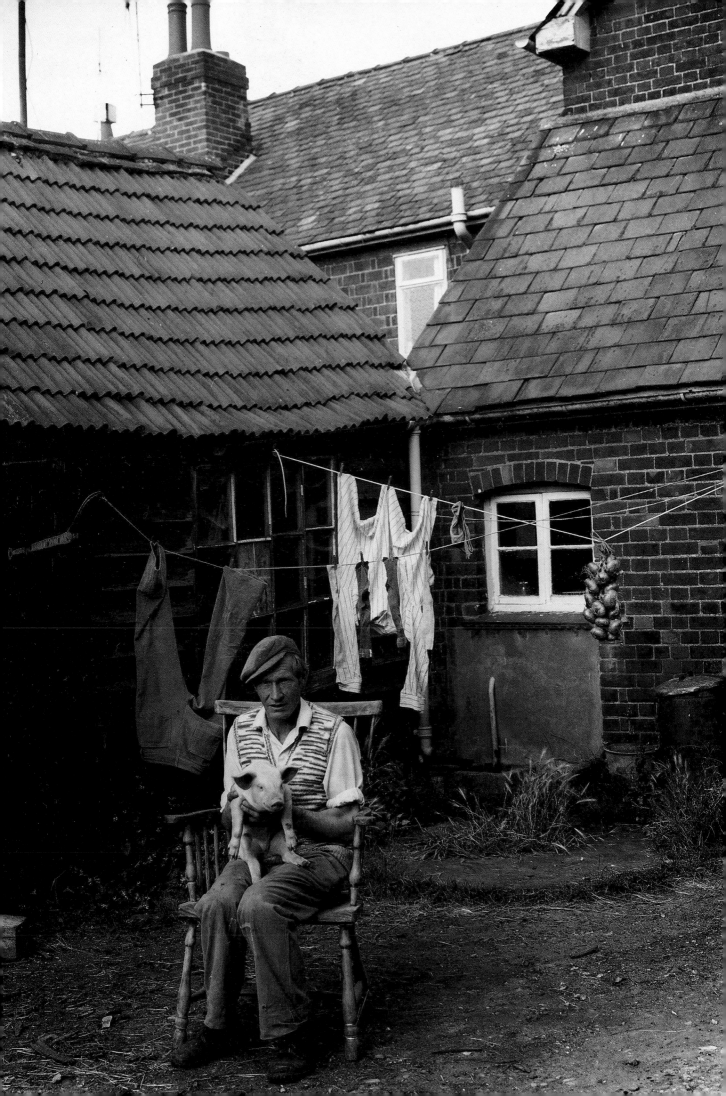

Essence of the place

This is the sort of picture that I would say is 'Dynasty-like' – too good to be true. The sky and the pool are too blue, the beautiful girl is overdressed for the situation, and the whole has that feeling of opulence that one knows is only skin deep. It reveals the gaudier trappings of western civilization, of those who aspire to wealth and glamour. Capturing this feeling, however, is not as easy as one might imagine. Firstly, it requires sun and this brings with it extreme problems of contrast. If the model's features are to be seen, reflected light must be thrown on to the face. Secondly, the relaxed atmosphere has to be artfully arranged, the furniture positioned in such a way that it seems someone has left only a moment ago.

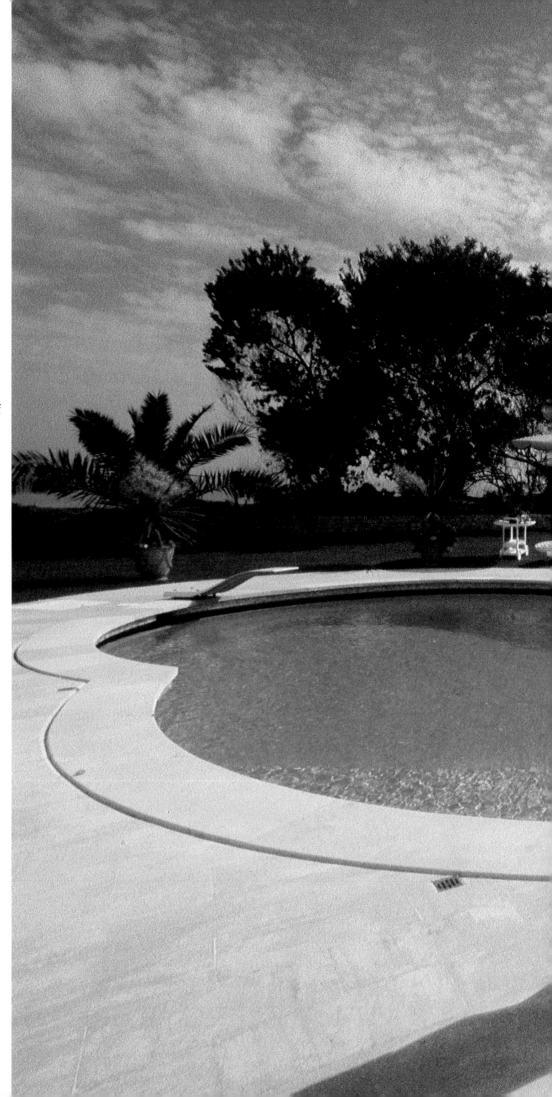

Topographical photographs: 1

These pictures sum up a situation that is almost decadent in its blatant exploitation of the environment for human pleasure. It is a situation in which, from what was once a remote part of Portugal, nature has been excluded. Not a weed is to be seen, air-conditioning, refrigeration and security-bars have been brought in. The over-blue pool, pristine surroundings and beautiful girl are like a parody of

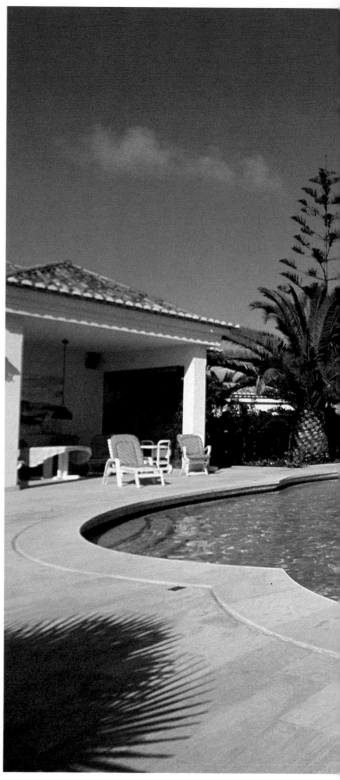

nature.

This type of scene brings both opportunities and problems for the photographer. Shadows on glistening bodies, for instance, can destroy a good composition. And very bright sunlight can create strong general shadows which, over a wide area, cannot be controlled by reflectors. My approach was to keep the technique as simple as possible. I used a wide-angle lens, a hand held 35mm camera and medium speed film.

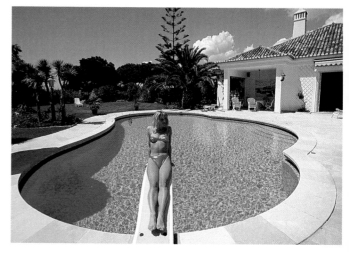

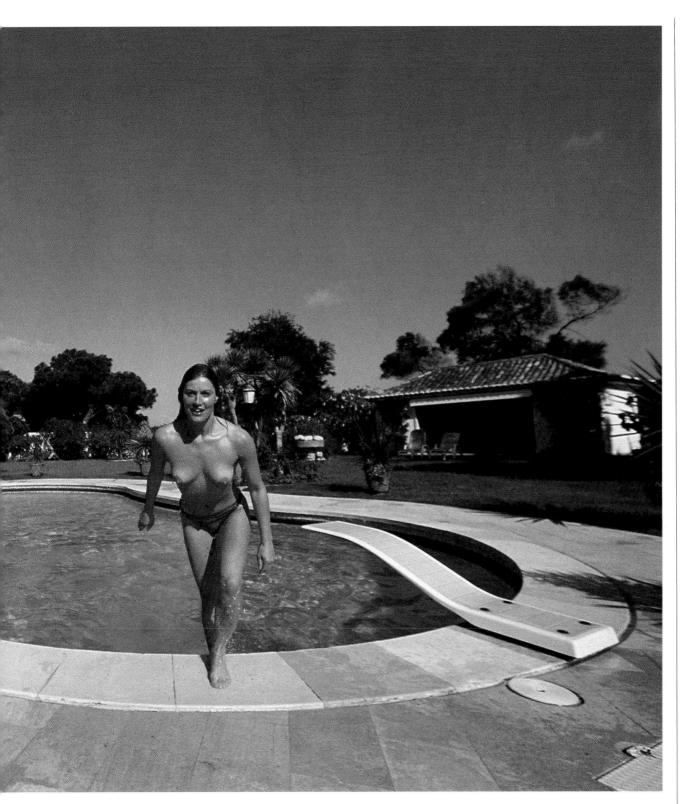

A sense of place

Here I'm taking pictures of scenes that would normally pass unnoticed. However, with these shots showing what to include and exclude, I have produced an unexpected and successful result. One picture is quite crowded, the other incredibly simple – each conveys a different feeling and atmosphere. These are pictures that happen to you, rather than you making them happen.

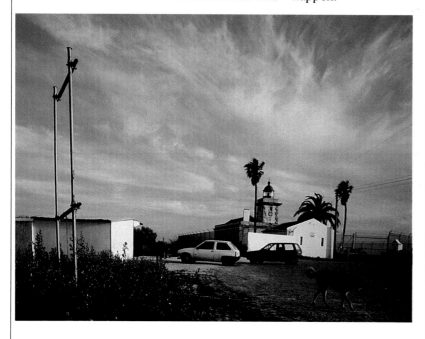

In a certain place you may feel an affinity with the surroundings, often without knowing why. When this happens, it is a good idea to explore the place, because it means that you are in sympathy with it. One should respond to that feeling, and search for pictures – because they are there. As you shoot, the light may change and give you quite different scenes or, as here, people or animals may appear – such as this dog – to add humour. This gives more than just a documentary record, it gives a sense of the spirit of the place.

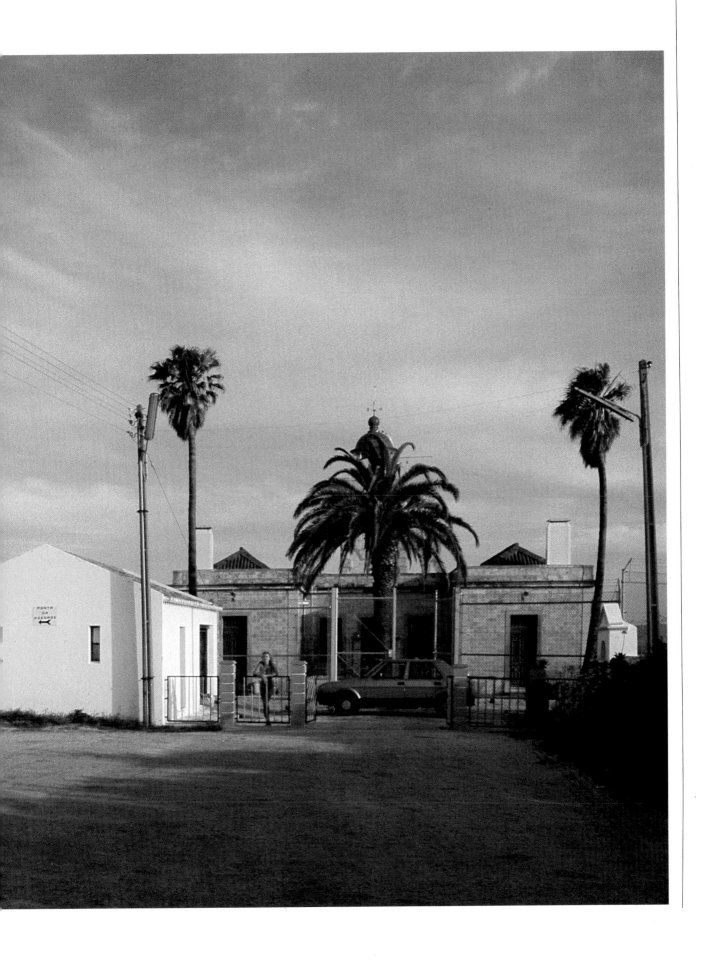

Topographical photographs: 2

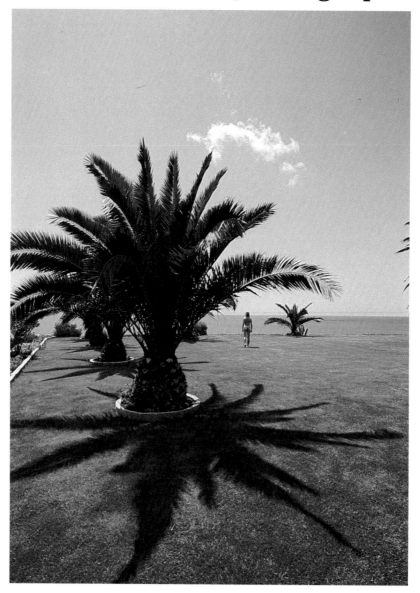

A photographer may decide to shoot a landscape or townscape mainly because of the particular light in that situation. Although one takes these shots straight, without artificial interference, they have an aura and presence of their own; often they seem slightly unreal. This atmosphere was especially noticeable when I came across these two trees. I've taken both pictures against the light and the shadows have become important elements, almost stronger than any of the other elements. These shots needed the strong sunlight to make them work.

Above The palm trees look like giant pineapples that have been put down on the grass, almost wider than they are high. The girl walking by gives them scale. But it is the luminosity of the light that gives the photograph its presence.

Right This small and skinny tree has leaves like two hands coming out from the trunk. Under an unpolluted, luminous sky, dotted with two small clouds, it seems artificially placed.

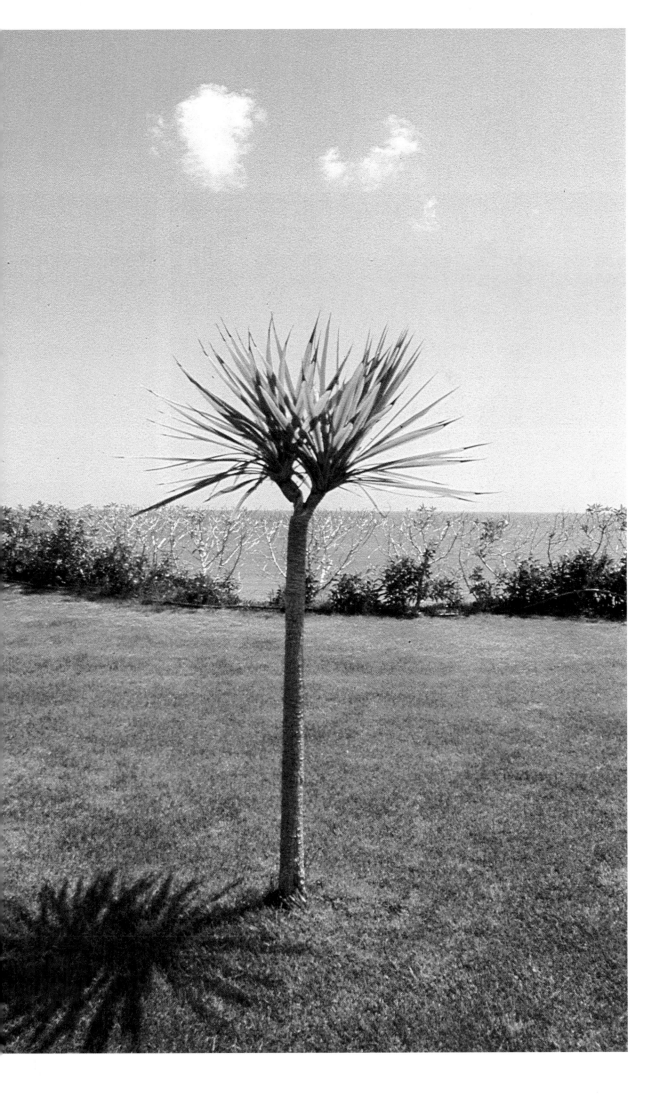

Interior style

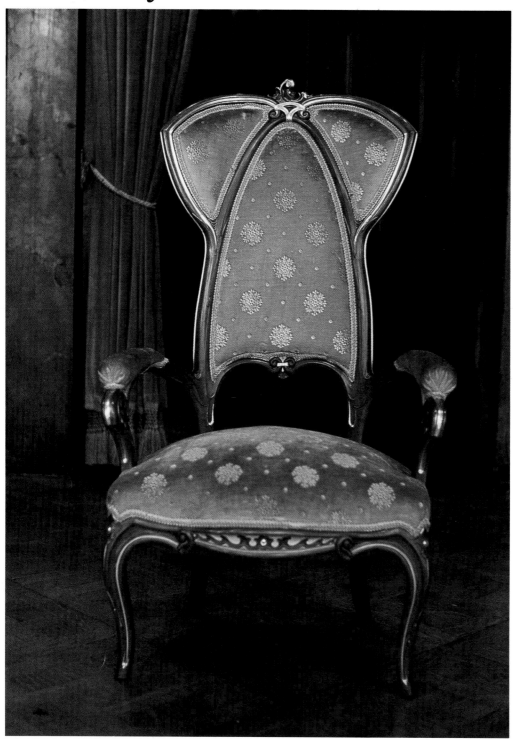

hooting interiors means using a wide-angle lens and choosing your position with care.

elow In this shot of ne of the rooms of an partment in arcelona by the rchitect and designer Gaudi, I had to make sure I was not reflected in the mirrors and glass surfaces. All the furniture in the room was also designed by Gaudi; it is incredibly elegant and it was important to reveal his unique style in the picture. The photograph was lit only by daylight from the windows on the right.

Below left The same lighting was used to take this single-piece shot in the same room.

The inner view

People often only take pictures when visiting opulent surroundings or staying at luxury hotels. When in more primitive surroundings, they usually don't bother, which is a mistake. In a sense, all surroundings – without exception – are interesting and the question is whether you photograph them in a straightforward way, focus on elements of the interior, use reflections in a mirror, or combine the place with a portrait. There is hardly any environment which you can't make into something of interest, or of historic worth. Things can change so quickly that it's always worth making a record of them.

Left The abandoned breakfast table, with its Van Gogh sunflowers and colou scheme makes an interesting still-life.

Below It is the unusual yellow-painted beds – looking like an illustration from a children's story book – that make this picture.

Left The incongruity of the green spotted trousers drying over the balcony and viewed through a doorway inject humour into this picture.

Preparation, transformation

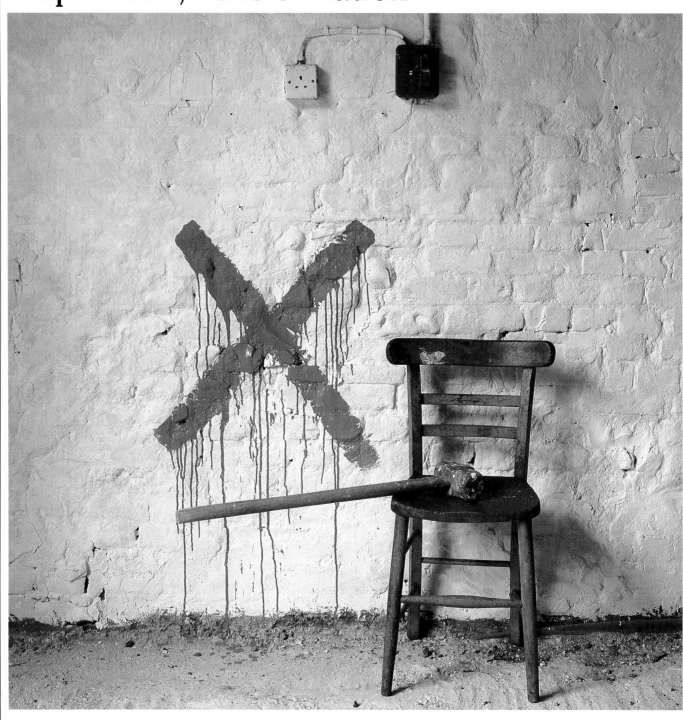

These changing still-lifes were found as builders were doing work on the inside of this barn. When they broke off for lunch, I looked in and shot the scene without any alteration to the still-life groups that they had left. Both contain narratives.

The huge red cross (*above left*) is to mark where the fuse box is to go, painted so large that the decorator will not paint over it. In the other (*above right*) the rough

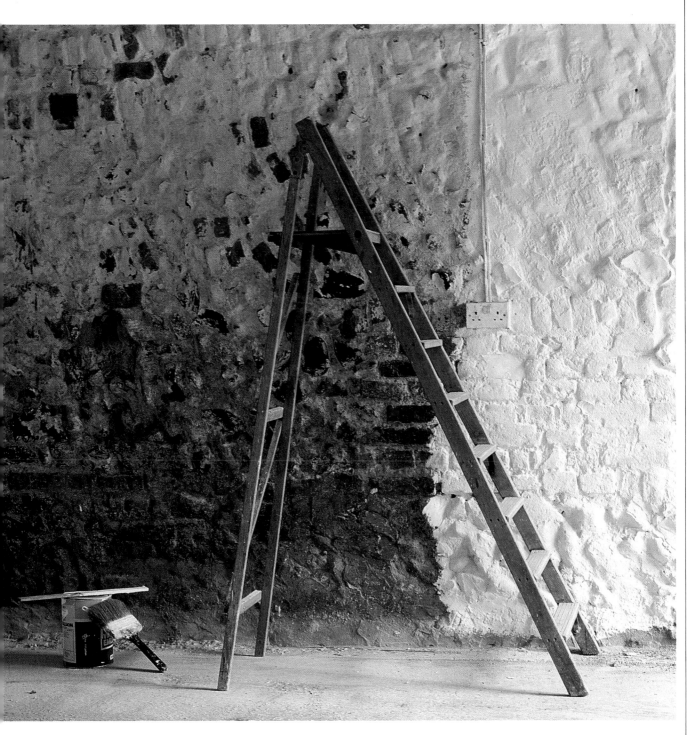

brickwork is in the process of being transformed by a brilliant white finish. Their tools and equipment – the steps, hammer, brush and paint make unusual groups together with the walls being worked on. I used a standard lens and available light. Interesting pictures can be found in the most unlikely situations, so it's always a good policy to take your camera with you everywhere.

Period group

For period still-lifes you must have a strong theme or idea, one in which the relationship of shapes and colours are appropriate. It could be a personal collection, or perhaps concerning a famous author or actor. The lighting should imitate daylight, looking as if there is one main source of light. In real life, such a room would have a fairly dingy light, which is why these two shots are not overlit. Both room sets are of a particular period in Britain, the 1950s. The photographer must collect the necessary paraphernalia and then place it – here, for instance, in a suburban house. Build the set to look as if you've just walked in and are surrounded by the kind of objects that people would have collected at that time.

Using strong shapes

In each of these pictures, the shape of the subject dominates the whole. The boldest images are created by silhouettes, which simplify subjects into basic shapes, emphasizing their outlines. By photographing against the light, thereby producing no modelling on the images, the forms are described as flat shapes. These are much more powerful and dramatic than they would be otherwise.

Near and far left Delicate portraits can be achieved using shape and silhouette.

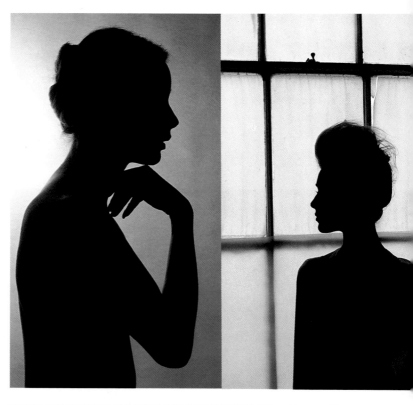

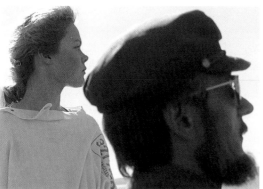

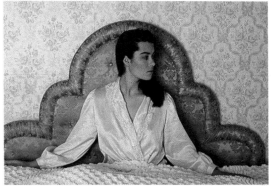

Below This portrait is really about the mirror; its incredibly strong shape entirely dominates the picture. However beautiful the girl, she is no match for its elegant shape. Here, I've used a wide-angle lens shooting from a low angle to avoid my own reflection appearing.

Above left By arranging these two profile heads against the light, and at different distances from the camera, an unexpected amount can be learnt about them. The shot has a unity about it because the heads are both obviously looking at the same thing.

Centre right In the portrait of the girl in bed, I used the shape of the bed-head to dictate the triangle-shaped pose.

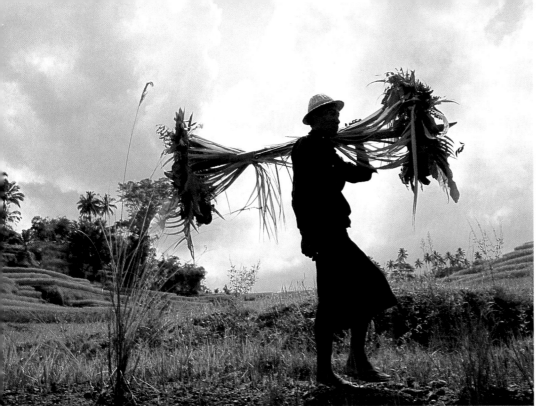

Left By shooting into the light from a low angle rather than with light directly on the subject, details of this man's dress and his burden are greatly emphasized.

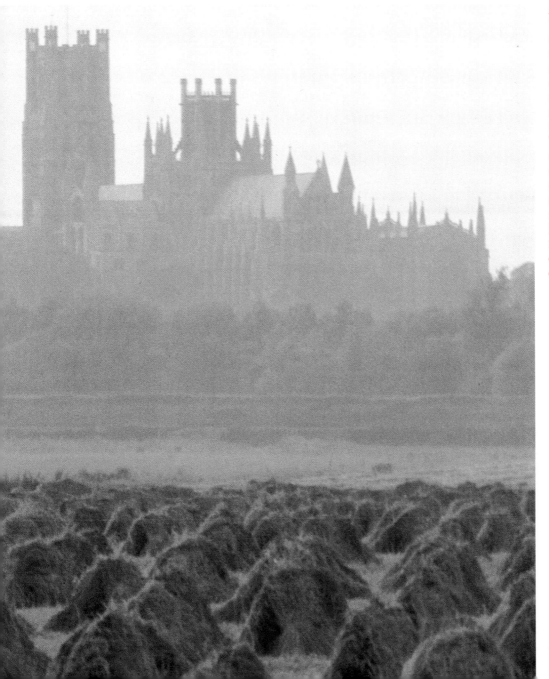

Left The beautiful 'aspiring to heaven' outline of this cathedral in its rural setting is given dramatic emphasis in a gentle way, by shooting into the light and overexposing. The unusual combination of cathedral with fields of corn creates a strong, almost medieval atmosphere in the picture which a more detailed, front-lit close-up would not convey.

Man-made signs

Whether they are amusing posters used for advertising, or street signs used for directions, man-made signs can be great fun to photograph. Given the right environment or setting, interesting pictures can be made from them. These were all taken on a journey through Europe.

Right Though concentrating on the guitar, I've included a little house in the photo in order to give the instrument relative scale. In a shot such as this, a careful choice of lenses should be exercised.

Below Relating signs to buildings to give scale adds another

area of interest. I have made the Michelin man appear to be coming towards you over the brow of the hill.

Below right This aeroplane advertisement is both beautiful and amusing.

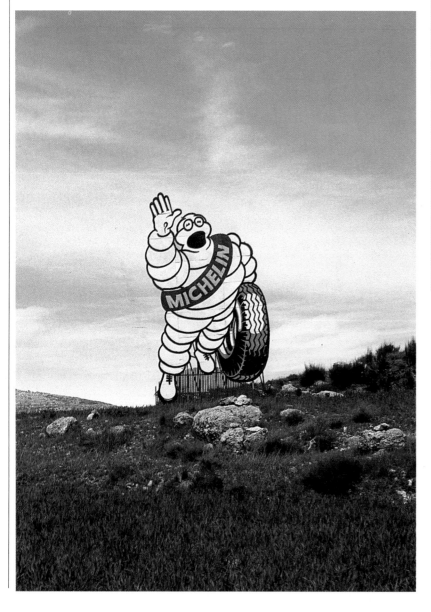

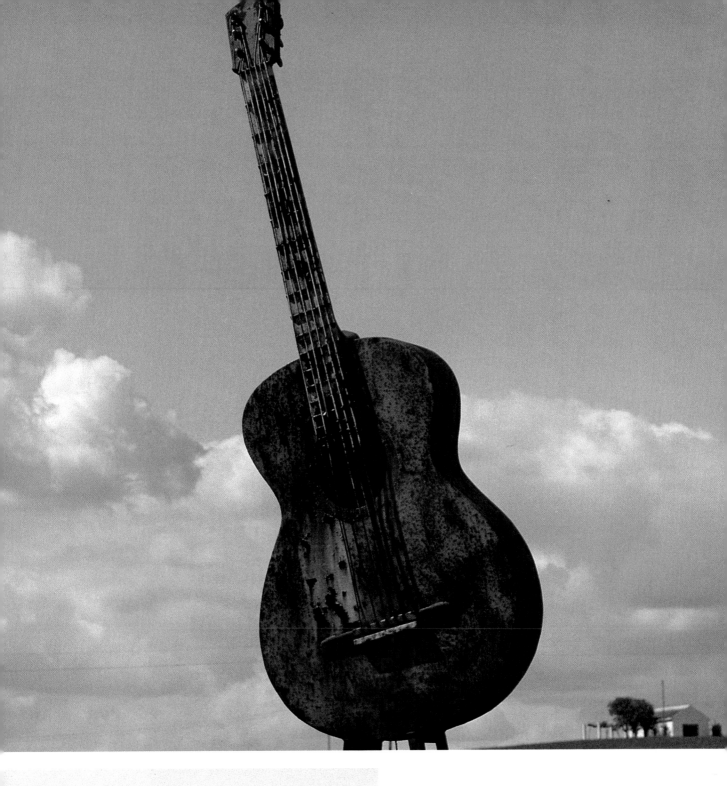
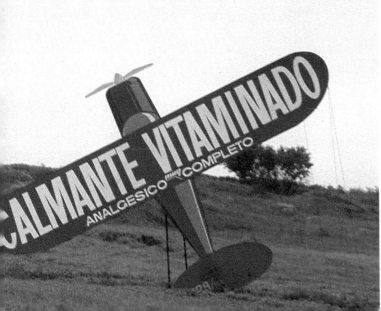

Using symbols

Both of these photographs are concerned with linear perspective. To achieve a sense of space and distance in a picture you need to anchor the foreground very firmly with strong, eye-catching shapes.

I've used a level crossing across a railway line (*opposite*) with its familiar symbols to attract the eye, which is then drawn along the track to the far distance. In the other picture (*above*) I've used the abstract shapes of the motor-cycle club symbol, painted on the side of the car, to liven up an otherwise boring view. It makes the viewer examine the foreground first. Using a wide-angle (28mm) lens has heightened the perspective.

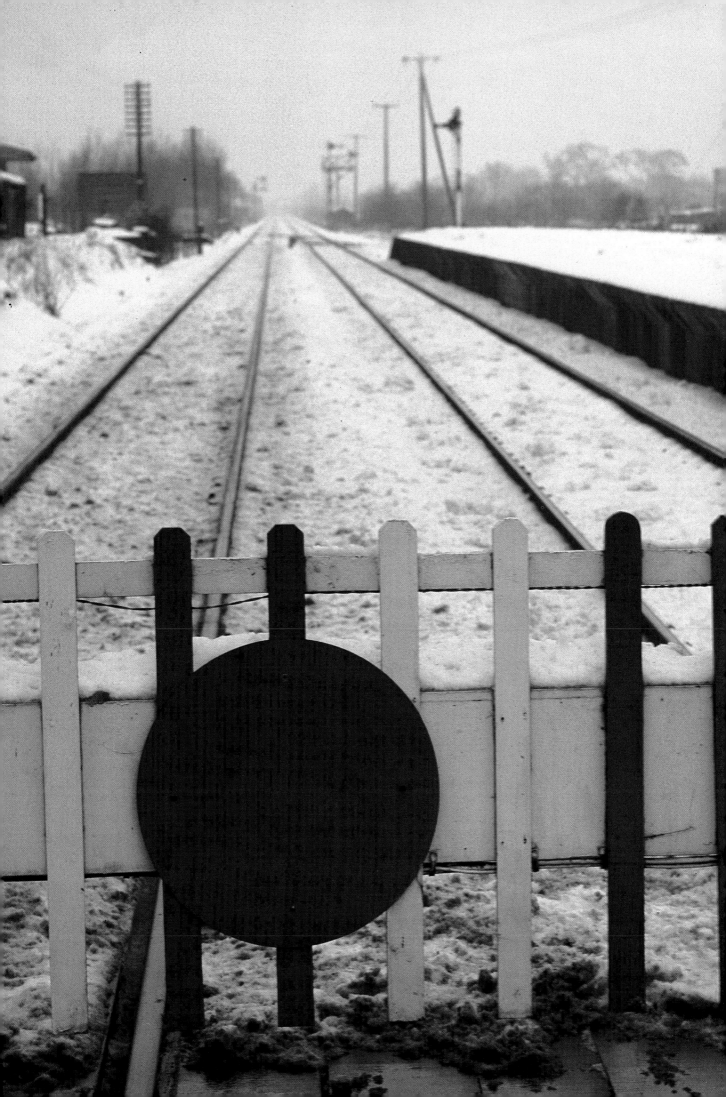

Lines in landscape

In what is called a natural landscape you often find that man-made lines of communication and energy have produced structural elements which are almost like landscape sculptures. With the right light on them, instead of being a disfigurement of the landscape, they become an integral part of it and play one off against the other to great effect.

The power cables, *right,* glistening in the sunshine across a Norwegian landscape create a rich pattern – almost like the strings of a giant musical instrument. Equally, the lines on the roof of the building in the big picture – also an idyllic setting in Norway – make it look, I think, like a box harp or a musical box with strings across it. In both cases the pictures

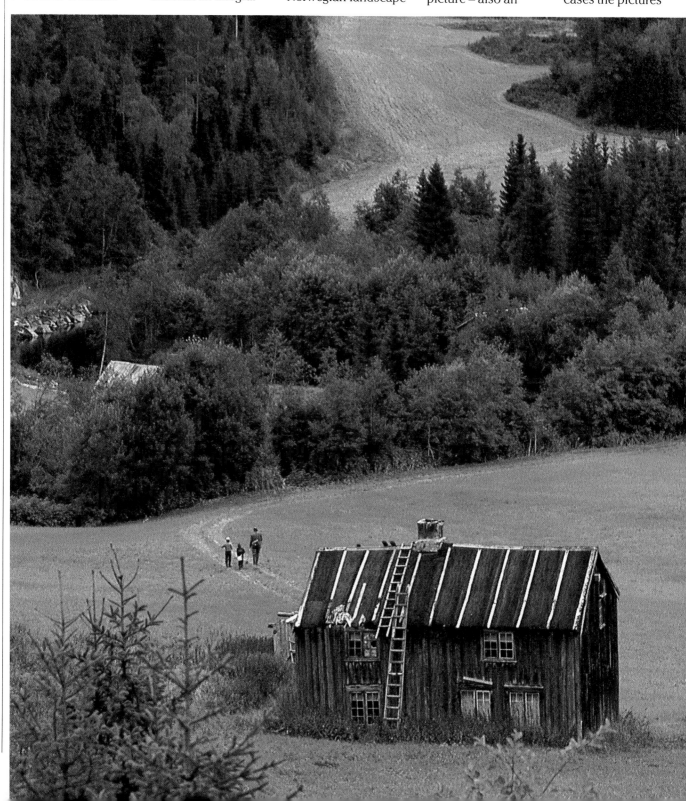

were taken in early
evening to take
advantage of the rich
colours that a certain
light can produce.

The romantic view

You often discover by chance what is your dream of an idyllic cottage in the country where you'd love to live. This house at Heveringham in Suffolk, with especially beautiful Gothic windows and ducks waddling about its lawns, is seen under glancing sunlight. The important thing with such a picture is to capture the romance of it. You actually need the setting, and you need the detail.

In the first shot (*right*) I've identified the house, but in the second (*below*) included the setting as I first saw it. By shooting from a dark place with just odd glimpses of sunlight it becomes much more hidden and mysterious, and certainly more romantic, infused with the essence of the place. Other elements

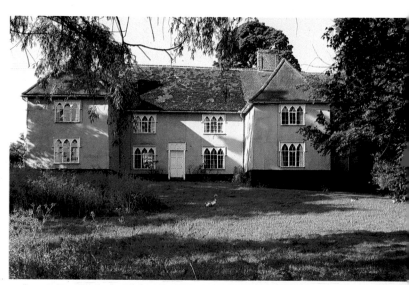

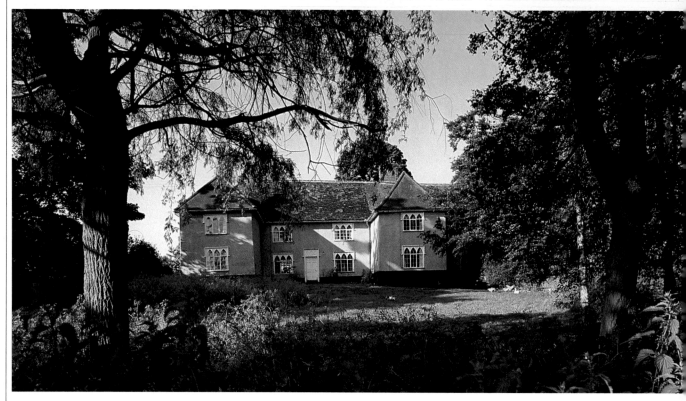

that made it such a fascinating place were the patterns of shadows of the iron railings decorating the tree (*opposite, below*) and the way that the shadow of the tree imposed on the rather empty landscape beyond (*opposite, above*). Most exciting of all was that as the sun went in and out, so the highlights and shadows switched on and off, one moment they were there, the next they were gone. Dramas like these, together with the appearance of the rainbow all create a romantic view of landscape. The first shot is often what people take but the others are what you should take; all are done with a wide-angle (28mm) lens.

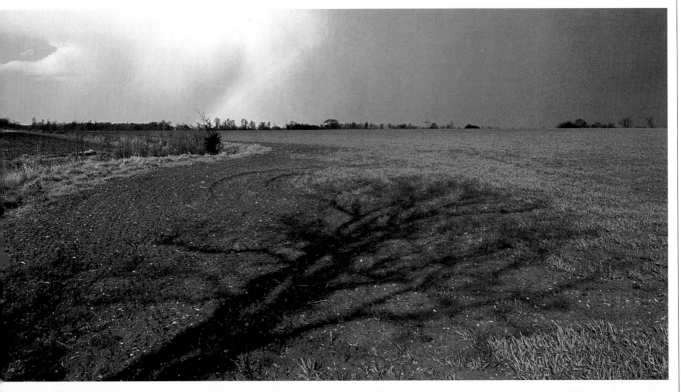

Atmosphere

Atmosphere is not all that easy to photograph, for one senses an atmosphere rather than sees it. You hear the birds singing, the wind rustling in the trees, experience a calmness or quietness. But when trying to photograph a scene, it is often disappointing to be unable to capture the mood or feeling experienced there. In addition, there is just the one eye of the camera in a single place, so the angle from which you choose to sum up must echo exactly what you felt. Often there is only one angle available. In any case you must ask yourself exactly what it is about the scene that makes you respond to it and it is this effect which you must try to conjure in visual form.

Below These chairs in a garden offer a combination of highlights and shadows, with light just fleeting across the lawn. It's a scene one only gets at dawn or dusk; the moment of expectation or memories. It is a very simple picture yet sums up an awful lot.

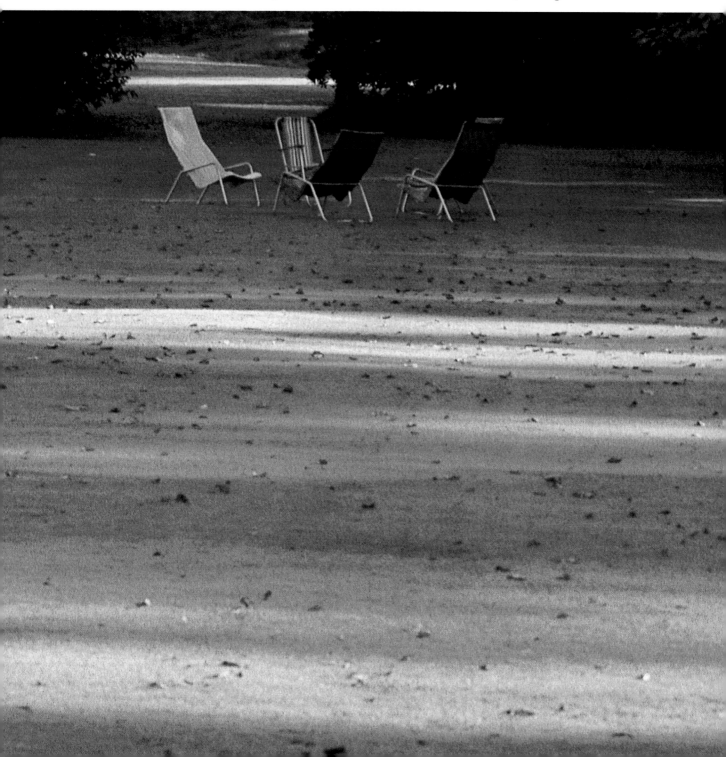

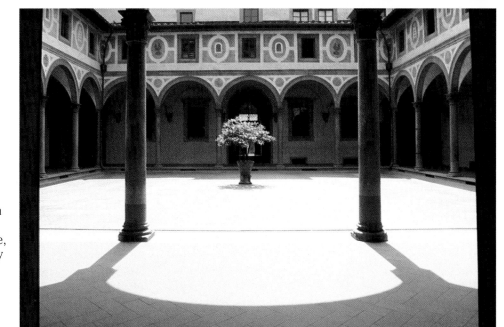

Right In this formal courtyard, encased in stone and brickwork, the innocent little tree, all on its own, already has light focused on it. It gives a certain strength and warmth to the symmetrical composition.

Changing the view – developing ideas

As I liked the 'set' of the abandoned swimming pool, I was on a balcony taking a shot of it when this gardener came into view. I moved the camera down to get him in the picture as well as the various little happenings occuring around him. The fact that he carried on working hard, seemingly oblivious to the fact that other people were on holiday, introduced a humorous element. It was one of those situations where you start out photographing one thing but end up doing something else. It is important to be quick-thinking and ready to adapt to a changing scene. Although these are quite commonplace happenings, they can be infused with significance by the

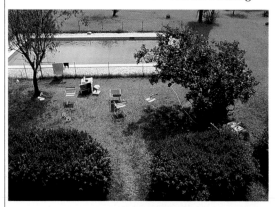

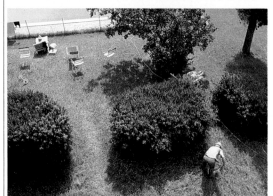

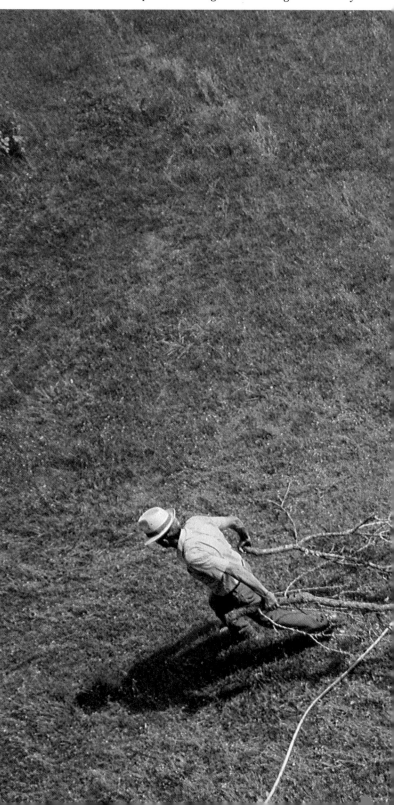

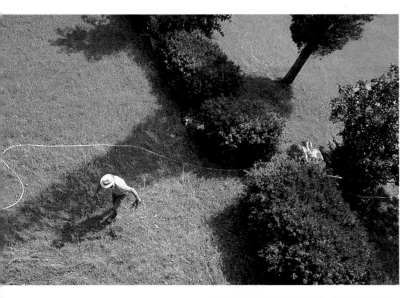

way in which you photograph them. A wide-angle lens is best for shooting moving people in a landscape because you can get them more quickly in focus, as you can the whole landscape around them.

Gloom of the day

Nowadays, with a fast lens and fast film, if you can see it – you can photograph it. These pictures were all taken in fading light; the three white horses in the winter at dusk when it was almost dark.

Because they've been given the correct exposure they have come out clearly; I used 400 ASA film and an aperture of f1.4. The silvation of the shaggy white horses coming out of the gloom has given them an almost phosphorescent quality.

The shot (*opposite*) was also taken several hours after sunset, but there was moonlight. I used 1000 ASA film and the shot is taken at one eighth of a second at f1.4. As I had no tripod, I wedged the camera up against a gatepost to hold it firm for the long exposure needed.

Diagram *In dark conditions, where long exposure is required, the came must be held firm. the absence of a tripod, I wedged th camera against a gatepost.*

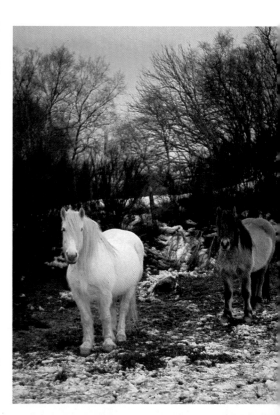

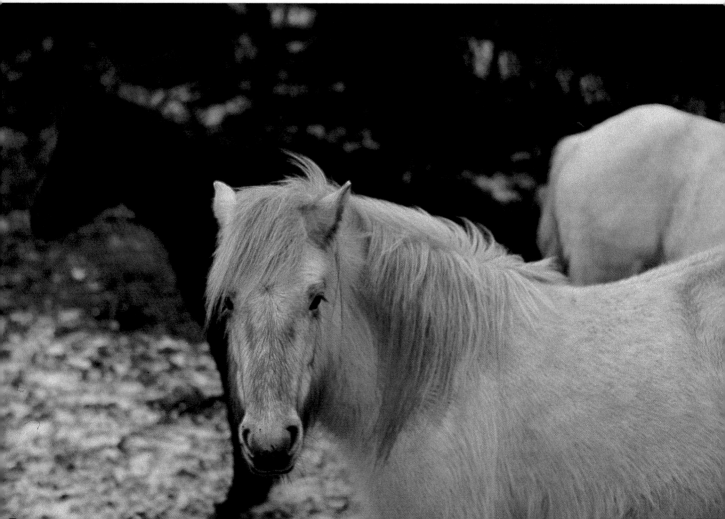

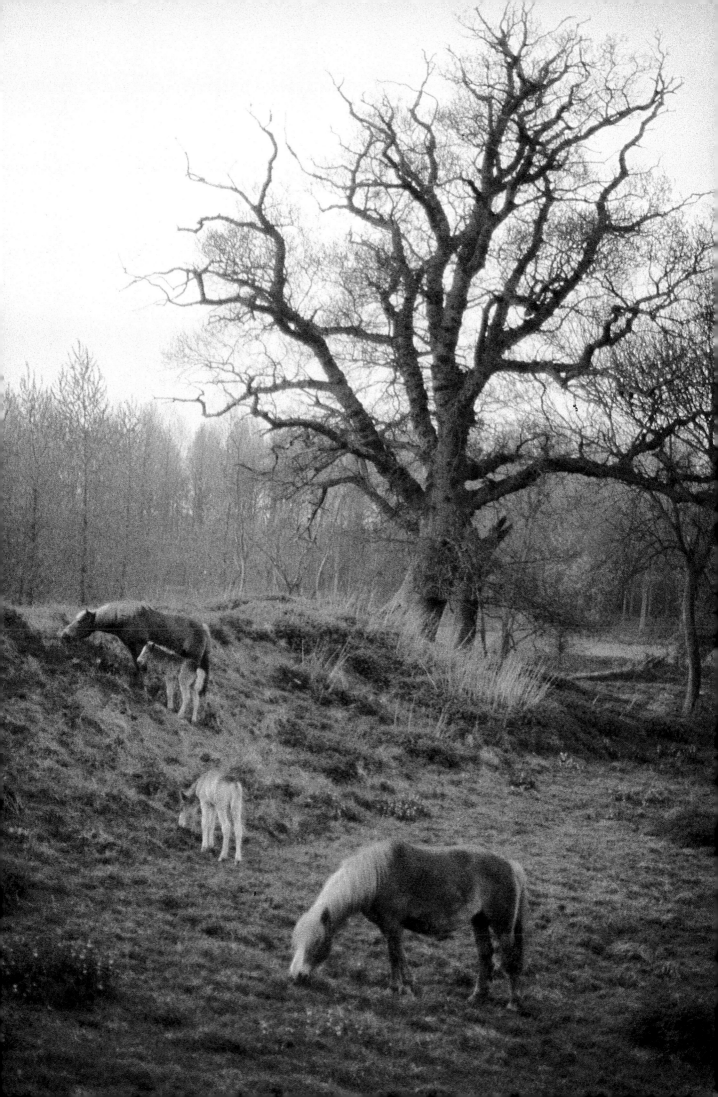

Textural qualities

Rather than capturing texture alone, the photographer can use textural qualities in the way that a sculptor does, with a concern for the tactile surface of things. The peeling paint (*opposite*) was obviously originally flat but, with the erosion that has taken place, the surface has peeled apart, leaving some paint firmly adhering to the door while other areas have curled up into relief. This has produced a surface that is sculptural in effect; some of the relief is as much as an inch deep and the viewer looks at it as he would a carving or collage. Rust marks, stains, wood grain and what were quite bright colours have now mellowed into a patina, giving the effect of looking into a great landscape. Something functional, done for protection and decoration, then broken up by the forces of nature, has now become something of great consideration aesthetically so that the viewer automatically considers it in a different way. Photographing it, thereby isolating it still further, allows its intrinsic beauty to shine forth. Such accidental discoveries can be very exciting.

Diagram *An Acme peg-bar system on a lightbox can achieve the picture,* right.

Right The image has been repeated to create a pattern. This has been done by 'flopping' the transparency over and re-photographing it, getting accurate registration by using a pin-register system.

Below The textural qualities of the Canova sculpture are brought out by using oblique lighting. This rakes across the surface, adding drama to the form.

Enchanted places

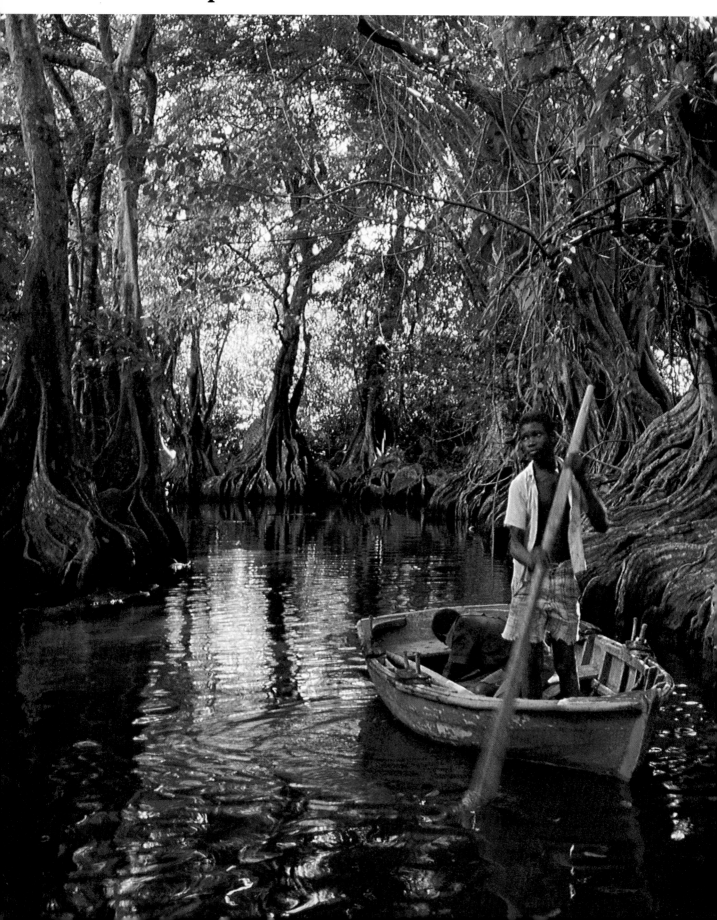

When travelling, it is frustrating to be in a photogenic place with the wrong lens and wrong film, which is why I always carry at least three lenses and a variety of films. Even though this shot was taken in the Caribbean, it required very fast film because it was incredibly dark. It was a secluded hidden place, requiring a wide-angle lens to shoot, and I ended up uprating 400 ASA film and shooting at a thirtieth of a second. Even in the tropics, where one would think fast film is not necessary, the contrast between the highlights and the shadows is so great that you will often use more fast film than in Northern countries.

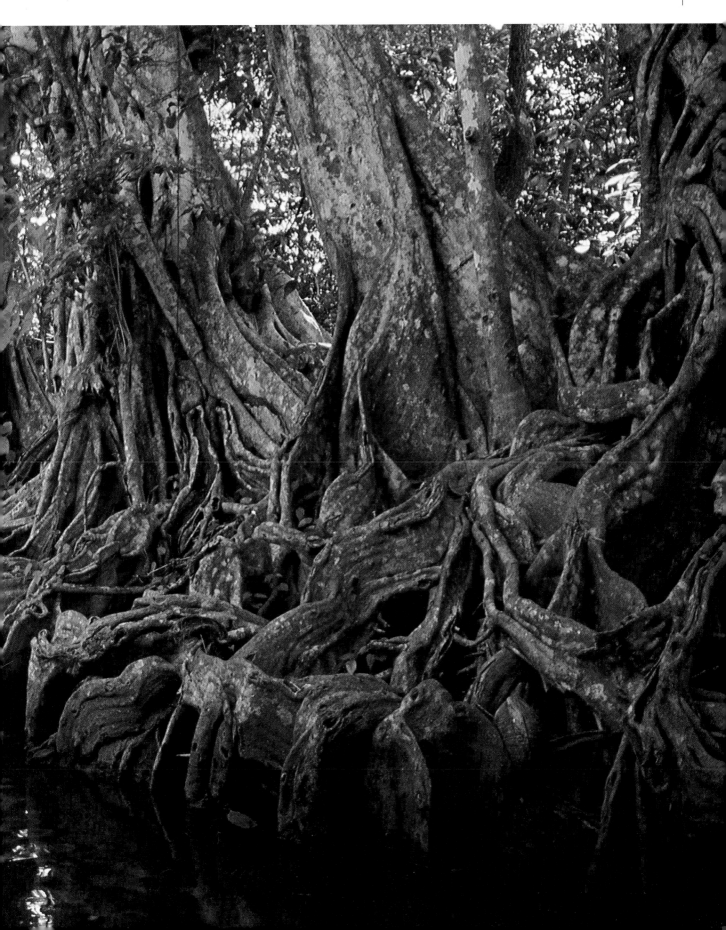

The romance of water

The important thing about water is that it is like the sky, ever-changing, responding to the different seasons of the year. It can be exciting to photograph in early morning and in early evening light, when it has a mirror-like surface and reflects the sky. Water can be the subject of a picture in itself or alternatively, can include an aspect of the land.

Garden designers say that a garden isn't a garden without water to add another dimension, to give the translucent effect of reflected light. These reflections often deceive the eye; objects and features which appear to be at a distance are brought close-up, creating a pattern effect.

Left To distort the straight lines of the reeds at the water's edge, I threw a small stone into the water. Because the reflections only take up a limited area, you need a long lens to capture them – here I used a 135mm lens. What makes the picture work are its strong abstract shapes and purity of line.

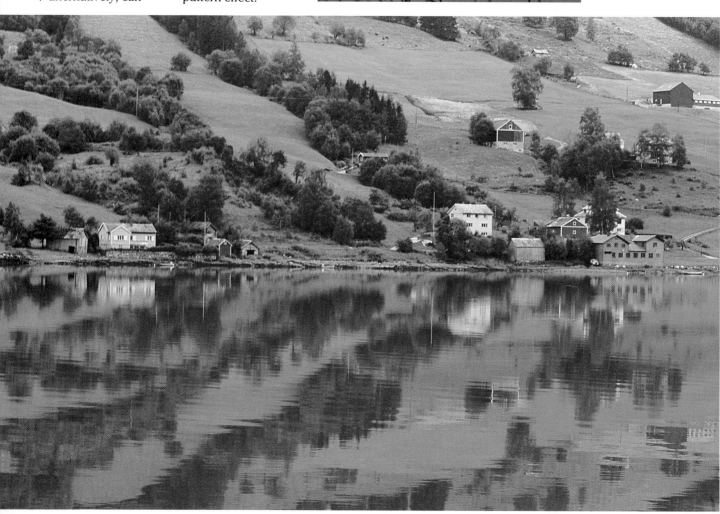

Above These reflections in a Norwegian fjord of a hillside village are so complicated that you look first at the reflection and then begin to look for reality. There is hardly anyone who remains unmoved by reflections in water, for it is like looking into a world beyond.

Here the diagonal lines of the landscape, repeated in their watery reflection, give strength to the composition.

Right In this shot the effect of peacefulness and isolation was paramount, so I used a wide-angle lens to capture the immediacy of being among the waterlilies. I was shooting from another boat and had to move slowly and carefully so as not to disturb the surface of the water.

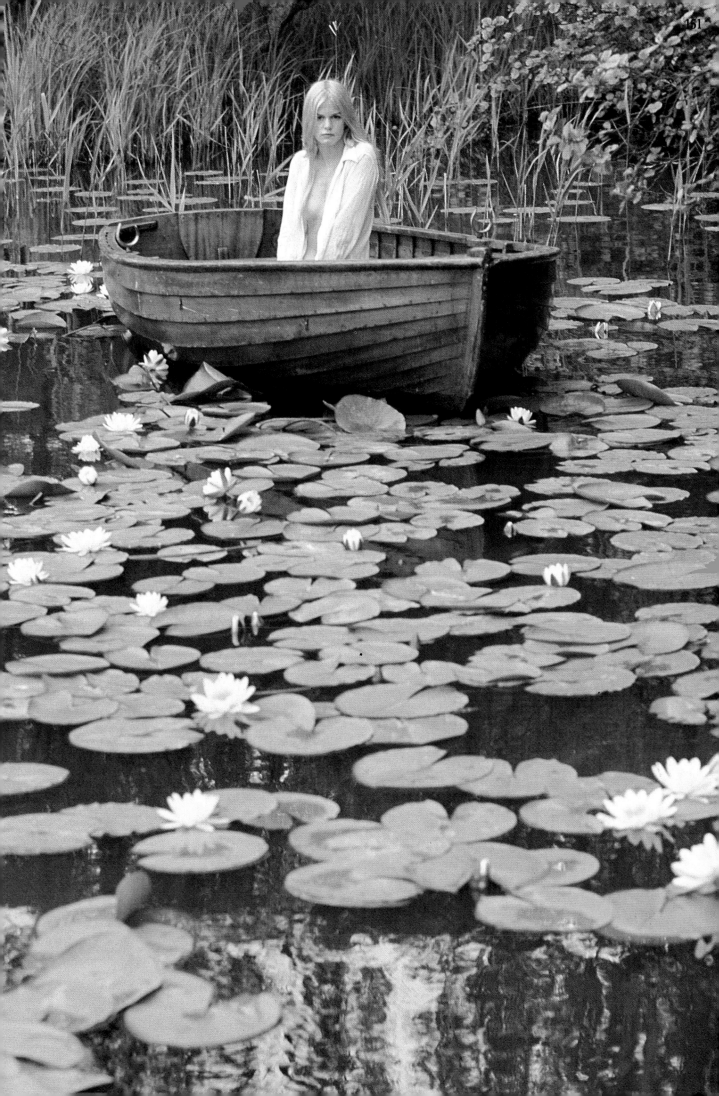

Autumn leaves

Spring and autumn are the most exciting periods of the year for the photographer when the colours of nature are astounding.

For instance, when flowers are freshly picked and arranged they make attractive subjects but it is worth remembering that they are often better after a few days – or even weeks – when they have died and dried up.

The roses (*right*) have been picked and arranged then left to decay, and in the process have changed colour. They have gained a great deal of enrichment in both texture and colour, to give new opportunities for photographs.

In the shot of the boy (*far right*) I was photographing autumn leaves when I saw him with the branches framing his face. He was watching his cat up in the tree. I exposed for the face using the Pentax point-source spot-meter (*see diagram*) to take light readings. I particularly liked the contrast between the mellowing leaves and the innocence of the young boy.

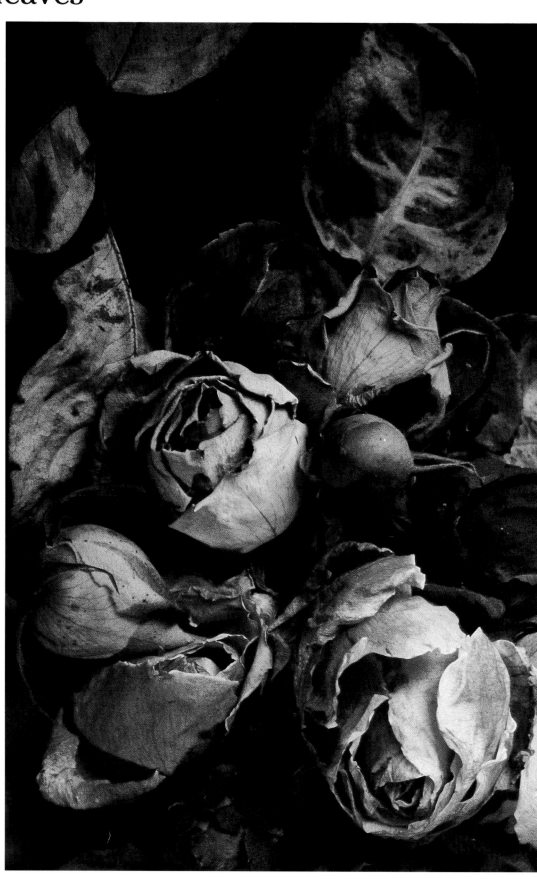

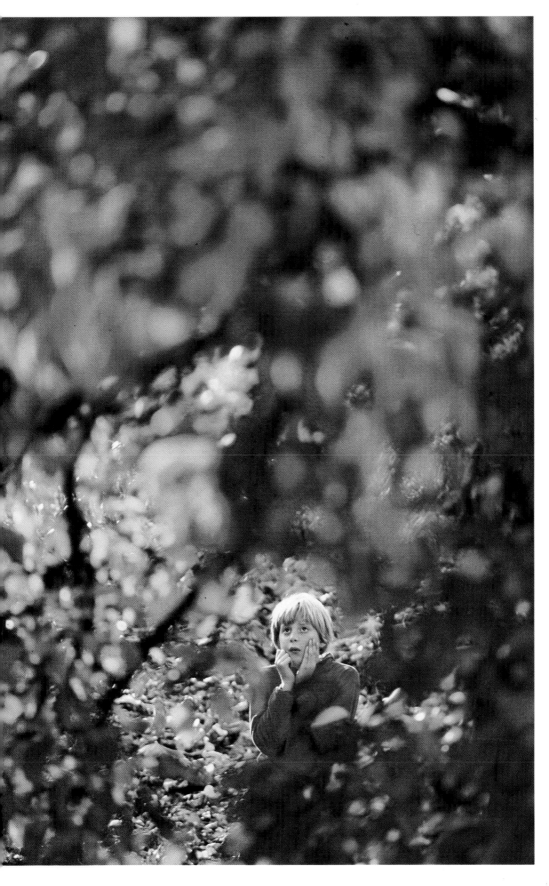

Diagram *Ordinary light meters measure light coming off the subject, while incident readings measure light falling onto the subject. Spot-meters – as in this diagram – measure light from very selective areas.*

Close-up on nature

I often use a 100mm macro lens as it allows close-up photography at a reasonable working distance. A macro lens is a purpose-built and corrected lens that is at its best at close-up. It usually stops down to f32 or f45 so you can give maximum definition: it is best to use it on a tripod with long cable release. Close-ups offer huge areas of interest to photograph with seemingly endless possibilities. One has to compose in such a way to give life and intensity to these magnified images. The danger is that one tends to try to get too much in, and is not sufficiently selective.

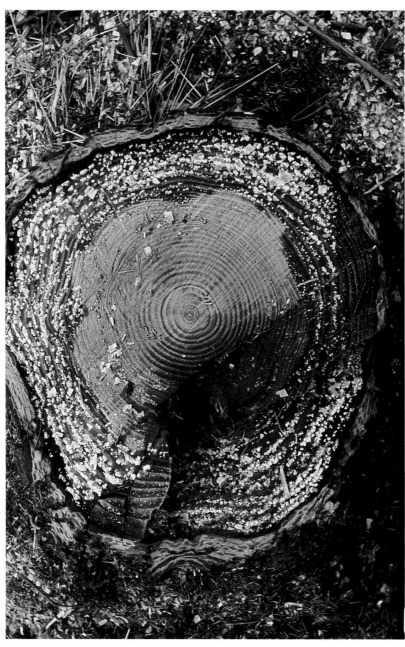

Using a macrolens

When photographing nature in close-up, it is best to have a macro lens and a tripod with an extension arm. Macro lenses are available in focal lengths of 50mm to 200mm, and they focus down to half life-size. The longer macro lenses, 100mm and 200mm, are more useful, in that they allow you to stand further back from the subject, making lighting it easier. The problem in close-up work is the very shallow depth of field, as stopping down with a macro lens very close-up does not improve the picture very much. The focal length and weight of the lens, together with increased lengths of exposure, makes a tripod essential. One with an extension arm that can put the camera directly over the subject is best because it is more stable and so can give you a greater ease of access to your subject.

Using a tripod extension arm, I have got the camera directly above the old tree stump (*far left*) shooting downwards onto the new grass growing out of it.

The shots of cucumber flowers (*left*) show the front and back of the same one – an illustration of the truth that you should assess every view of an interesting plant structure.

Diagram *A tripod with extension arm which can reach out over the subject to be photographed is invaluable in nature photography.*

Fruit and Vegetable

You can make effective still-lifes using only one item, if it is beautifully photographed. Here, a medium-format camera has been used on a tripod to shoot down on the cauliflower and apple, lit by daylight. The cut apple half was allowed to stand for a few minutes to lose its extreme whiteness, which would have presented too great a degree of contrast against the dark pips. A reflector was used to fill-in light.

I used a medium format camera with a 150mm lens stopped down to 32 for maximum definition.

Spring

Spring is a time of rebirth and regeneration, with new leaves and blossom on the trees, all providing opportunities for interesting pictures. It is worth remembering that often one can get better shots of blossom that has fallen on the ground (*top*) than when following through the more obvious idea of shooting it on the tree (*right*). The larger photograph combines a decorative garden seat with a light which rakes across the lawn. The fallen blossom, shot with a 50mm lens, has a more romantic atmosphere than the more straightforward flower study. That close-up was obtained using a macro lens.

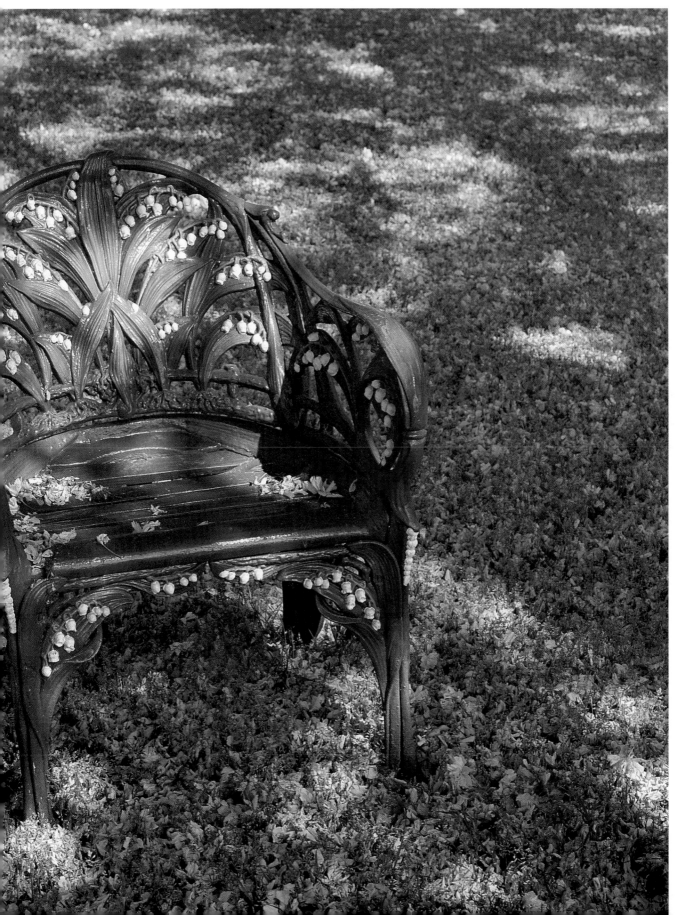

Dramatic landscape

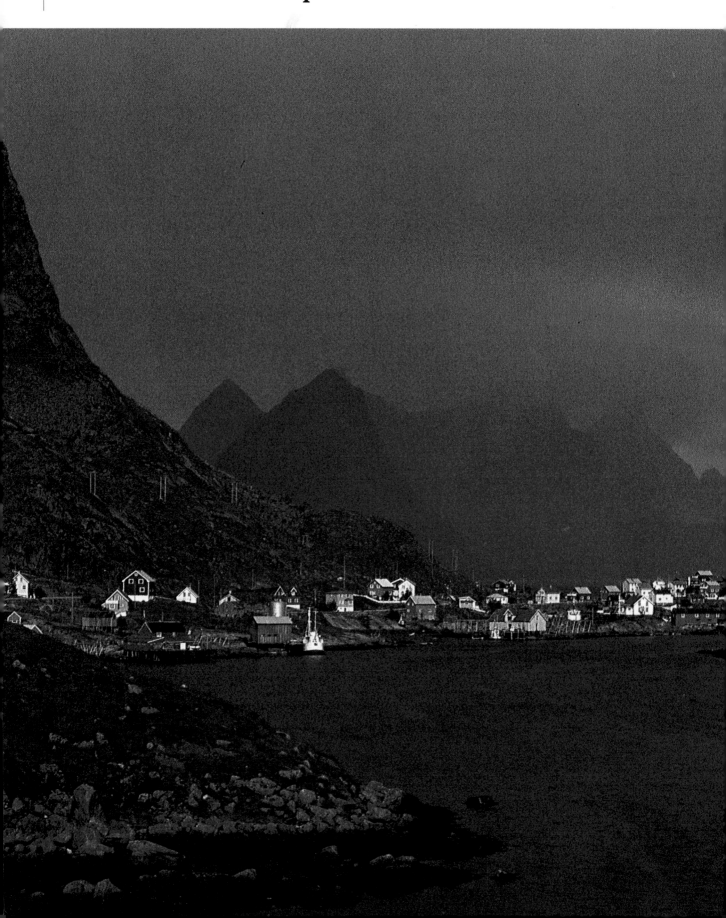

When you get great variation in the sky, from light to very dark, it is good practice to bracket. With exposures of half stops both sides, and using one stop under to one stop over, the results will all be quite good images that vary in drama.

In a situation of summer storms, combining rain and sun together, then you know the likelihood of rainbows appearing is very high. What makes the picture – as here over a Norwegian fjord – is the scenery or background to the rainbow. I've actually driven five miles to find the best setting for a rainbow. They usually last about twenty minutes or so, so you have time to look. Luck favours the prepared mind; it brings the rainbow but *you* must be in a position to capture it where it looks best.

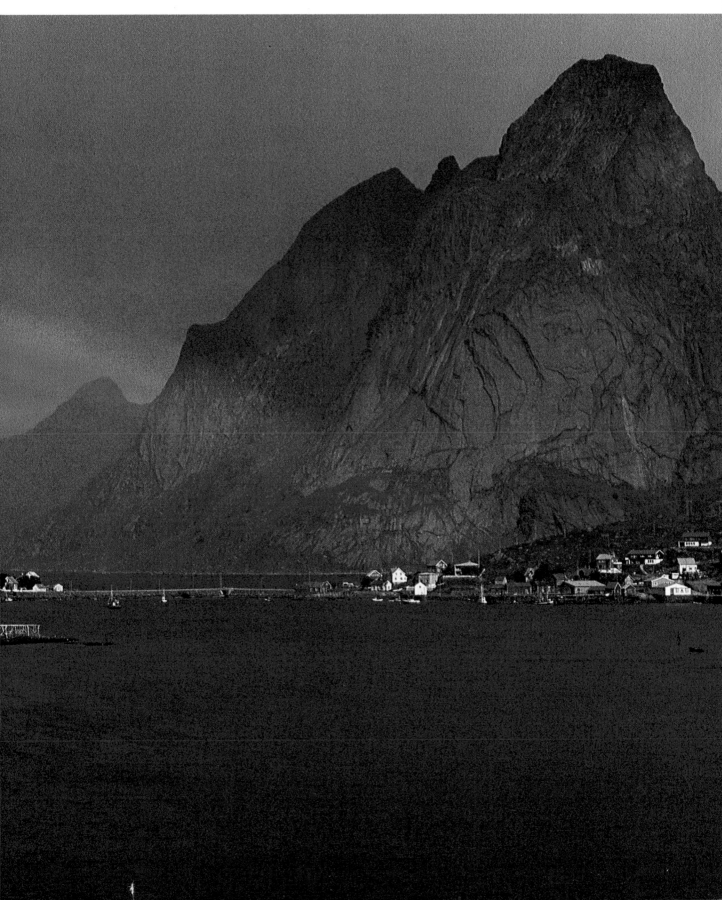

Spanish scenes

Below and centre
These scenes show how quickly the ever-changing light alters the landscape. Changes in the light happen by the second – especially in spring, when you tend to get more wind and the clouds moving across the face of the sun. The shifting shadows cast on the land below create a variety of pictures in terms of form and colour. But you have to work fast for the effects of the fleeting light.

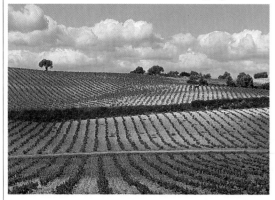

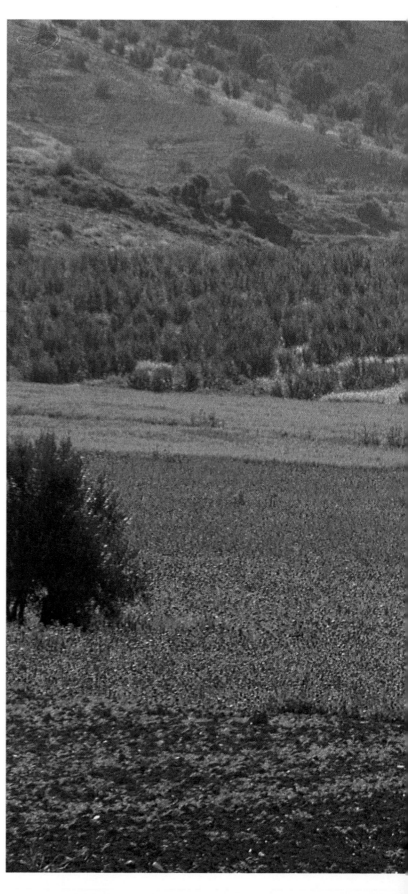

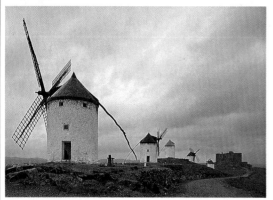

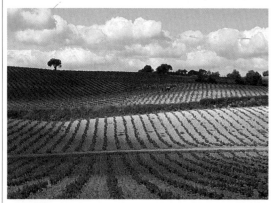

Above By means of the diminishing size of the windmills in this perspective shot, the eye is taken from the nearest to the most distant. A regular pattern like this is a very good way to construct a landscape. Such strong shapes lead the eye into the distance and back again.

Below Taken from a high viewpoint, these poppies are cradled and surrounded by a broad sweep of landscape. When one sees fields of poppies, the general inclination is to do close-ups of the flowers, but I think it a good idea to get back from them also, and do location or placing shots.

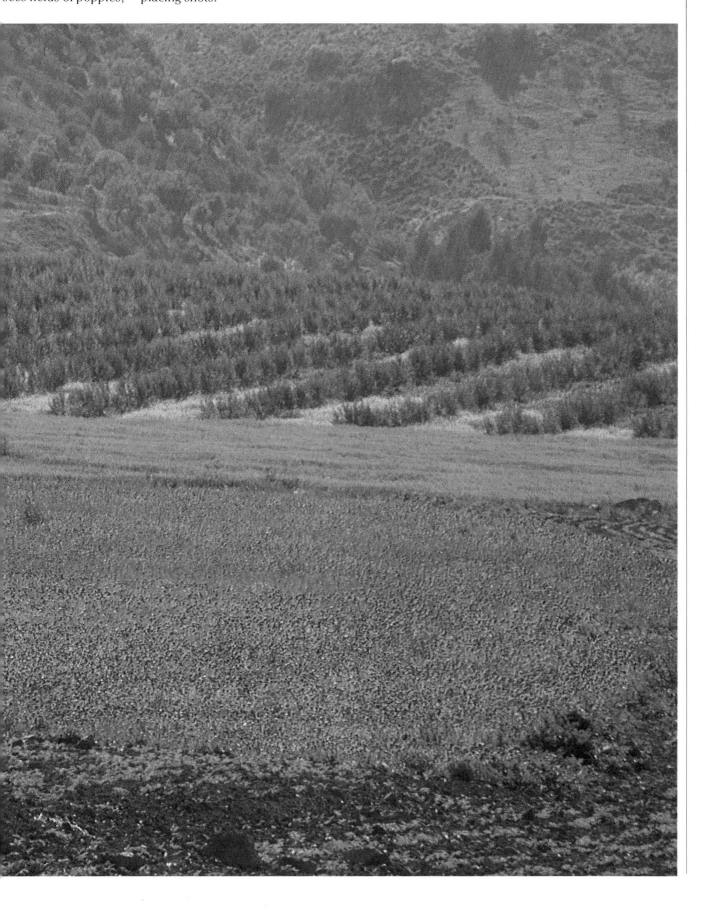

The varying view

Below This road through a wood, made for purely functional reasons, has produced an interesting abstract pattern that also raises questions. Where are the two roads going to? Driving along, you're faced with a decision. Which road? Where do they lead? What will I find there? This makes the picture suggest more than it reveals.

Right A simple shot of a little tree against a stormy sky is equally suggestive. I thought the tree looked like a broom that could be used to clean up the sky.

Opposite The superb colours of the landscape, two weeks after a forest fire in the South of France, indicate the swift regeneration of nature. What was there was destroyed, but it has been replaced by another kind of beauty, composed of stunning, fresh colours, which have brought the landscape alive again very quickly.

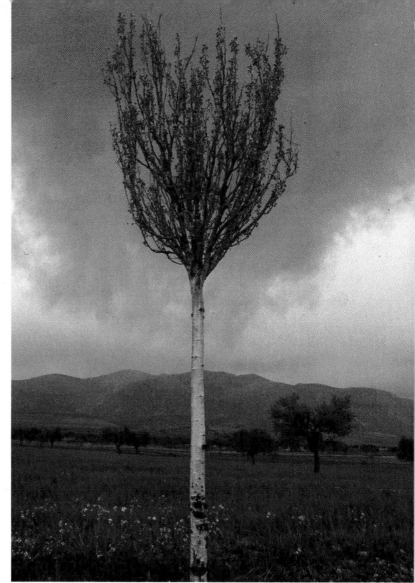

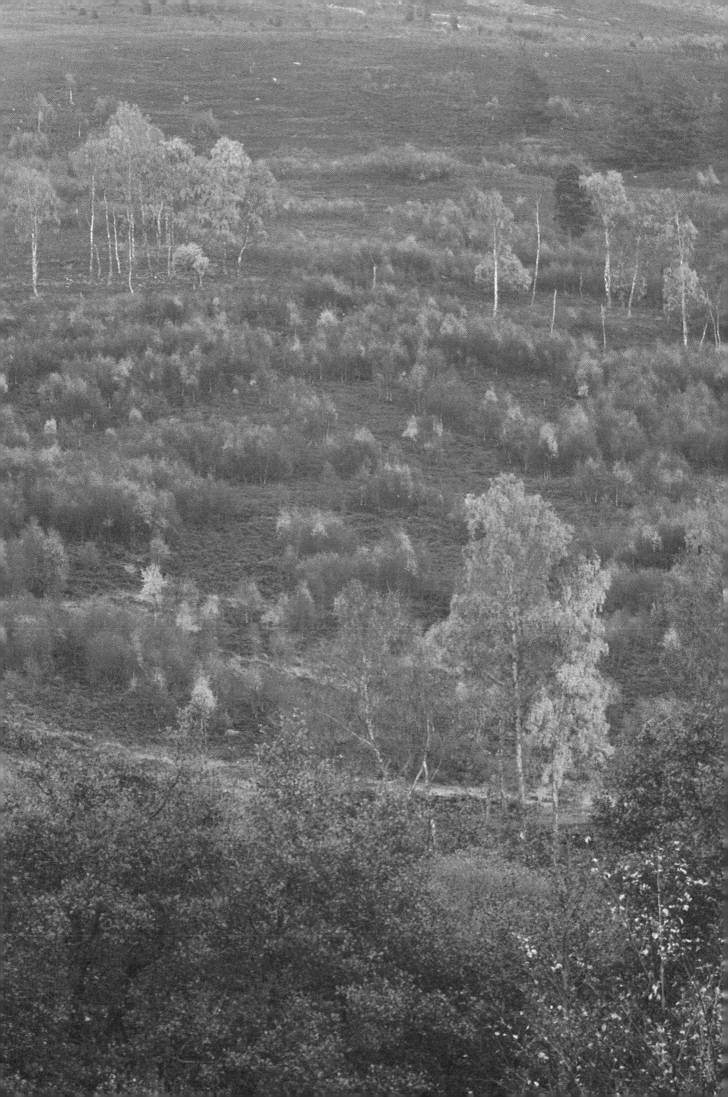

Broad landscape

When contemplating shooting a landscape, remember that, as a rule, the best time of year is the spring. Then the grass is very green and lush, the flowers are out and the sun is still fairly low. It is the season of oblique lighting, which rakes across the surface of the hills and hollows, producing an evocative contrast of light and shadow and bringing out all the richness in scenery. One misconception about landscape photography is that any particular view remains constant, but in England cloudy

skies and wind causes it to change by the second. Wind and weather alter shapes, definition and colours radically, and the photographer has to be quick to judge the right moment to shoot.

Shooting on safari

When taking pictures on safari you can often be more successful by aiming for a definite type of shot at the outset. The fiercer animals make terrific close-ups for which you will need several long lenses. As they more often than not spend their time in the shade, you will need fast lenses and fast film. Fast film, or film that you can uprate, such as Ektachrome, will be essential here because of the extreme contrasts. On safari, I use a conventional telephoto lens rather than a mirror lens (despite the fact that it is lighter) because of the necessity for wider

apertures. For a 35mm camera I would recommend taking a 100mm macro lens, 200mm, 400mm or 500mm telephoto or zoom lens, and a tripod. The best tripod is one with a reversible centre column for swift height changes and independently variable legs to cope with rough terrain. So that reflections do not draw attention to your presence, have all bright parts of your equipment taped or blackened. Make sure your camera doesn't stand in hot sun for any length of time, as the heat will ruin the film. Precautions should also be taken to protect your equipment from both dust and moisture by using plastic bags and silica gel. Most of all, you will need to be able to pan, zoom and focus critically and quickly, often in poor light conditions.

Simple still-life

The way that light strikes objects can make even the most commonplace of them come alive. A simple glass of water placed on a table can become very exciting and enriched in colour, form and texture when it has sunlight streaming through it. I merely had to move the glass about half an inch to balance it within the pattern of shadows and highlights. A 100mm macro lens was used. If you have got the opportunity, use a tripod and stop right down to get maximum depth of field so that the whole shot is in focus and has a professional quality.

Found objects

Everyone collects things: photographing them is just going one step further. For me, anything I'm attracted to – objects I like for their aesthetic value – is inspiring to bring together to create a still-life picture. One aspect of composing a still-life that intrigues me is using things that have been abandoned, to which nature has added a patina – as in these pictures with the old car jack and plumber's crucible found lying around in an old barn. I put them together because their qualities of shape, form and colouring relate to each other. You may discover objects that were originally made to be purely functional, yet you can often create something from them since they usually exhibit an intrinsic beauty.

Left The lighting that I prefer to use in nearly all my still-lifes is what I call 'soft directional light'. This can be supplied by weak direct sunlight or alternatively, it can be simulated by using a diffusing sheet to prevent a harsh light overpowering a subject. Always use a tripod with cable release, and compose through the viewfinder. Here, for the background, I made a mobile plaster copy of an indoor wall so that the photograph could be shot in daylight, in this case the light of the setting sun. The camera was medium format, using 80mm and 120mm lenses and colour reversal film. One can give emphasis to subjects by exposure control – here the exposure is one stop darker than the usual correct stop, in order to emphasize the shapes of the objects.

Below The exposure here is one stop lighter than usual, in order to see the colours and detail in the shadows. After getting the correct exposure for the main subject, always bracket a stop above and a stop below; sometimes I do half stops as well. This allows you to create variations in the colour saturation and enables you to compare subtle differences in the colour changes. With the camera on a tripod it is better to stop down to the maximum depth of field – i.e. 22, 32 or 45 – depending on the aperture of the lenses. If possible, arrange the lighting so that you are shooting at $\frac{1}{15}$th or $\frac{1}{8}$th of a second.

Right Here I have used the 'correct' exposure, although no one exposure can be said to be absolutely correct. Different exposures vary the saturation, each time providing a different expressive effect for the picture. The soft directional light gives form without too much contrast and there is enough 'pick-up' light from the base and the wall to fill in the shadow area.

Adapting still-lifes: 1

When I start to compose a still-life picture, I usually put all the collected objects on a table and place one item in front of the camera. While building up a group, a variety of ideas will occur and, instead of one picture, there will be half a dozen to take. You may start off with one shot, but a couple of hours sees you into something drastically different, developing the theme. Ideas produce ideas, and one should go with them.

The pictures here are very different, but all started off with the checkerboard, plate and mannikin figure. I liked the cloth so used it again. The 'meaning' of these images can be many but usually it is very much up to the viewer.

Adapting still-lifes: 2

The photographer reacts and makes changes while he goes along. What you are looking for is harmony, a combination which suddenly comes to life. A picture, in a sense, that will live outside its frame, that says more about itself because of the interaction of its components. Essentially, the shot should create an emotion, a feeling of nostalgia or strangeness, or an atmosphere which heightens emotion and the viewer's reactions.

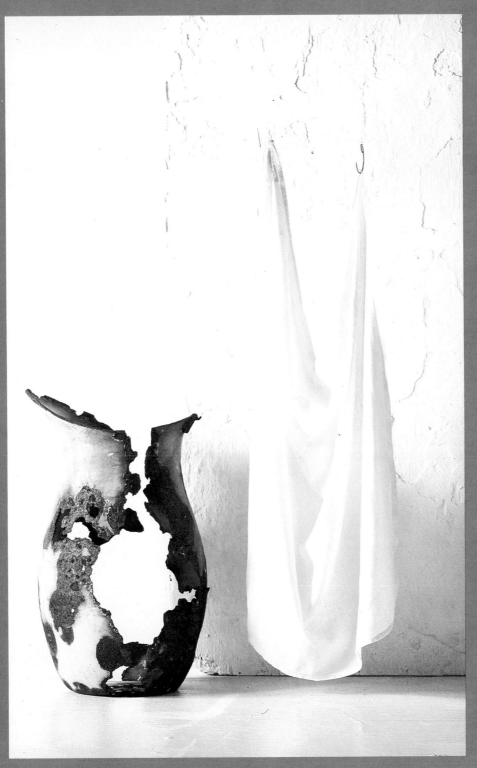

Flowers

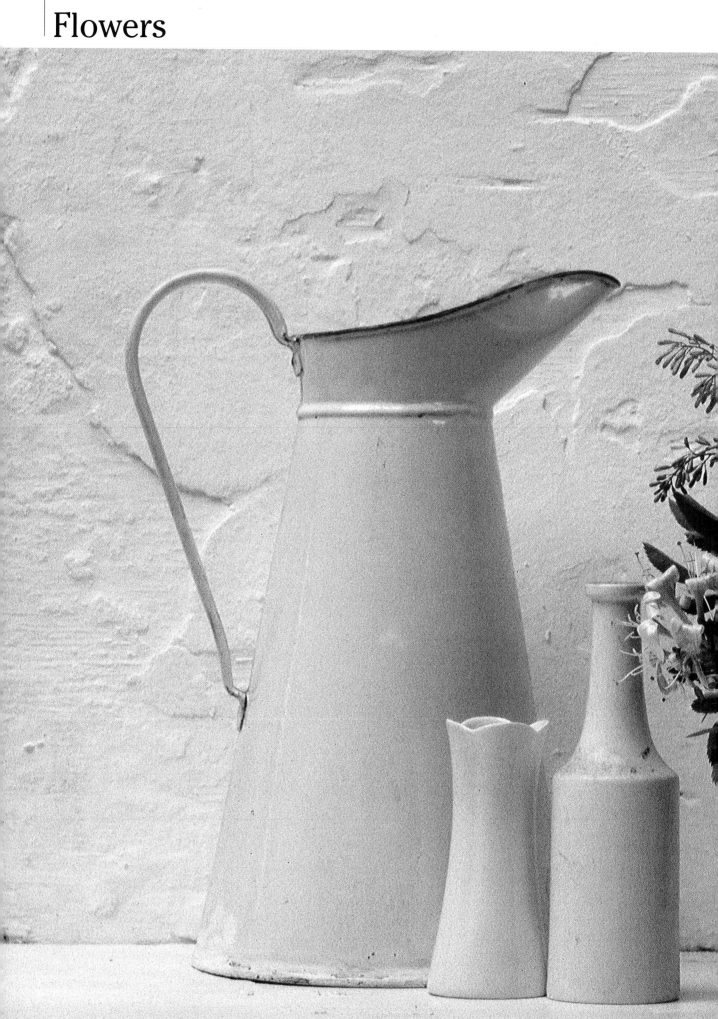

wanted this still-life
f roses to be strongly
tmospheric so I used
ery fast (1000 ASA)
lm with a soft-focus
filter and a 100mm
macro lens. It was
taken in fairly weak
light, so it required a
long exposure. My
intention was that,
when enlarged, the
colour base would
open up to give a
grainy effect.
I used the jug and
vases to accentuate
the strong silhouettes
made by the flowers
themselves.

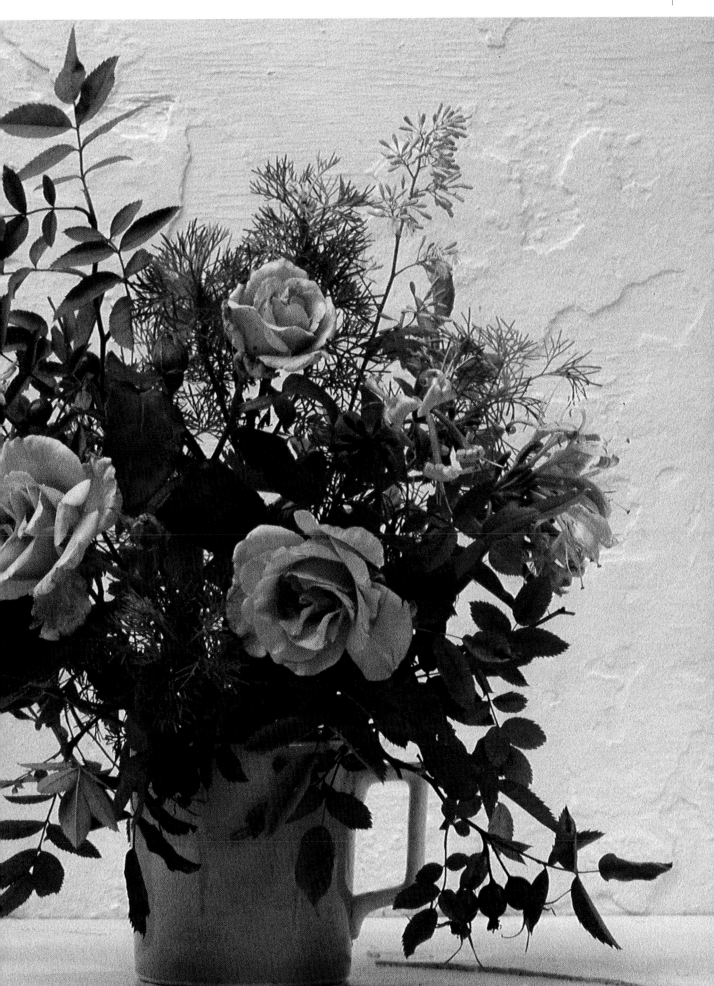

Colour themes in still-life

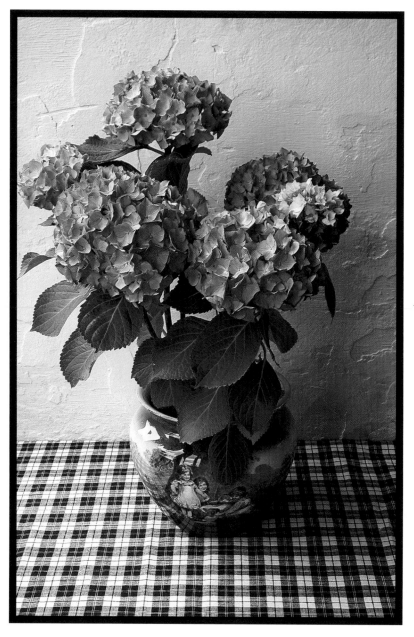

Above These still-life elements are all in shades of blue – blue flowers, blue pot, blue background, blue cloth – with them I've tried to compose a harmonious group. But it's not a monochromatic picture: the use of restricted colours actually gives it its own strength.

Right and above The bright colours of the Art Deco pots and flowers have dictated the colour themes in these photographs. I created the backdrop in the sunflowers to be like an abstract painting by using torn pieces of coloured paper; this was a deliberate attempt to get away from sunflowers as represented by Van Gogh. If you use your ingenuity, you don't have to have expensive backgrounds. The colours of the chosen objects will often dictate a backdrop in keeping with the theme.

Details and decay

Some of the most absorbing still-life subjects to photograph are objects which are well used and have weathered. They show the passage of life and time and therefore have a lot of character. They can also be aesthetically very beautiful, especially in close-up. Once you have found such a subject, the photographic possibilities are inexhaustible. A shot may reveal both interesting abstract patterns on the items being photographed, and a great deal about their history. These still-life pictures evoke a real sense of atmosphere. It is easy for anyone to use them as a starting point to tell a story, to provoke the imagination and thought. And that is all one can ask from any picture.

Above This close-up shot is of peeling paint on boats, taken with a 135mm lens on an Olympus. The layers upon layers of paint show that every year the boats have been painted a different colour. It is the subsequent neglect which reveals evidence of this annual attention, received at the start of every holiday season. Because the boats are weathered, normally discordant colours work together. Although an almost abstract composition, the subjects are immediately recognizable, and also suggest their own story.

Left This torn poster has started a whole new life since someone went to the trouble of drawing in a simple face where the original one had been. What started out as a serious fashion poster has been transfigured into a humorous semblance of its former self.

Right Although decayed, these tulips have not lost their beauty but found a new one. I used a medium format camera and reflected daylight to light these formal flowers in a formal setting, producing a soft, even light. The narrative they suggest is that their owner has been away for some weeks perhaps, allowing the flowers to die and the petals to fall. The stark skeletons of stem and stamens, not usually seen unprotected by the petals, reveal a surprising beauty.

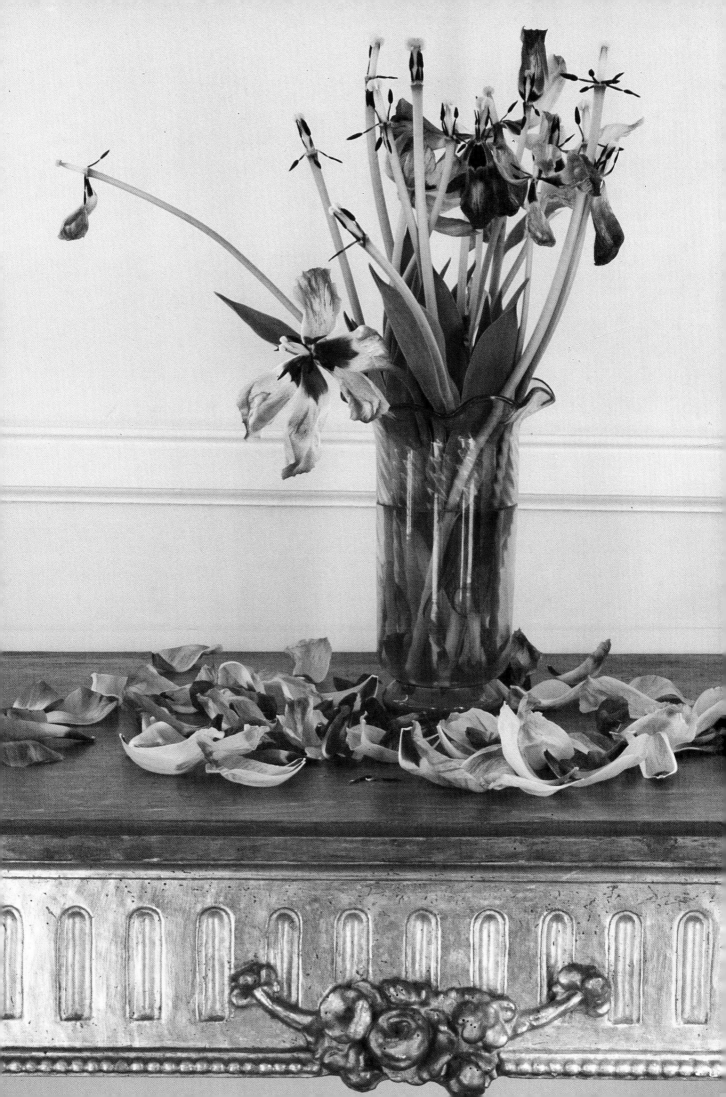

Creating atmosphere with long exposures and fast film

To create these atmospheric still-life pictures I used fast film and long exposures in fading – almost obscure – daylight. The flowers in the patterned vase (*below*) were taken with 1000 ASA film and the group with the portrait head (*right*) with 400 ASA. Both films give a hazy, grainy effect to the pictures. Teamed with long exposures, the camera mounted on a tripod, this technique gives a soft delicate atmosphere making the photographs more than a straightforward record of the still-life groups. The results are mysterious and intended to stir the imagination.

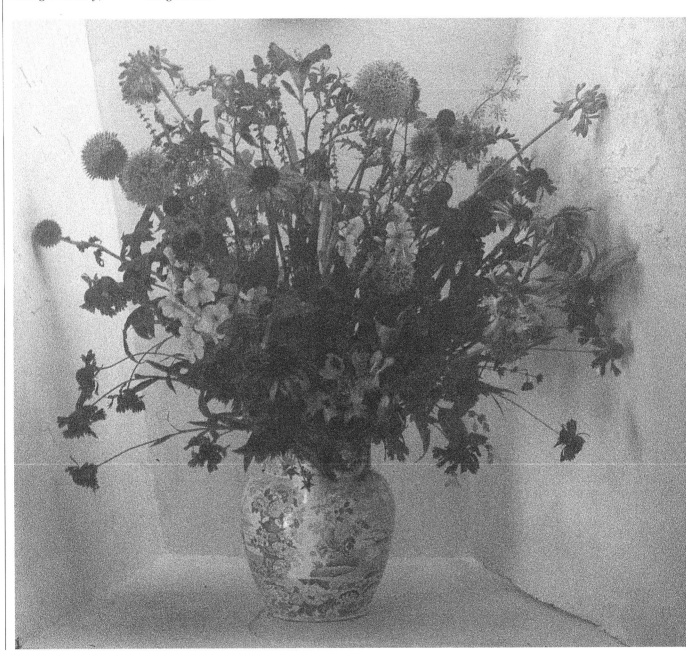

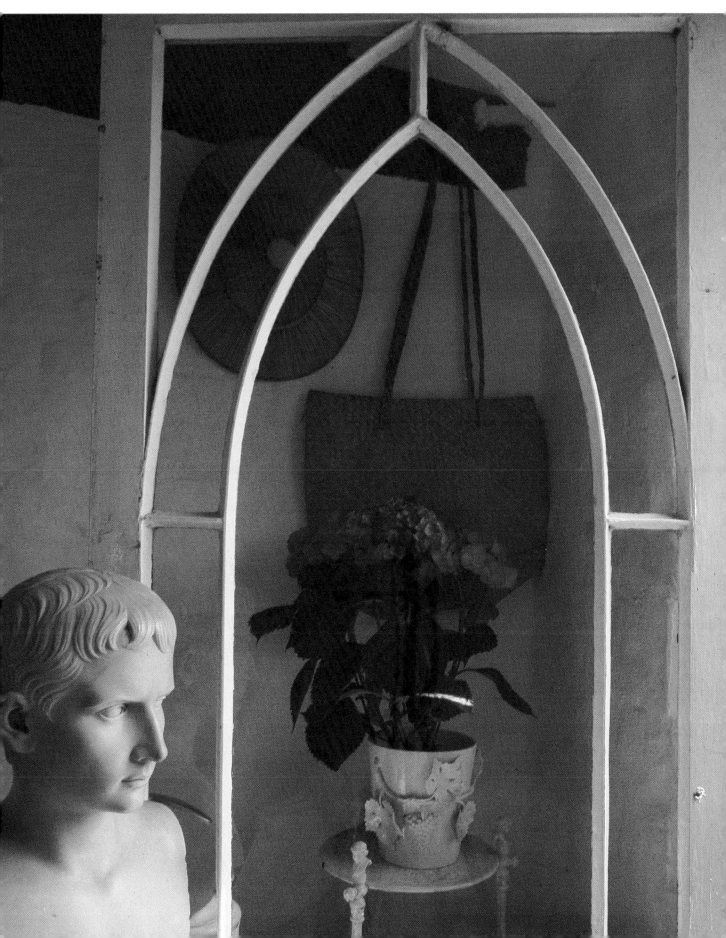

Black boots

I came across this old pair of boots lying on a wall, while on holiday in Tuscany. The early morning light wasn't very good but I judged that at eleven the next morning it would be how I wanted it – stronger and harsher. If I'd taken the picture when I saw it, it would have been very soft, but I saw the boots as rather strong and chunky, and this meant that I needed the appropriate light. Even with simple still-lifes it is important to suit the light requirements to the subject, by judging when the light will be best. I used a tripod and 100mm macro lens.

Window on dolls

The curiosities that are often to be seen in shop windows can make superb found still-lifes if you have an eye for a picture. Of course, you will not be able to rearrange a shop window so exact framing is essential. As you will be shooting through glass, you must be very careful to avoid reflections. These shots were taken through a shop window in existing light with a hand-held camera at open aperture. The film I chose was 400 ASA daylight film as there is little available light when shooting into a shop window. It is also mixed lighting – daylight and tungsten. This can give an orange cast, which is acceptable so long as it is not too strong. These dolls are good subjects because they have a lot of character about them. When you come across such a find, it is worth taking time to make a series of pictures. Go inside the shop and ask if you can take pictures in there, too. Usually people with a passion for their subject, are delighted if you show an interest. Fast film and a standard lens and hand-held camera are all you require.

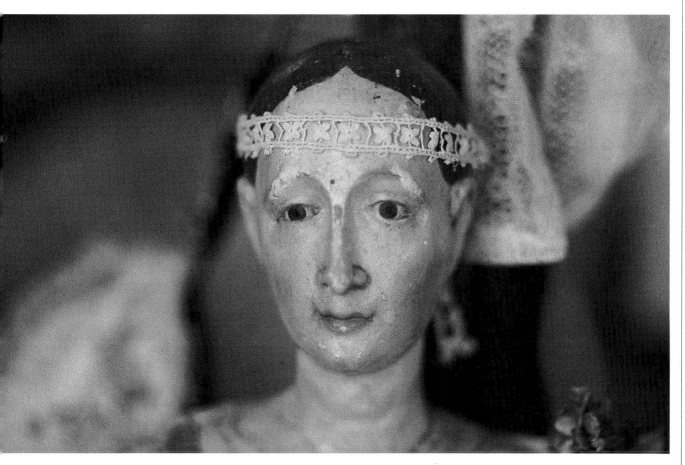

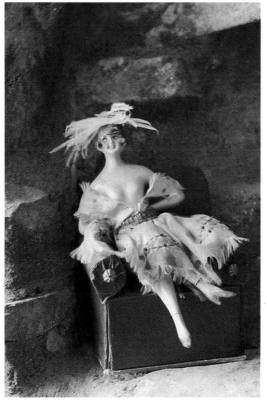

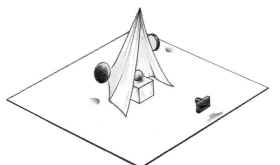

Diagram *A light tent made of muslin, constructed between the still-life group and the lights will soften the glare and reduce reflections.*

The busy still-life

For the busy still-life to work you must have a strong idea of its main theme. When photographing collections of objects for still-life pictures – for albums or to record for insurance purposes – it is a good idea to provide some sort of uniformity by using a neutral background. Shades of grey and brown are best; the background should not overpower the objects. You will need even, balanced lighting (*see diagram*) and you must make sure that the camera is absolutely square and lined-up. Exposure can be done using a mid-grey card. Always use a tripod and cable release, set up on a firm table or bench, positioned so that it can be lit from all sides. View the group constantly through the viewfinder. A longer lens is best – 100mm or 135mm – as it gives you space between the subject and the camera to get the light in, which can be electronic flash or daylight. Lighting is crucial for identifying

objects, and soft, shadowless, diffused light is the most effective. If more contrast is needed, directional light will add drama to form and texture; adding a spotlight will allow precise control over shadows and highlights. However, the overall effect should suggest only one light source for the photograph.

Left For this still-life group I arranged several exotic butterflies on a wooden surface, using a 5 x 4in (12.5 x 10cm) MPP camera on a tripod with Ektachrome 160 film. To obtain the diffused and even lighting on the group, I used four photoflood lights which were bounced off a white ceiling.

Above To photograph the badges I made a light tent, which is always useful for softening highly-polished surfaces that might reflect too much. Light tents can be made from muslin or tissue paper. Here I used a 100mm lens on a 35mm camera.

Right In this collection of Victoriana no one item takes prominence. To create the diffused light, greaseproof paper has been placed over a window – through which the sunlight was streaming – on one side of the set-up, and a white card reflector used on the other side to give detail. The 5 x 4in (12.5 x 10cm) MPP camera on a tripod was positioned to shoot downwards.

Constructing a still-life

It's often great fun to photograph still-lifes that are in fact very complicated to produce but look quite straightforward. Alternatively, still-lifes which look complex, but are very simple to do can also be rewarding. Below is an example of a difficult shot and on the right, an easy one.

Below I wanted to show the different wine glasses together with a pink rose in close-up, the whole in different shades of red and pink. The problem was that most glasses are all much the same height. So I constructed a stepped platform to control the height of the glasses and stuck the rose on a wired stand. Glass tends to reflect things, so the lighting is kept simple – daylight with a reflector. Wine itself photographs quite dark, so it had to be watered down quite a bit to get the correct shade of pink.

Diagram *A bracket holds the plate up against the wall and bluetack holds the watch against the plate.*

Opposite In this group, the plate is sitting on a bracket coming out of the wall; I shot downwards so it wouldn't show. The oversized watch – in fact a clockmaker's shopsign – leans against it, with blu-tack holding it in place. I chose a six-sided plate because I didn't want another circle in the picture. At a glassworks I got the bottle cut in half, filled it with orange liquid and sealed it with plastic and glue. Under straightforward lighting – top and frontal North light – it becomes a strong image. The effect is one of defying gravity. Although it looks hard to achieve, it was in fact very easy to construct and shoot, yet it has the look of a sophisticated advertisement.

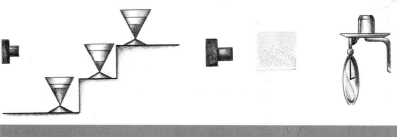

Creating a theme

These portraits of village children were all taken in Gambia. All of them had asked for their pictures to be taken. I pinned up two small tablecloths for backdrops on a wall and created a photographer's studio in the open. Using a 135mm lens and camera on a tripod I photographed their beautiful heads, some wearing extraordinary hats. The two coloured areas of the backdrops are essential for brightness as some of the portraits are virtually silhouettes.

Out of a simple idea has come a theme of twelve pictures: a series of shots like this is very quick to do and can be done with anything or anybody.

Variations on a theme are good practice for a photographer. Such a series can show you which elements are needed to make the most satisfying portraits – and this will develop your photographer's eye.

Positioning in the frame

Although there are some rules in composition about positioning in the frame and relating subjects to the background, they should not be adhered to too closely, but used as guidelines. For instance, it is a fact that a centrally placed subject does have its energy restricted. There is no need to position things symmetrically – it's really a matter of judgement of balance and proportion. By odd and disquieting juxtaposition, an energy can be brought to the most boring of images.

Top left Here I wanted to show the room and one's view of the scene by having the two girls looking out. In reality the top girl is standing on a chair to give height. It is often necessary to go to extremes to obtain the appearance of normality. The girls are linked by the frame of the window; the eye is drawn to the highlight and then does a circular route around the picture.

Centre left Pattern usually destroys form, but the strong diagonal line of the composition complements the girl in the harlequin outfit, leading from one corner of the picture to the other and holding it firmly together.

Bottom left This portrait of a baby includes a very strong compositional device, being in the shape of a cross with its diagonal thrust across it. One first sees the strength and roundness of the body, then the texture and quality of the fabrics, and then the chubby face.

Top right Just half a face, which is so symmetrical that it tells you about the whole face, creates a more arresting picture.

Above right A girl leaning forward out of the darkness makes the picture more alive.

Below right The portrait of the three girls is united by an overall grey-blue colour background, and by the way the heads are arranged in perspective, making a pyramid of diminishing sizes.

Bottom right In this portrait of John Piper, I'm trying to give his work equal prominence. By harmonizing the colours I've united the man and one of his paintings together in a formal way, making the picture easy on the eye.

Opposite The shape of the model gives the picture its thrust; strong diagonal/ parallel lines of legs and back create force and energy across the picture surface.

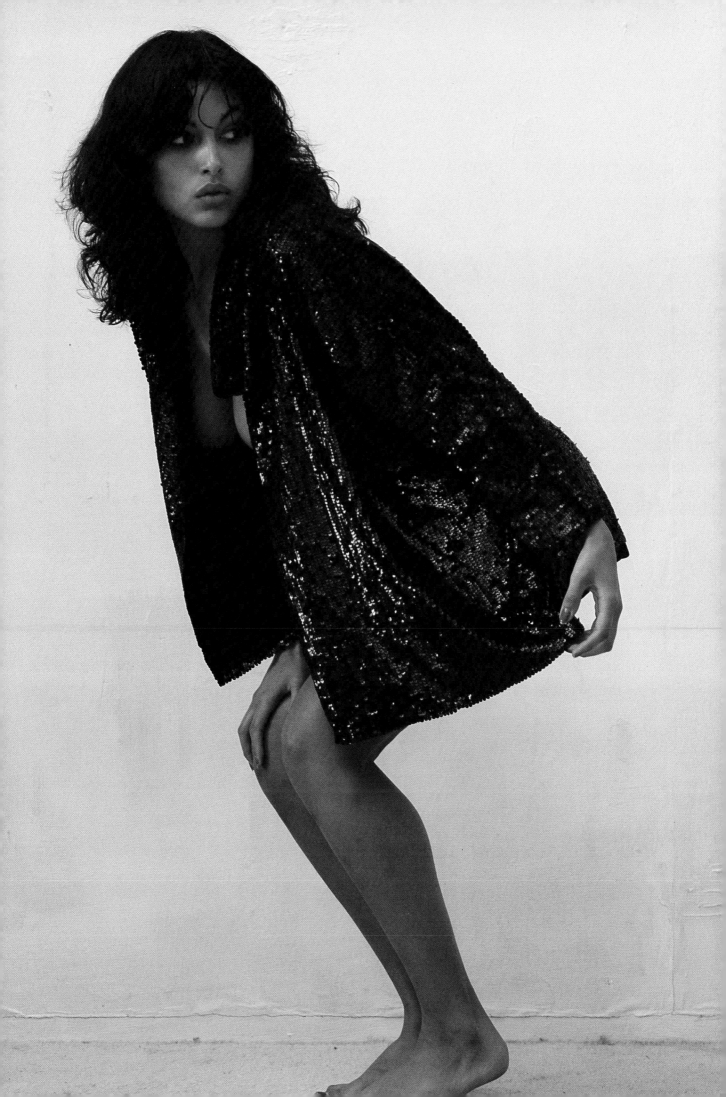

Abstract shapes

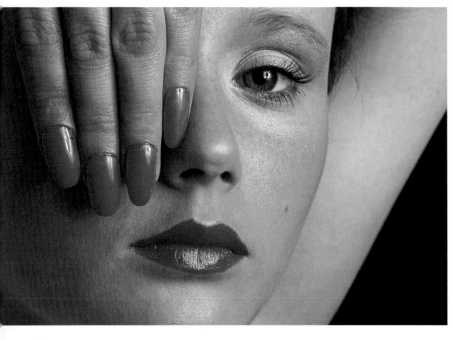

In photographing the human body it is often amusing to isolate parts of it, achieving arresting pictures which can be either bizarre or straightforward. If one finds a good model (dancers make the best models for this) they will create the shapes for you. It's usually best to use a long lens and overall lighting and select areas which are both confusing but recognizable. This will guarantee an

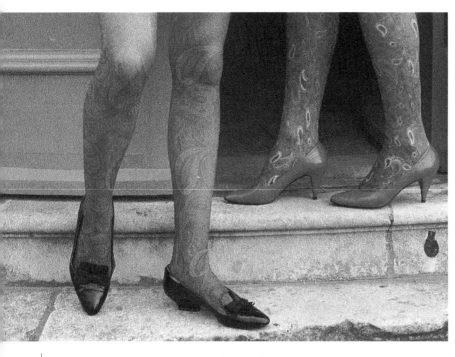

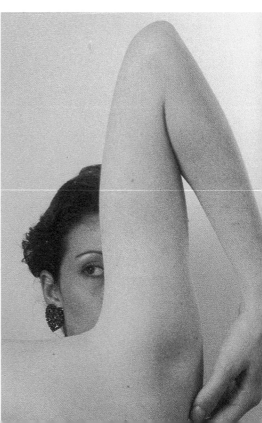

impact. The number of shapes that can be produced are inexhaustible. You can do sectional areas – eyes, nose, hands or a combination of features – to produce innumerable shots of abstract shapes and colour. The excitement – like creating a painting – lies in experimenting, in not knowing what you will end up with.

Deliberate underexposure

By deliberately underexposing, one increases the colour saturation, thereby producing richer colours. This makes it a technique well worth cultivating. During a photo session, when I've taken the pictures I'm after, I often then experiment by shooting at different angles with a variety of lenses. I also try to vary the exposure quite a bit, particularly if the subject is one that can be enriched. A quite ordinary subject, emerging from a darker background, is given an 'edge' it would not normally have.

Underexposure by as much as two stops adds a sense of mystery and excitement to the subject, which in the half-light triggers the imagination into believing that anything might happen. The girl in the chair (*right*) is two stops underexposed and the face (*below*) is one stop underexposed, both using reversal film. It would be the other way round if you used negative film.

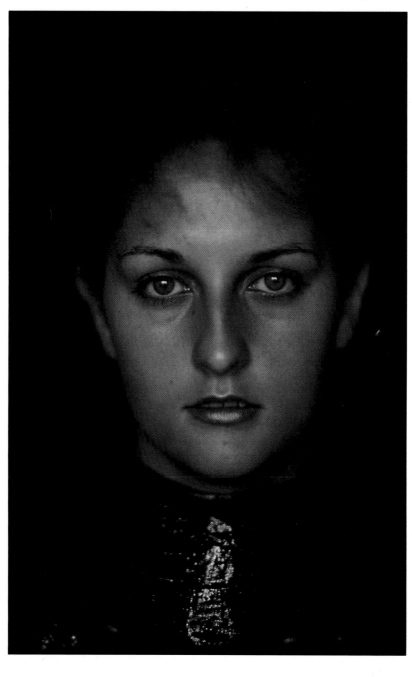

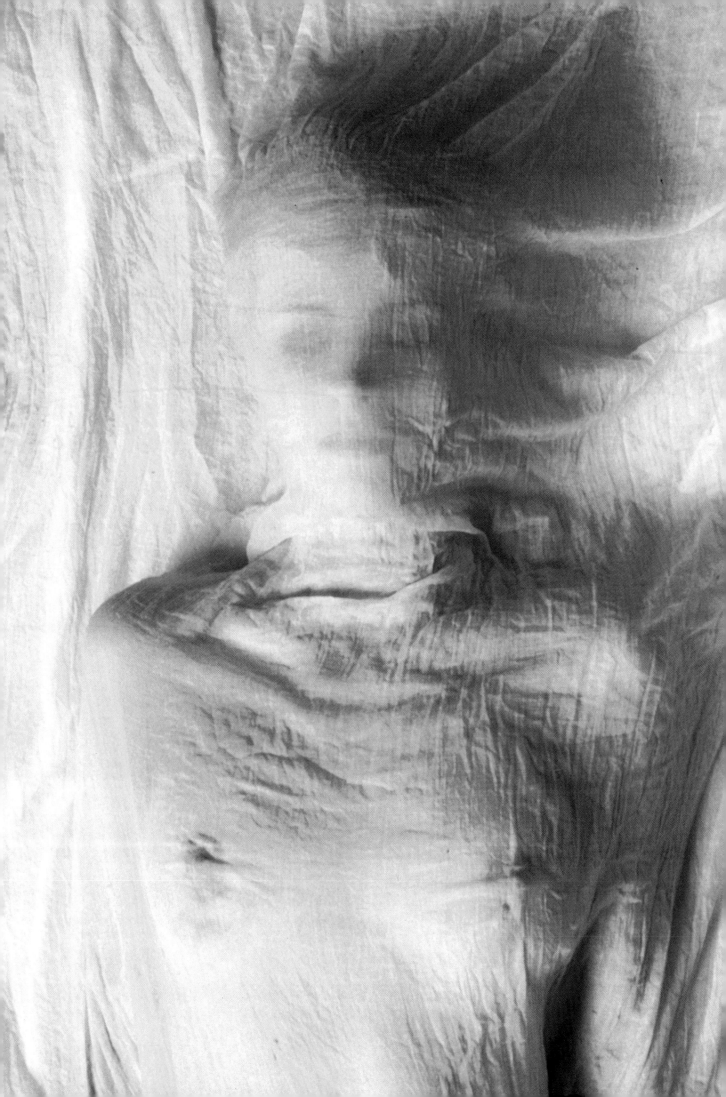

The contrived background

Whether you are doing set portraits or pictures of friends, there is always a background to be taken into consideration, too. Often it is the background that can make a picture. It can certainly give you ideas – perhaps some garment the model is wearing or an interesting found background will inspire you. When such notions strike, give them your attention, because it will affect the way you view your subjects. Every element in the picture should support the subject and, though the background should not overpower the central subject or model, it should reinforce and strengthen the picture.

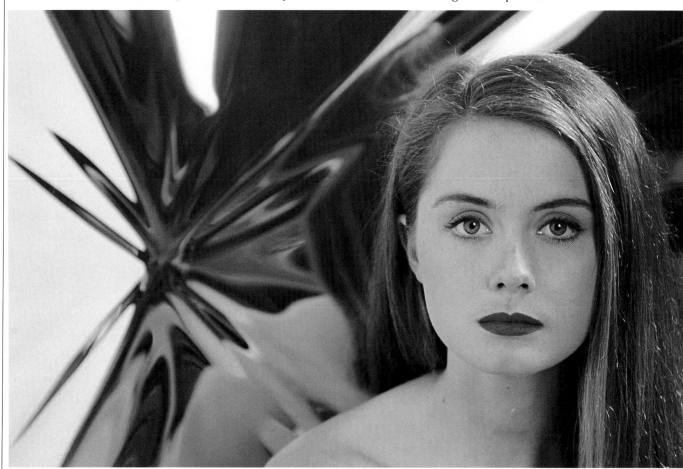

Above This simple picture was created by leaning a plastic mirror reflector against the model's chair, producing these star shapes and light and dark reflections, which I photographed in a soft light.

Left and right Both of these shots incorporate a hand-painted background inspired by the clothes of the model. In the large photo I was able to create a double image by using a mirror.

Below I've chosen the sympathetic background of a palm for this portrait of a girl dressed and painted as a harlequin for the Rio Carnival in Brazil. Its colour sets off the flowers in her hair and the shapes painted on her face.

Refraction in water

Below The exotic feel of the setting creates its own presence in these pictures. In such a situation I try to use imagery that does not detract from the setting and poses that harmonize with it. Because this figure is underwater, it is distorted by refraction.

Right Here water is used as a foil, and the figure's distorted pose echoes the refraction of the water. Both this and the photo below were taken with a wide-angle lens.

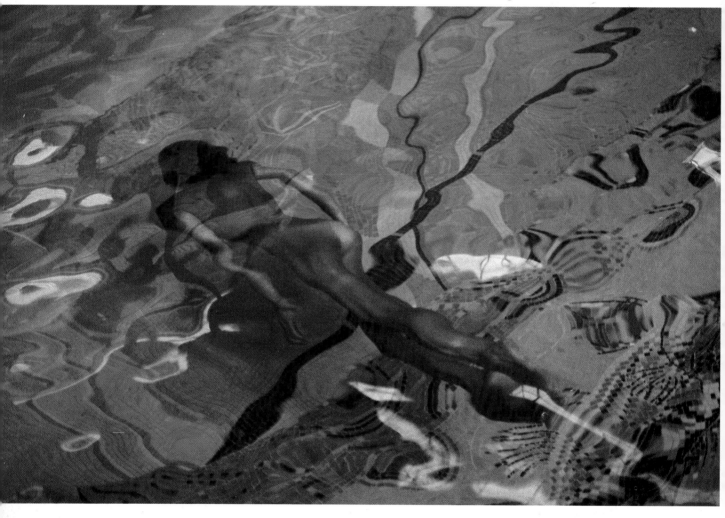

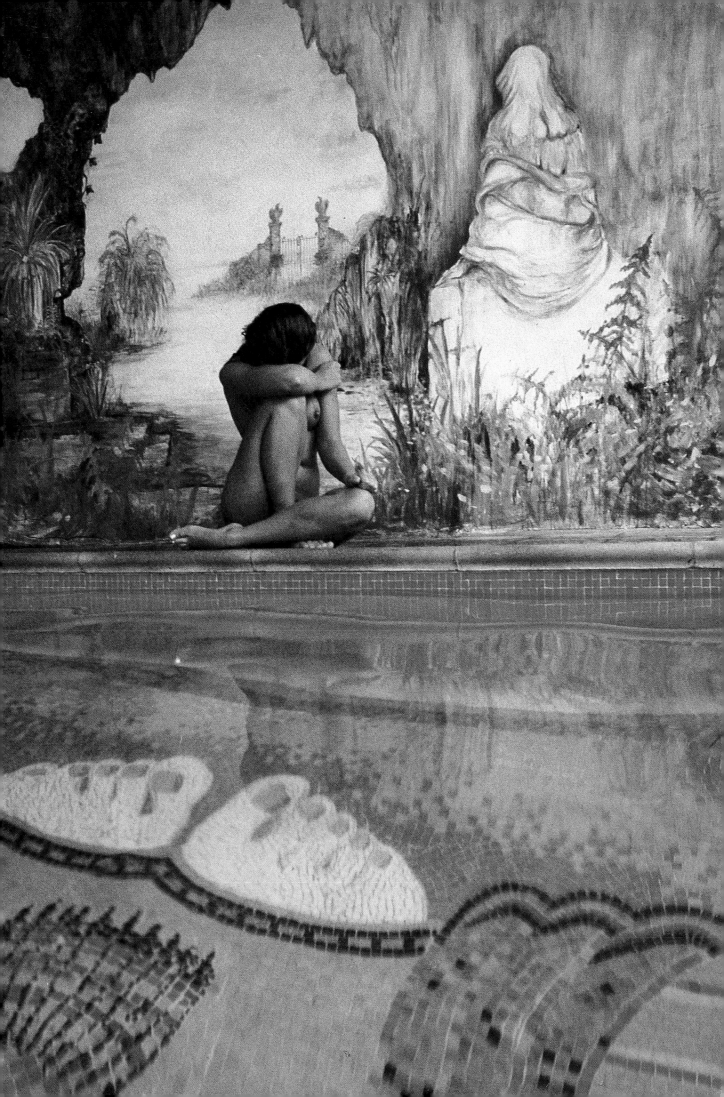

High speed, slow speed

You can shoot at both high speed and slow speed to capture movement, depending on the effect you wish to convey. Here, the girl in the sea (*below*) was shot at a thousandth of a second to capture both the feeling of ferocious waves and her expression. But a slow speed, a thirtieth of a second, was used to convey the pattern of movements of the pigeons being released (*right*). This could have been shot at a sixtieth of a second to arrest the moving images a little more, so you would see more of the pigeons and less of their movement, but that's a matter of judgement and taste. There is a choice, and it is up to the photographer to decide how he wants to express movement. If I'd taken the sea picture at a slower speed there would not have been the feeling of pounding waves. In the pigeons shot, if action had been frozen by shooting at high speed, you would have lost all sense of movement.

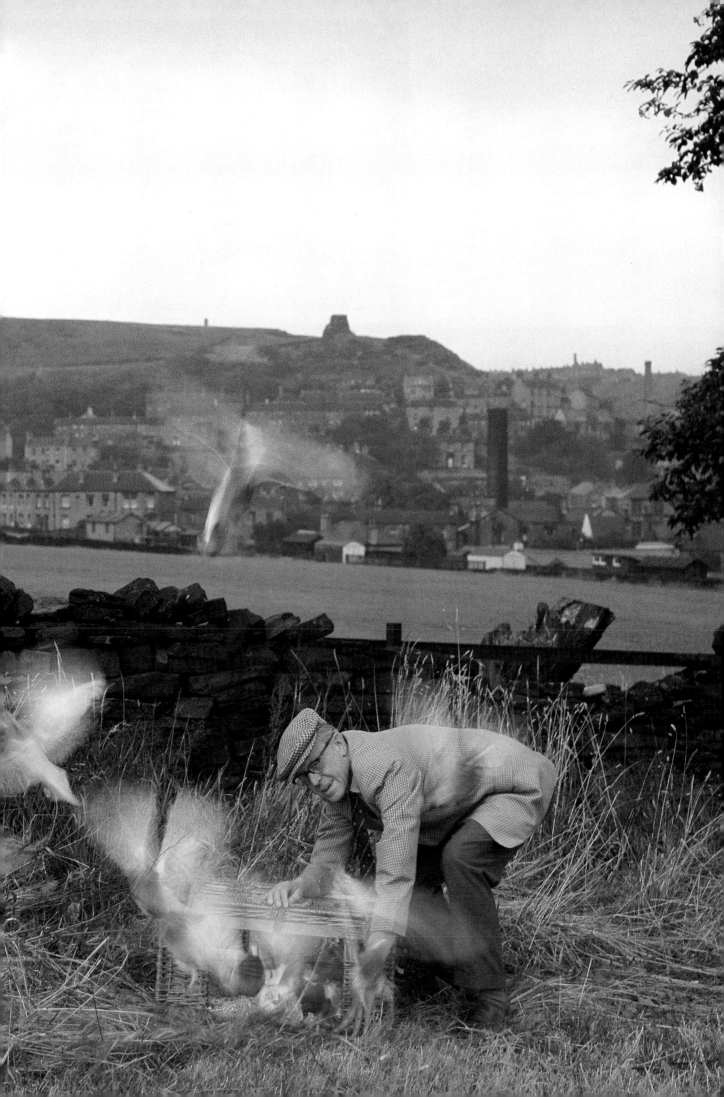

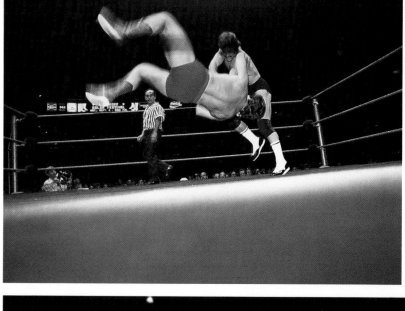

Sport with flash

Indoor sports with their often poor lighting but fast action offer the perfect opportunity for creative use of flash. Understanding just what effects flash can provide is important because, this way, you get variety into your shots.

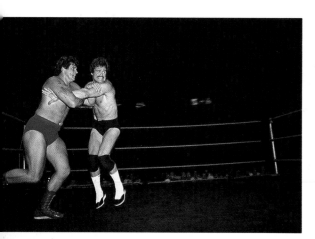

In these three pictures, the action of the wrestling is caught in different ways. In the shot (*above*) it is completely frozen but in the other two photographs, the blurring of the wrestlers' legs and hands conveys the fast-moving action. In a situation such as this you are limited in where you can move. At the same time you have to get in close, and hold the camera in front of or between the ropes. Flash will bounce off the ropes throwing light back. I prefer to use flash as a fill-in, rather than a main light in photographing sporting activities, otherwise it freezes everything. I use fast film to give me maximum definition, and try to use a shutter speed of a thirtieth of a second, so that the flash freezes the action but you still see the life and movement of the action. Here I used a hand-held camera with wide-angle lens and on-camera flashgun.

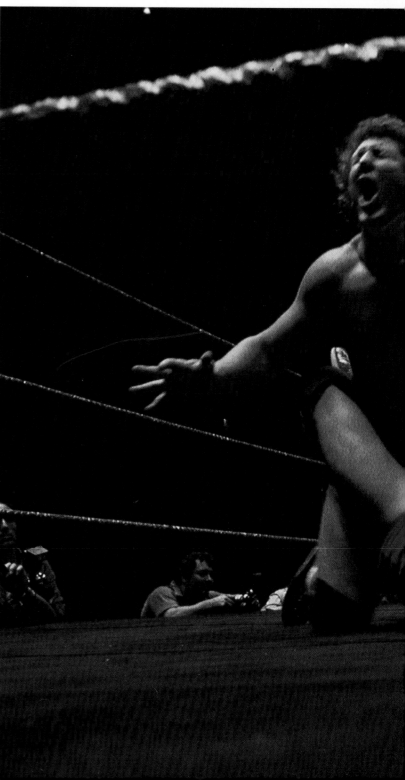

Technical Appendix

CAMERAS

Working in medium-format

Roll-film SLRs are small enough to hand hold, but produce a picture around four times larger than 35 mm SLRs. The blown-up print from the former is therefore of much better quality, being relatively grain-free. Medium-format cameras are not as quick and easy to use as 35 mm versions, but are very convenient compared to sheet-film or large-format – particularly for studio work and especially portraiture. Those with Polaroid film backs are particularly useful.

The camera body is just a box frame containing the shutter and viewing mechanism, onto which clip the lens, focusing screen, viewfinder and film magazine. Not all have focal plane shutters; some have leaf shutters within the lens which allow a synchronized flash at all speeds. Usually the viewfinder is a folding (or sometimes rigid) hood of metal plates, protecting the focusing screen from light when up, and from damage when folded down. It has a magnifier in its top for a clearer view of the image, which is laterally reversed. Prism viewfinders will give an upright image; metering prisms can also be fitted to measure light. Three different picture sizes are available in this format: 6 × 6 cm, which takes twelve frames 6 cms square on a roll of 120 film; 6 × 4.5 cm, which can take 15 frames, and 6 × 7 cm cameras, taking ten frames. Some 6 × 7 cm cameras have revolving backs to change the format from portrait to landscape. Each size has a different standard lens; 6 × 6 cm an 80 mm lens, 6 × 4.5 cm a 75 mm lens and 6 × 7 cm a 90 mm lens.

735 mm Single Lens Reflex Cameras

Nowadays, you will find a 35 mm SLR for every level of experience. Of all available types of camera, it is the most convenient to use under a wide range of conditions, as well as possessing the ability to produce good quality images. It is the most commonly used camera by the serious photographer. Fully automated models produce excellent results even when used by those with limited knowledge of photography; when used by knowledgebable photographers, however, 35 mm SLRs and their accessories are tools that provide endless creative possibilities.

They all have a shared design concept, dictated by the central bulge of their reflex viewing system, and are recognizable by this distinctive shape which houses the eyepiece and viewing prism. But a most important aspect in their favour is that one can compose with the camera at eye-level. This can be done because the mirror inside the camera body reflects the image from the lens upwards to the viewfinder, revealing exactly what appears on film. Also, inside the camera body, is the metering or light-measuring system to advise on exposure. Although the basic premise of film running behind a focal plane shutter across the camera back remains constant, the amount of electronics within the camera is assuming an increasing role. Recent models include integrated circuitry for metering and exposure setting.

35 mm SLRs differ from each other in the amount of automated features they include, the quantity of user-assembled elements, light versus a robust construction, and in their price. The one thing that the 35 mm SLR will not do, however, is to give the facility of being able to change from one film to

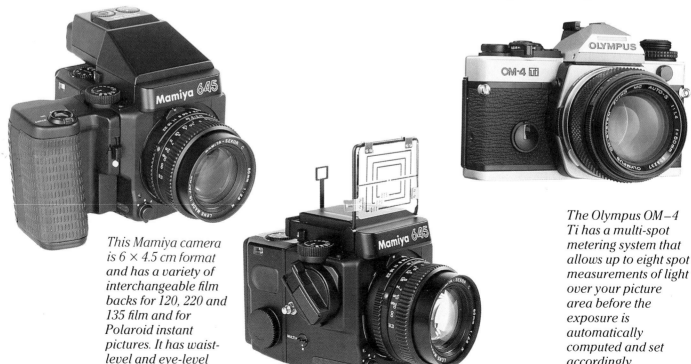

This Mamiya camera is 6 × 4.5 cm format and has a variety of interchangeable film backs for 120, 220 and 135 film and for Polaroid instant pictures. It has waist-level and eye-level view finders.

The Olympus OM–4 Ti has a multi-spot metering system that allows up to eight spot measurements of light over your picture area before the exposure is automatically computed and set accordingly.

another. You must rewind the film into its cassette and reload. So in situations where film changes are needed, roll-film cameras are used.

Films

The most important characteristic of film, whether black-and-white or colour, is its speed. It's a good idea to practise using all types and speeds of film; the subject and lighting conditions will determine the final choice. Slow films, which produce fine grain and sharp detail, need much more light to form an image than fast films. Unless the light is bright, slow film will force you to use a too-slow shutter speed and too-wide aperture. They are ideal for well-lit, detailed and still subjects, such as architecture and still-life.

Fast film allows you to take pictures in poor light, but when enlarged the photographs reveal a grainy texture and poor definition. High-speed films are necessary for action photography, for with bright light you can use a fast shutter speed and small aperture to get good pictures of moving subjects. Slow film (25 and 32 ISO) can only be bought in black-and-white or colour slide form; medium speed film (50, 64 and 100 ISO) includes colour negative film at 100 ISO; fast film is available at 125 and 200 ISO. Very fast film (320 and 400 ISO) is highly versatile, while the extremely high-speed films (640, 1000, 1250, 3200 ISO) and black-and-white recording film (4000 ISO) will produce exceptionally grainy results, and are only useful when the light is too low for anything slower.

Working with black-and-white film presents great creative opportunities. In addition, it can be processed and printed in minutes from exposure. The most popular film is colour print or negative film, which has more exposure latitude than colour transparency or reversal film. It also allows altering of its colour and tone both at shooting and at printing stage. Colour reversal film produces a finer image quality than colour negative film of an equivalent speed, because its component grains of silver are smaller. The colours are also cleaner and more intense. During development, under and overexposure of colour slide film can be compensated for. This is called 'pushing' and 'pulling'. It can be done because the film's density relates also to the duration of its first development – the shorter this step, the darker the film and vice versa. So a photographer can increase or 'uprate' the speed of slide film, which can then be compensated for at the processing lab. 'Pulling' will reduce film speed.

Heat, humid conditions and airport x-rays will all damage exposed and unexposed film. It should always be kept as cool and dry as possible and in humid or damp conditions sachets of silica gel crystals should be used to absorb moisture. X-rays, like light, will fog undeveloped film; the extent of the clouding depends on the type of film, the power of the dose and the number of doses. Fast film, being more sensitive, is more vulnerable to fogging than slow film. Lead foil bags will afford some protection.

Reflectors

The importance of reflectors is often overlooked. They can improve pictures a great deal, particularly portraits. Any surface capable of reflecting light qualifies as a reflector; in photography they are invaluable for shadow areas, softening dramatic, one-sided lighting

A selection of the many available makes of film.

Lastolite reflectors.

and creating a broader balance and more even illumination by diverting and bouncing back light onto the subject. White walls and ceilings are the simplest of reflectors, but sheets of white, grey or silvered card are the most used. You can make your own reflectors when maximum reflection is needed by glueing screwed-up pieces of aluminium kitchen foil onto a large piece of card. There are three different sizes of Lastolite circular reflectors – 20 (0.75m), 38 (0.9m) and 48 (1.2m) in diameter – all of which fold away to about a third of their respective sizes. Because they weigh only ounces, they are portable and useful outdoors. Of the four colours available, white can be used either as a reflector for soft portrait light or as a diffuser between the light source and subject; black will absorb unwanted light; silver gives the strongest reflection which has a sharp quality; gold reflects warm tones. Indoors, they can be fitted onto a holder and stand or a boom arm.

Studio lights have bowl-shaped mirrors as lamp reflectors and electronic flash heads often use collapsible umbrellas mounted on stands. Umbrellas come with a variety of linings, usually white, silver or gold.

Lenses

All 35 mm SLRs take interchangeable lenses and, according to the lens used, the size of the image can vary enormously. How much or how little of the scene in question a lens takes in depends on its angle of view. This is determined by its focal length, which is the distance from its optical centre to the film plane, when set at infinity. Although many lenses with focal lengths from 8 mm through to 2000 mm can be obtained, for a 35 mm SLR you really only need a 28 mm (wide-angle) 50 mm (standard) and 135 mm (telephoto). This will be adequate for the majority of photographs; other lenses are for more specialized work.

A 50 mm 'normal' lens is so-called because it renders the scene as the eye sees it, and has become established as the standard lens because it gives relatively normal-looking perspective. It is called 50 mm because that is the length of the diagonal on the 35 mm format. These lenses usually have apertures of f1.8 or f1.4 (larger than other focal lengths) and are – compared to other lens sizes – compact, light and less expensive. They focus to within two feet of a subject and also at a considerable distance, and the image is distortion-free. A 50 mm lens is therefore primarily useful for street scenes, full length portraits and still-life work.

Lenses of short focal length are called wide-angle lenses, because the compress a broader field of view into the format. This is done by bending the light passing through the lens, making objects appear smaller, so that, for example, a person can be shown within a broad landscape. Because of this optical shrinkage, there is some distortion of the image. This is most noticeable where straight lines are involved, at the edges of the picture o when the camera is tilted. The more extreme the wide-angle, the more distortion is created.

But the enormous advantage of wid angle lenses is that they have greater depth of field than standard lenses at the same aperture. Focusing is therefore less critical, so they are muc quicker to use and enable the photographer to point and shoot in fast-action or low-light situations. Muc favoured by photo-journalists, the sho produced by this lens seem to pull the viewer into the scene by virtue of its wider angle of view and sharp detail, from close-up to infinity. Examples

50mm

28mm

135mm

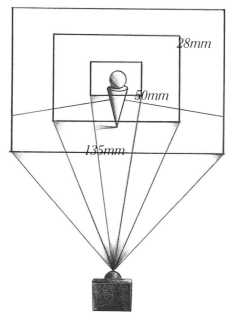

28mm

50mm

135mm

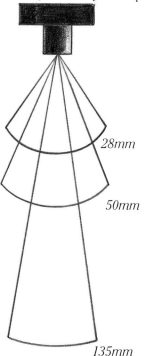

28mm

50mm

135mm

between 35 mm and 21 mm are considered wide-angle: below that, the 16 mm, 15 mm, and 8 mm lenses are called 'fish-eye'. These compress an exceptionally wide view onto the film, creating extreme distortion.

The telephoto lens is really the opposite of the wide-angle. It magnifies a small area of the subject, allowing the photographer to fill the frame from a greater distance. It appears to compress perspective in a dramatic way and its degree of magnification is dependent on its focal length: a 135 mm lens will magnify by 2.7, a 200 mm by 4, and a 400 mm by 8 times, respectively. Telephotos give less depth of field than normal lenses, producing an unsharp background which is useful in eliminating distracting elements in portraits. At the same time they allow you to operate from a comfortable working distance.

Two other lenses which are useful in close-up and architectural photography, respectively, are a 100 mm macro lens and a 28 mm shift lens. Macro lenses are optically superior at close distances and can focus down to eight inches or so from the subject. The longer focal length gives a greater working distance.

Olympus OMTi with on-camera flash

On-camera Flash

The portable electronic flashgun is the most convenient form of providing extra light for photography, giving complete independence to the photographer. With on-camera flash, he is free to shoot anywhere, whatever the light. By sliding the unit into the hot-shoe on top of the camera, you complete a circuit. When the shutter is released, a high-voltage current is discharged between two electrodes in the glass-filled gas tube in its reflector. This gives a brief but intense flash of light which can be used as a supplement to daylight or artificial light, and is especially handy at night. After dark, that brief burst of light freezes movement and illuminates those parts of the subject nearest the camera, which will stand out against a black background. Close-up it gives rich, saturated colours.

The speed of the flash determines the length of the exposure, but because most on-camera units vary in this output, they have calculator dials to give the distance to which the light will extend. The shutter speed is usually set to 1/60. Some units now automatically synchronize aperture, shutter and light

output. Recycling is done by drawing power from batteries between flashes, which usually take from five to ten seconds.

Although flashguns are incredibly useful such direct, frontal light can produce a harshness that is unattractive. The technique called 'bounce flash' will soften that unflattering quality by bouncing it off a surface, such as a wall or ceiling, giving instead a reflected light. Most units have tilting heads that allow this. In outdoor portrait work, 'fill-in' flash will lighten shadows on a face in the foreground, while keeping the natural light of a landscape behind.

Studio Flash

Studio flash units are really only larger versions of portable flashguns mounted on a stand, but with a great deal more available power. The flash tube is usually in the shape of a ring – with a modelling light in the centre – or a long strip. These flash units can operate in cojunction with daylight, and daylight film is used. Unlike tungsten ('hot') lights, they remain cool and freeze movement. All photographic lamps need to be diffused to give a softer, less

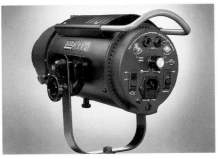

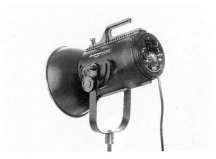

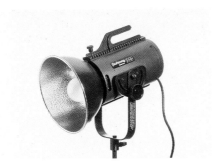

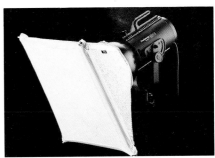

Courtney make five flash units that vary in power and output – the Solaflash 1000, 1000S, 2000, 4000 and 8000.

contrasty light: there are many kinds of reflectors and diffusers to modify the light beam.

The Darkroom

The importance of setting up your own darkroom depends on the scope of work you plan to undertake. Simply processing slide film can be done in just a wardrobe at night; colour enlarging must be done in the dark but colour processing can be done in a kitchen or bathroom. It is black-and-white printing that takes up the most room. You will need wet and dry benches, space for processing trays, running water and a shallow sink.

The wet-and-dry processes should be kept apart so that paper and negatives are not splashed with water or contaminated with chemicals. The room must be well-ventilated and heated, while at the same time light-tight and dust-free. Rubber flaps will seal the gap between floor and door, black blinds or plywood frames may cover the windows when light-proofing. The walls around your enlarger should be dark, to prevent escaping light from its lamphousing reflecting onto the paper.

For black-and-white printing, safelights give a low level of orange light that does not affect enlarging paper, but they should be kept at least four feet from the working area. One safelight is sufficient for a small room, but two are more useful, in order to see generally, and also specifically when cutting paper and inspecting prints. Equipment needed for making prints are: an enlarger, easels to hold different-sized papers in position, safelights, test-strip printer, developing trays, print tongs, enlarging paper, print developer, rinse and fixer. For developing films you will need a developing tank, thermometers, measuring graduates, chemical mixing jugs, force film washer, film clips and squeegee. Paterson make all these items.

A colour head on the enlarger, or alternatively, a set of colour filters is needed for colour printing, together with chemicals and paper, a colour processing drum or the Paterson Orbital processer, storage bottles and measuring cups.

Tripods

Using a tripod brings many advantages,

the most important being the improvement in image quality its use can produce. You avoid the softening of detail and streaking of image that betrays camera-shake, caused by low light conditions. A tripod is particular useful for providing a fixed viewpoint for the camera, so that you can concentrate on the subject. You are fre to move around, perhaps talking to the sitter during portrait work, while for still-life work you possess a precise angle of view from which to compose the group.

The tripod's steadiness comes from its weight: the heavier it is, the less it will vibrate. The most solid tripods are those with the least leg sections, eithe equipped with steadying cross-braces or capable of having their three legs spread wide apart.

There are two common types of tripod heads – ball-and-socket and pan-and-tilt. A ball-joint head allows quick and radical changes of movement in any direction when its one locking knob is loosened. Pan-and tilt heads usually have three-way controls so that the camera can be reorientated forwards and backwards, round and round, and left to right. Ease of adjustment of the head is crucial.

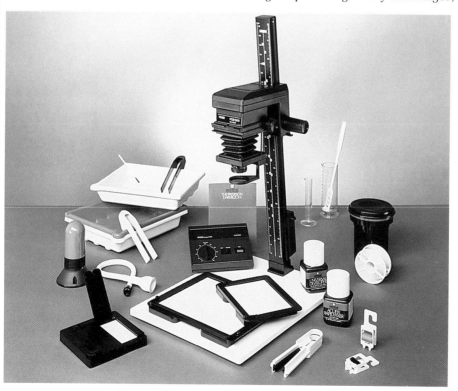

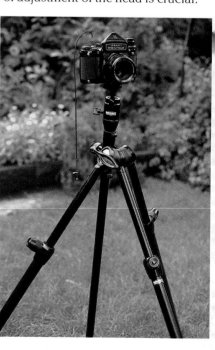

Left: Paterson darkroom equipment
Above: Benbo tripod

GLOSSARY

Accessory shoe A fitted component which enables a flashgun to slide on top of a 35 mm camera, more often called a 'hot-shoe'. It provides the contact between shutter and flash unit, in a circuit which synchronizes flash to the shutter when it is released.

Angle of view The angle which a lens covers and takes in light on a 35 mm camera. A lens of long focal length – such as a 135 mm telephoto – has a narrow angle of view (about 20 degrees); a lens of short focal length – such as a 28 mm wide-angle – has a broad angle of view (about 73 degrees). A standard 50 mm lens has an angle of view of about 47 degrees, roughly equivalent to normal human vision.

Aperture An opening at the front of the camera lens, usually circular. It can be varied in size by the diaphragm, which is calibrated in f numbers. This controls the amount of light passing through the lens to the film.

Artificial light Any light source used in photography other than natural light, such as flash, studio lights or tungsten lamps. Films are rated either 'daylight' or 'artificial light', due to the difference in sensitivity of photographic emulsions to these two light sources.

Automatic exposure A system to set correct exposure automatically. It connects the camera's exposure meter with the shutter or aperture diaphragm, or both. Of the three main types the

system called 'aperture priority' is the most popular. The photographer sets the aperture and the camera selects appropriate speed. 'Shutter priority' allows the shutter speed to be chosen by the photographer and the camera sets the right aperture. 'Programmed automatic exposure' is when the camera sets both aperture and shutter speed — ideal in fast action situations.

Available light This term is used to refer to existing light, whether indoors or out, without any added lighting by the photographer.

Backlighting Lighting which illuminates the subject from behind, shining towards the camera. It can be used to create a silhouette, or in conjunction with some front lighting, to produce a 'halo' effect in portrait work. It makes exposure very difficult to estimate because of the high contrast created. Careful exposure meter readings of the area to be normally lit should be taken rather than an average, whole-scene reading.

Bounce flash A technique of softening the direct, frontal light from a flash head by 'bouncing' the beam off a reflective surface onto the subject, giving a quality of diffused light. The ceiling, a wall or a reflector board are most commonly used. An exposure adjustment is required for the extra distance the light beam has to travel, and because some light is absorbed by the reflecting surface. The colour of the reflecting

surface will also affect the light cast on the image. The technique is often used in portrait work, because direct flash on the camera can cause unflattering 'red-eye'.

Bracketing A technique used to ensure the best possible exposure by taking several pictures of the subject at different exposure settings either side of the presumed correct one, usually in ½ stops.

Colour negative film Film processed into negatives from which colour prints are made.

Colour reversal film Film processed directly into colour transparencies.

Colour temperature Measurement of a light source's colour quality, expressed in kelvins (k).

Daylight film Film balanced to give accurate colour rendering when used in daylight; also suitable for use with electronic flash.

Definition This describes the clarity and sharpness of a photograph. Good definition depends on accurate focusing, the speed of the film and the quality of the lens.

Depth of field The distance between the nearest and furthest point from the camera, within which there is acceptable sharpness of subject detail. It can be controlled by varying the size of the aperture, the focal length of the lens, and the camera-to-subject distance. Depth of field increases the more you decrease the aperture size. Many 35

mm SLR cameras have a depth of field preview button.

Diaphragm The adjustable device forming the aperture of a lens, controlling the amount of light passing to the film. Most diaphragms are composed of overlapping curved blades which form a circular opening that can be varied by moving a ring on the lens barrel.

Diffused light Light reflected from an uneven surface or shone through a translucent material (such as tracing paper) to soften harshness and glare.

Electronic flash Artificial light source with repeatable, short but extremely bright bursts of light, produced when an electric current stored in a capacitor is activated by the camera shutter. It is used in photography as a supplement or alternative to the available light. Ordinary flash-units are powered by batteries or mains power.

Emulsion The layer of a film or printing paper that is light-sensitive. It consists of silver halides suspended in gelatin, which blacken when exposed to light. Colour film contains in addition colour dyes or couplers in its gelatin.

Emulsion speed The sensitivity of an emulsion to light. This is indicated on a roll of film as an ISO number, which denotes the speed with which the emulsion reacts to light.

Enlarger Apparatus for

projecting and focusing the image on the negative or slide onto sensitized paper in order to make an enlargement.

Exposure The total amount of light reaching the film through the lens. It is controlled by aperture size and shutter speed, both of which must relate to the emulsion speed of the film. Over-exposure means too much light, which creates a pale image; under-exposure means too little light, producing a dark image.

Exposure meter Instrument for measuring light intensity which enables the aperture and shutter to be set for correct exposure. Exposure meters exist either inside the camera or as separate units. Built-in meters measure reflected light; separate meters can make incident readings (light falling on the subject), as well as measuring the light reflected by the subject. They usually convert the light measured into a range of shutter speeds and aperture settings for correct exposure.

Fast lens Lens of wide maximum aperture in relation to its focal length. Fast lenses are more difficult to design and manufacture than slow ones, and are therefore more expensive.

Fill-in lighting Direct or reflected light that is used to supplement the main light and to reduce the shadows caused by it. Single light sources from one side of the subject may create heavy shadows on the other

side. This can be balanced by the use of an additional light.

Film Sensitized transparent material in the form of a strip or in sheets, consisting of a thin plastic base coated with emulsion.

Film speed The degree of sensitivity to light of film, rated numerically for exposure calculation. ASA (American Standards Association) and DIN (Deutsche Industrie Norm) have been replaced by ISO (International Standards Organisation). A high numerical rating denotes a fast film *ie* one that is more sensitive to light, such as 200 ISO or 400 ISO; slow films are 25 and 32 ISO.

Filter Thin sheet of glass, plastic or gelatin, placed in front of the lens to modify or control the light passing through it. Some filters alter tone or colour, others cut down haze, reflections or create special effects.

Fish-eye lens Extreme wide-angle lens with a 180 angle of view, producing very distorted circular images.

F-number Number produced by dividing the diameter of the aperture by the focal length of the lens. A set of f-numbers are marked on the lens ring that controls the lens diaphragm, calibrating the aperture in steps known as 'stops'. The interval between one f-stop and the next is a halving or doubling of image brightness. As the aperture is reduced, the f-numbers become higher.

Focal length The distance between the optical centre of a lens and the point at which light rays from objects are brought to focus when set at infinity. The longer the focal length, the narrower the angle of view.

Focal plane The plane on which the image is brought into focus by a lens *ie* the film itself.

Focal plane shutter A shutter system using two blinds lying just in front of the focal plane. When a gap between the blinds passes in front of the film, exposure is made. Exposure is controlled by adjustments to the gap's size.

Focusing Method of adjusting the lens-to-film distance by moving the lens forwards and backwards, in order to form a sharp image of the subject on film. The nearer the subject, the further the lens must be moved from the film, and vice versa.

Format Size and shape of the print, negative or slide *ie* 35 mm format for a slide and vertical or horizontal format for a print.

Grain Granular texture appearing on a photographic print caused by tiny particles of black metallic silver formed when the silver halides have been developed. The faster the film, the coarser the grain.

Grey card Card used to obtain average reflected-light exposure readings.

High-key A photograph containing predominantly pale

tones: the opposite, or mainly dark-toned picture is termed low-key.

Highlights The brightest parts of a subject which become the lightest on the final print or transparency.

Incident light Light that falls onto a surface, rather than light which is reflected from it. Most hand-held exposure meters can measure both incident and reflected light.

Joule Used to measure the output of electronic flash: a unit of energy equal to one watt-second.

Latitude The ability of films to make a reasonable image when the exposure is not quite right. Black-and-white, colour print and fast films have greater latitude than colour transparency and slow films.

Lens Optical device of glass or plastic that can bend and focus light rays. The size, shape and placing of elements within a lens determines its focal length.

Lens hood An opaque tube made of metal or rubber, placed around the lens to shield it from unwanted light or flare.

Macro lens Lens specially designed to give fine quality images from subjects very near to the camera. Gives a 1–1 magnification (life-size) or larger.

Medium-format camera A camera taking roll-film, producing a negative or transparency of 6 × 4.5, 6 × 6, 6 × 7

and 6 × 9 cms. They come in three types; the single-lens reflex, the twin-lens reflex or the non-reflex.

Mirror lens A lens using curved mirrors in its composition instead of all glass elements. It makes a very long lens lighter and more compact than it would otherwise be.

Normal lens Also called a standard lens. It produces an image close to the way the eye sees and has a focal length of 50 mm in most SLR (single-lens reflex) cameras.

Over-exposure Excessive exposure of film to light, increasing density and reducing contrast. Over-exposed transparencies have burnt-out highlights.

Pan and tilt head Tripod head with separate locking screws to allow movement in the horizontal plane (or panning) and movement in the vertical plane (tilt).

Panning A technique of following a moving subject to freeze it while blurring the background, creating an impression of speed.

Reflector Any surface from which light is reflected. Photographers usually use sheets of white, grey or silvered card, or fabric, to reflect light back into shadowed areas. Studio flash often has umbrella reflectors.

Reflex camera Camera using a mirror in the viewing and focusing system to reflect the image rays from the lens onto a focusing screen.

Refraction Light rays changed in their angle of direction while travelling through one transparent medium to another of a different optical density.

Safelight Darkroom lighting of a colour and intensity that will not spoil sensitized materials.

Saturated colour Pure colour free from any grey. It reflects light of one or two of the three primary colours.

Self-timer Device on a camera to delay shutter operation by up to ten seconds after the shutter release is pressed.

Shift lens Lens that can be moved off-axis both vertically and laterally. Used chiefly in architectural photography to control perspective.

Shutter Mechanism in the camera that controls the length of the exposure. There are two types: diaphragm or between-the-lens shutter, in the barrel of the lens; and focal plane shutter, within the camera body just in front of the film.

Soft focus Intentionally diffused image definition, often used in portraiture.

Stop The aperture of a camera or an enlarging lens. The term 'stopping-down' means reducing the aperture of the lens.

Telephoto lens A kind of long-focus lens that has a narrow angle of view, magnifying distant objects.

Time exposure Exposure where the shutter is

INDEX

opened and closed for the length of time worked out by the photographer. They are usually necessary in poor lighting conditions and make use of a cable release to depress the shutter of the camera mounted on a tripod.

Tripod An adjustable, three-legged camera support, used for stability during long exposures. It has a head on which to attach the camera and usually has collapsible legs.

Tungsten light Electric light for domestic and photographic purposes in which the current passes through a filament of tungsten. Its light is much warmer than daylight or electronic flash, and requires tungsten-balanced films or a converting filter with daylight film.

Underexposure Result of too little exposure, reducing density and contrast in the image.

Uprating Term used to denote intentionally underexposed film which is then compensated by overdevelopment.

View-finder Area on a camera through which the scene that will appear in the picture can be seen.

Wide-angle lens A lens with short focal length and a wide-angle view of the subject. The more extreme the wide-angle, the more distorted is the image.

Zoom lens A lens in which the focal length can be varied between two defined limits. Typical ranges of focal lengths are 28–50 mm, 35–70 mm, 50–135 mm or 80–200 mm. 200 m lenses are heavier, are of lower optical quality and have smaller maximum apertures than fixed-focal length lenses.